HIGH
QUALITY
DESIGN

BUDGET

WATSON - GUPTILL PUBLICATIONS / NEW YORK

HIGH

QUALITY

DESIGN

STEVEN HELLER AND ANNE FINK

Copyright © 1990
Steven Heller

First published in 1990 in
the United States by Watson-
Guptill Publications, a divi-
sion of BPI Communica-
tions, Inc., 1515 Broadway,
New York, N.Y. 10036.

Library of Congress
Cataloging-in-Publication
Data

Heller, Steven.
Low-budget/high-quality
design : the art of inexpen-
sive visual communication /
Steven Heller and
Anne Fink.
p. cm.
Includes index.
ISBN 0–8230–2880–1
1. Communication in
design.
I. Fink, Anne.
II. Title.
NK1510.H438 1990
741.6–dc20
 90–12520
 CIP

Distributed in the United
Kingdom by Phaidon Press
Ltd., Musterlin House,
Jordan Hill Road, Oxford,
England, OX2 8DP

Distributed in Europe, the
Far East, Southeast and Cen-
tral Asia, and South Amer-
ica by RotoVision S.A., 9
Route Suisse, CH-1295
Mies, Switzerland.

Manufactured in Singapore

First Printing, 1990

1 2 3 4 5 6 7 8 9 10/94 93 92
91 90

For
Nicolas Gianni Heller

Sincere gratitude and deep affection go to Anne Fink, who has been a loyal and intelligent collaborator and without whom this book would have been impossible to produce. Thanks to everyone who enthusiastically contributed their work to *Low-Budget/High-Quality Design*. Special thanks to: Mary Suffudy, executive editor at Watson-Guptill, who saw the need for this book and made it possible; Candace Raney, senior editor at Watson-Guptill, whose guidance was invaluable; Louise Fili, my wife, who designed this book with her usual good taste and intelligence; Michelle Willems, the design associate, for administering to the book's smooth completion; Carl Rosen, associate editor at Watson-Guptill; Edward Spiro, who took the additional photographs; Francine Kass, Eric Baker, Dugald Stermer and Martin Fox for their support and encouragement; Larry Klein at Design/Type, Inc. (West Orange, NJ); and Sarah Jane Freymann, my agent, for her wisdom. — Steven Heller

CONTENTS

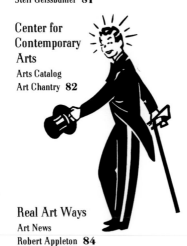

by Steven Heller

The State of the Art

During the 1980s *design* became a household word (well, sort of), and designers in various media virtually became cultural heroes. Labels were worn ubiquitously on the outside of apparel, and furniture was marketed not necessarily on the basis of craft or function but on the prestige of the designer who conceived it. Caught up in this groundswell, certain graphic designers decided to upgrade their images in order to attract the growing number of corporations and businesses who realized that design professionals were needed to develop their visual images and corporate identities. Among some upwardly mobile graphic designers there was the correct assumption that in a competitive marketplace small design studios lacked the prestige, and hence the resources and leverage, of comparatively larger firms. Many small and medium-sized boutiques (as they are now called) either merged with other studios to become big firms, or promoted themselves to appear to be large-scale through sophisticated (and expensive) advertising. To be considered a bona fide professional by their clients, some designers borrowed a page on designing offices from Michael Korda's *Power Principle*, trading in the traditional drafting table and taboret for luxurious and stylish offices.

American graphic designers have been working with business and industry for well over a century, but during this past decade they became more concerned with expanding their own businesses than ever before. The conventional design studio was transformed into a *communications firm*. The commercial artist diversified by adopting the title *visual communicator*. And the *design manager*, akin to advertising's account executive, emerged as a client-"artist" go-between. *Design consultancies* also sprang up like mushrooms, offering expert advice and a panoply of custom services from logo to interior-office design. Someone, probably at a power breakfast, even coined the phrase *strategic design* to describe how graphic designers could position a product in the marketplace just as effectively as the more-established marketing professional.

The look of graphic design has become more professional as a consequence of the adoption by boutiques of the airs necessary to elicit high-priced commissions from high-paying clients. Some critics argue that design in the eighties was indeed too professional (or "slick") at the expense of surprise, warmth, or humor, resulting in ostensibly better-looking work and a curiously high level of mediocrity. While such generalizations are debatable, one thing is certain: in the 1980s, graphic designers were considerably more concerned with surface than content. In his keynote address before the 1985 AIGA National Conference in Boston, Tom Wolfe satirically compared the veneer achieved by using expensive papers, pastel inks, and multiple varnishes to a tasty confection like marzipan, stating that certain graphic designs were so mouthwatering that he had an uncontrollable urge to eat them. Considering the look of so many of today's elaborate brochures, annual reports, and capability studies, one can agree that there is a prodigious amount of tantalizing graphic communication being produced, but at the same time one could ask, in the parlance of the eighties, "Where's the beef?" Much of graphically designed material today is really no more than a garnish on an empty plate. In any period there are different balances of high and low aesthetic and conceptual levels. In the eighties, as design budgets increased and technique became an

alternative for ideas, the aesthetic level was raised at the expense of the conceptual level, which became mundane.

One of the major functions of the graphic designer is to improve the packages of lackluster products and the broadcast of tired ideas, but for anyone interested in design as a positive social tool, this is an inadequate description or goal. Today's graphic communications — a process of orchestrating words and images to convey messages, as well as to stimulate the appetite for a product or notion by projecting a style or point of view — indicate a more direct and inclusive influence by the designer on the huge amount of information to which we are routinely exposed. Given that *visual communicator* is such a loaded term, the individual who assumes this title might even take on more responsibility than a mere graphic designer for making accessible and understandable the daily barrage of data and ideas.

Design Responsibility and Conspicuous Consumption

Social responsibility, however, should not imply that visual communicators must consistently use spartan approaches or minimalist vocabularies. The fact is that we live in a culture bombarded by countless images competing for public attention. So rather than be safe and staid, our designed environment should be genuinely interesting, if not also challenging. The visual communicator must employ every available tool (and trick) at his or her disposal — but never at the expense of the message. Though I would argue against the use of flagrant gloss or glitz, such mannerisms are acceptable if required as a solution to a specific design problem. I would also argue that legibility is the prime concern of the graphic artist, but sometimes an unconventional visual code is required and indeed acceptable. Given this license, however, visual communicators should still be accountable to the client and society. And this responsibility equals *restraint*.

Restraint in this context means that a designer, given the limits inherent in the product or idea being designed, should not allow the design of a project to be more obtrusive than is necessary to convey a message. For example, it is appropriate to luxuriously design a capabilities brochure for a pricey condominium owing to the nature of the audience the brochure wants to reach, as well as the fact that the brochure will be in use for a relatively long period of time. Conversely, a schedule of events for a nonprofit cultural center or a fund-raising brochure for a public-interest group should reflect its purpose and inherent monetary limitations.

Comparatively few design problems actually demand the opulent approach, but often a designer convinces a client that an elaborate production is necessary when it is not. High-budget design is a code that invariably uses opulence to connote status. This is fine when the product or idea requires it, but not when the designer simply wants to create work to be selected into design annuals or to score points with peers. With the notable exception of logo design (which can be rather expensive owing to factors that are invisible in the final product), most high-budget design is almost always conspicuous — otherwise, why spend the money? As an example, some time ago I saw an exhibition featuring the fifty most-elaborately designed, expensive, and beautiful pieces produced within a five-year period. Without exception the first comment raised by viewers was "those pieces must have cost

a fortune to produce." Conversely, one of the virtues of low-budget design is that in capable hands it is not necessarily obvious that it was "done on the cheap." Even on a low budget a designer needn't scrimp on creativity. The examples selected for *Low-Budget/High-Quality Design* reveal a production range from the conspicuously inexpensive to the comparatively expensive. Given this range (and the preceding polemic against conspicuous design manufacture) you are probably wondering how *low budget* is defined for this book.

Defining Low Budget and High Quality

Using work done within the past twenty years by veteran, neophyte, student, and even a few non-professional designers, *Low-Budget/High-Quality Design* examines the various ways to ensure effective design with limited resources. Much of the work here show how designers transcend the constaints of decidedly meager or relatively low budgets, and how they communicate just as effectively, and often with equal panache, as the high-budget items. Both terms (*low budget* and *high quality*), however, are relative.

First I will explain the parameters of a low budget in relative terms. A designer working on a poster for absolutely no fee with no production budget would consider another designer with a $1,000 production budget to be flush. But compared to the designer with a $5,000 production budget the previous amount is paltry. But $5,000 is nevertheless insufficient compared to the designer who is given a $7,000 budget for the same basic job. Also in this book are projects with seemingly high budgets, which were actually insufficient to cover the designer's needs and demands. And there are also projects that were allotted generous budgets yet the designer elected to go the low-budget route because it was more appropriate. The dollar amount is indeed relative, since having a reasonable budget does not necessarily insure good work. Other factors, such as the client's attitude, can enhance or adversely affect the outcome of the job. Therefore, in this book a designer's "official" budget will be a signpost of available resources. In some cases the dollar figure is discussed; in others (where the designer feels such a disclosure might be unfair to or jeopardize a relationship with the supplier), the budget is discussed in general terms.

Not just any old thing done on or that looks like it was done on a shoestring qualifies for inclusion in *Low-Budget/High-Quality Design*. Works were selected based on whether the conceptual and aesthetic success of a specific piece eclipses the budget afforded the designer or whether low-budget techniques were effectively employed despite the budget. These determinations are based on the designer's assertion that corners were cut and belts were tightened to achieve success, as well as my belief that the work in question conforms to the principals of this book as described above.

So now let's talk about high quality, which is a decidedly more subjective distinction. For those who judge the quality of graphic design based on the sheer number of colored inks, the elegance of the patina of the paper, or the flawlessness of the printing, one or two color pieces printed on inexpensive paper would be deemed inferior. Quality, however, is not determined exclusively by production values. Creative visual and concep-

tual ideas and the effectiveness with which they are communicated are the bases for inclusion in this book. Yet production is not ignored. As the range of concepts and ideas are broad, so too is the production range. Quality is measured by how uniquely the various low-cost printing techniques (that is, kodaliths, split-fountain printing, computer layering, and so on) are used to convey interesting and compelling ideas and information. Though the comparative level of quality can be debated, each piece shown in *Low-Budget/High-Quality Design*, whether or not designed by a professional, is a superlative graphic communication, given its context.

Categories

*L*ow-Budget/High-Quality Design is organized into eight thematic categories under which the reader will find work done for "Schools and Colleges," "Advocacy and Protest," "Society and Community," "Art and Culture," "Books and Magazines," "Business and Commerce," as well as "Letterheads and Trademarks." All the examples fall under one or more of the following definitions:

1. *Pro bono publico.* This is work produced in the public interest for advocacy or protest groups and for institutions committed to social or community welfare. In some cases the printing, paper, and type for these materials were donated by suppliers, while in others they were provided at cost. Some of the production donations were small, suggesting that the designer had to muster great creative acumen in the cutting of corners, while other donations were rather generous, allowing the finished product to be aesthetically comparable to a higher-priced version. Regardless, the bottom line in this *pro bono* category is that the designer either received no recompense whatsoever or a limited reimbursement for out-of-pocket expenses. Also considered *pro bono* are the letterheads, logos, and brochures produced by students for nonprofit groups who can only afford to pay for limited production and usually offer no design fee.

2. *Self-published,* perhaps for profit but more often than not for love, includes work by designers (as well as illustrators, writers, and editors) who do not take salaries or fees and routinely scrimp on the production end to achieve their expressive results.

3. *Commissioned or assigned work* is done for comparatively small fees and with low production budgets, usually for nonprofit organizations (such as senior citizens groups, church associations, youth centers, health care centers, and so on) and cultural institutions (such as schools, universities, zoos, museums, regional orchestras, music festivals, and so on). Though the designer may not have gone hat-in-hand to suppliers for donations, with this kind of work creative and production resources are decidedly circumscribed. In such cases, pick-up art or less-than-market-value fees paid to illustrators and photographers are often necessary to achieve a quality result.

4. *Work by designers who are paid reasonable fees* but who have decided to push

and squeeze their production resources to achieve a considerably more ambitious finished project, perhaps even donating portions of their fees to the "cause." These are designers for whom it might be said that quality, not profit, is the bottom line.

5. *Design for fledgling commercial businesses on limited budgets.* This is something virtually every neophyte designer has done. This includes logos, business cards, stationery, and even promotion for the small entrepreneur. In some cases veteran designers will do this kind of work for a friend or worthy client.

6. *School assignments* designed to advertise events and programs, often produced by students or faculty with few resources using the school's production facilities.

Who Says Everyone's A Designer?

One important goal, though not the exclusive purpose, of *Low-Budget/High-Quality Design* is to show that even in this revolutionary era of desktop publishing, professional designers cannot be replaced by erstwhile amateurs. Nonprofessionals will often provide an invaluable fresh outlook, breaking outmoded rules and occasionally producing an exciting graphic piece. The professional designer, however, who is skilled at the manipulation of type and image, is more adept at making effective communications — and particularly at transforming a low budget into a high-quality job. Although the personal computer has provided the nonprofessional with a wide range of design tools and with increased technical possibilities at low cost, the level of conceptual and aesthetic quality turned out is generally lower than comparable student or professional work done with the same equipment. Designers understand the nuances of type, space, and color; the nonprofessional can only guess.

Computer and laser technology has made it possible for organizations with prohibitive budgets, and thus denied access to designers' to have generally better-looking printed material. But with the increased use of graphic designers to solve a broad range of communication problems, the public has become, albeit subliminally, accustomed to a high level of design. Although "good" design is relative, the aesthetic level of the printed material in our daily lives has improved. Something that is graphically designed has actually become a kind of metaphor for authority and legitimacy. The examples shown in *Low-Budget/High-Quality Design* prove that all kinds of businesses, activist groups, and cultural institutions who might never have considered using a designer actually can benefit from well-designed materials, which can do a variety of things, from helping raise funds to announcing special events. Further, the better the design the more effective the message.

Why Low Budget?

Because certain clients can achieve quality work with a low budget does not mean that graphic designers will be devalued in the marketplace. Good graphic communication is a valuable service, if not a commodity. Businesses that can pay well for a designer's creative time and energy will do so because it is in their best

interest to have top-notch work. Yet clients, like the ones mentioned above who cannot afford full services, should not be dissuaded by their financial constraints. Indeed, most veteran designers will gladly devote time to clients whom they deem worthy. "Why shouldn't they have good design?" asks designer Michael Manwaring, whose pro bono work is represented in *Low-Budget/High-Quality Design.* "Some of these clients are doing more important work than many of our paying clients." Dugald Stermer, another staunch advocate for pro bono, explains, "I don't really work for cheap. I work for either a high fee or for free because I find that the latter allows for experimentation." And Judy Kirpich of Grafik Communications Washington agrees that "some of the projects which produce the least profit provide the most challenging and enjoyable creative experience."

In some cases the needy clients are the best ones because they allow creative latitude. The result for the designer is not only personal satisfaction, but also, in the interest of self-promotion, a good portfolio sample. For students, accepting low-budget work is usually the only way to get hands-on practice while accruing necessary portfolio pieces. In this relationship both designer and client have gained if the low-budget job results in a high-quality product. And as evidenced here, low-budget work is not only challenging but can be immeasurably profitable.

Continuing Studies Catalog

The programs announced in most continuing-education catalogs tend to change more quickly than those for under-graduates. It is, therefore, not cost-effective to produce an expensive publication. Since he was already doing a large amount of work for Rice University, Jerry Herring was asked to do its continuing studies catalog on a freelance basis. The budget was low. All art and photography were picked-up from public-domain sources or supplied by the school for free. By looking in the yellow pages, he found a grocery-store-circular printer who as a rule does inexpensive printing and who offered a low price for a large quantity. The mechanicals had all the art in place, save for a few halftones that need to be stripped in. This was 1978, before computers made similar jobs easier. The headlines were typeset; the text was set by a secretary on a typewriter to avoid typesetting costs. Herring earned little per project from the university, but he made up for this by working in volume. He also learned the value of cutting corners.

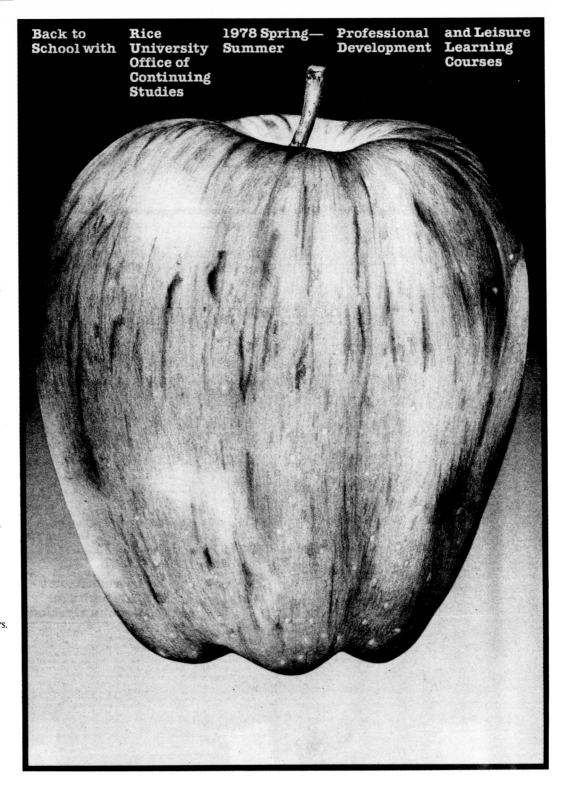

Back to School with Rice University Office of Continuing Studies 1978 Spring—Summer Professional Development and Leisure Learning Courses

Art Director: Jerry Herring

Designer: Jerry Herring

Client: Rice University Continuing Studies

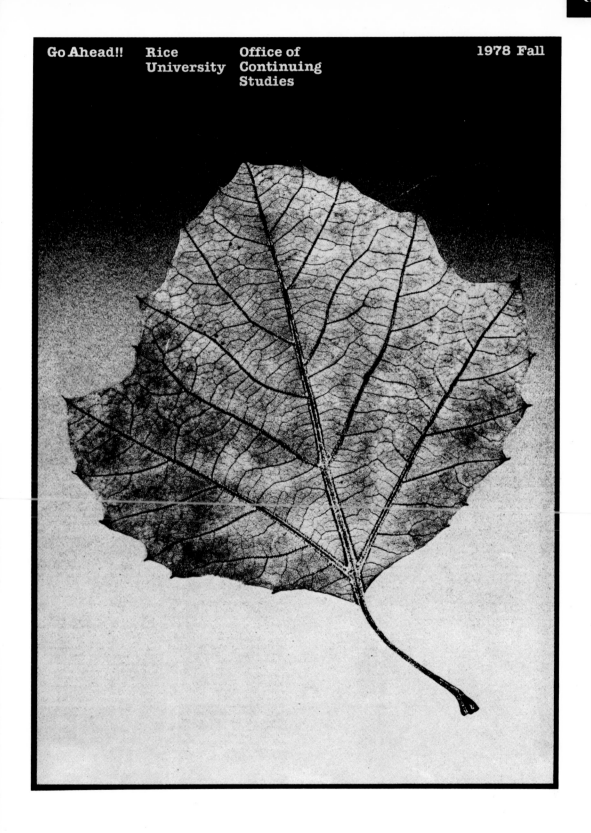

Go Ahead!! Rice Office of 1978 Fall
 University Continuing
 Studies

School Catalog

................................

The California College of Arts and Crafts doesn't ordinarily scrimp on its promotion budget, but in 1989 it reduced the allowance on its primary recruitment tool by almost one half. The budget for printing, typesetting, design, and production was a relatively small sum for thirty thousand copies of a hefty ninety-page tome. Michael Mabry, a former instructor at the college, was hired as the designer. From the overall sum, he was given a less-than-adequate fee for design, photographs, type, and mechanicals. The catalog took six months to produce, effectively reducing Mabry's design fee to below minimum wage, yet the project was handled with verve. Mabry's studio staff interviewed students and edited their comments for use inside. The majority of the catalog was printed in two colors used in imaginative combinations. Two-color printing is about 50 percent cheaper than four-color printing (which produces a full-color image) because the printer need prepare only two plates. The two-color process also saves money, as the spoilage of paper in color proofs is less than in the four-color process. The savings accrued with this strategy allowed for the printing of a small four-color section highlighting student work. To cut type and design costs they used a computer program for page makeup and typesetting. Before the computer, complex production tricks were time and cost consuming. By working in-house, "We had to sacrifice

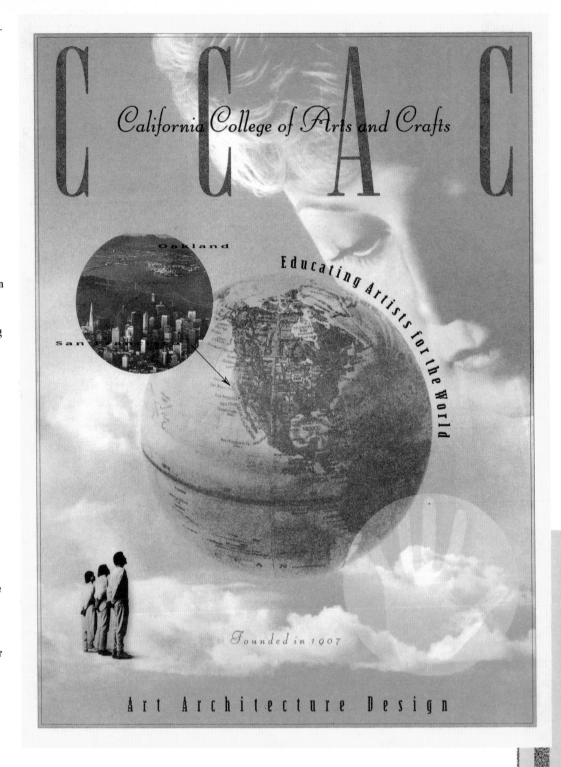

Accreditation and Degrees

Through its integration of theory and practice, the California College of Arts and Crafts has influenced our cultural lives for over eighty years. The College is truly unique: no other institution shares its special tradition and philosophy. Founder Frederick Meyer envisioned a college where unification of fine and applied arts would become reality. Influenced by the Arts and Crafts Movement of the last century and Bauhaus ideals, the college has maintained a special vitality stemming from an interdisciplinary exchange. Students learn to integrate skills, techniques and theory in working through problems to create practical solutions.

Accreditation

The California College of Arts and Crafts is accredited by the Accrediting Commission for Senior Colleges and Universities of the Western Association of Schools and Colleges. It is an accredited institutional member of the National Association of Schools of Art and Design. The Interior Architecture Program is accredited by the Foundation for Interior Design Education Research (FIDER). The program in Architecture has been granted candidacy status by the National Architecture Accrediting Board (NAAB). Copies of CCAC accreditation reports are filed in the Meyer Library and are available for public review. CCAC is approved for the training of veterans and eligible persons under Title 38, U.S. Code.

(18)

Degree Programs

Undergraduate Degrees

CCAC offers programs that lead to a four-year Bachelor of Fine Arts (BFA) Degree or a five-year Bachelor of Architecture (B.Arch.) Degree in the following areas:

School of Fine Arts
Ceramics
Drawing
Film/Video/Performance
Glass
Jewelry/Metal Arts
Painting
Photography
Printmaking
Sculpture
Textiles
Woodworking/Furniture Design

School of Design
Graphic Design
Illustration
Industrial Design

School of Architectural Studies
Architecture (B.Arch.)
Interior Architecture Design

Double Majors

Student may graduate with a double major by completing all requirements in both areas prior to graduation.

Bachelor of Fine Arts Degree

General Requirements

The BFA degree requires completion of a minimum of 120 semester units of credit: 75 units in studio course work; including the Core Program requirements; and 45 units General Education coursework. The final 30 units of the BFA requirements must be completed at CCAC.

Studio Requirements for the Bachelor of Fine Arts Degree

The 75 units of studio course work must include:

	units
Core Studio Requirements (See Core Program, page 20.)	18
Major or Program Requirements (Requirements differ for each major)	54
Ethnic Art Studies	3

General Education Requirements for the Bachelor of Fine Arts Degree

The 45 units of general education coursework must include:

English — 9 units	English I (3 units)
	English II (3 units)
	English elective (3 units)
Art History — 15 units	Introduction to Art History (3 units)
	Introduction to 20th Century Art History (3 units)
	Electives (9 units)
Cultural Studies — 9 units	History of World Cultures I (3 units)
	History of World Cultures II (3 units)
	An introductory art theory survey course (3 units)
Ethnic Art Studies, Humanities or Social Sciences — 3 units	
General Education Electives — 9 units	
Foundation Seminar	All students transferring in 30 or fewer units must take a General Education course offered as a foundation seminar in their first year.

Bachelor of Architecture Degree

General Requirements

The B.Arch degree requires completion of a minimum of 153 semester units of work including the Core Program and the General Education Requirements. The final 78 units of studio work for the B.Arch must be completed at CCAC.

Studio Requirements for the Bachelor of Architecture Degree

The 108 units of studio coursework must include:

	units
Core Studio Requirements (See Core Program, page 20)	18
Major Requirements	87
Ethnic Art Studies	3

General Education Requirements for the Bachelor of Architecture Degree

The 45 units of general education coursework are as for the BFA degree with the following changes:

	units
General Education Electives	6
Math for Architects	3

Master of Fine Arts Degree

General Requirements

To be awarded the MFA degree, the candidate must:

1. Develop a body of work which demonstrates that he or she is able to do individual, creative work at a professional level of competence;

2. Fulfill the specific requirements determined by his or her major program;

3. Complete a minimum of 60 semester units, including all course requirements (see Graduate Program, page 63);

4. Complete a written thesis and final exhibition that are approved by an interdisciplinary faculty review committee;

5. Participate in the final MFA exhibition.

Note: While completion of required courses and the requisite number of units is essential, the MFA degree is based primarily upon students demonstrating that they are able to do creative, professional work. The MFA candidate's status is subject to review at any time during the program.

(19)

"I began to explore architectural drawing and model building in the Core Program. I found out that even with all the rules, architecture can be very creative, intricate and delicate. Some of my instructors feel that I am so concerned about the smaller details that I will end up being more of an industrial designer than an architect. Although I have specialized in architecture, the skills I will acquire can be used for other careers with a creative base such as Industrial Design. The students at CCAC are close because the classes are very small, and sometimes the projects are very big - you couldn't do them yourself if you wanted to - so there is a lot of communal project building. These skills will be necessary when I work with colleagues in my professional career."

Luis Catala
Architecture Student

Luis Catala came to CCAC unsure of his direction in art, but knowing that he would use his professional art training to get a jump on his career. After completing Core, Luis is continuing his college career in the School of Architectural Studies.

legibility using the computer, but gained excitement on each page," says Mabry. "The textures gave visual interest and camouflaged the thin paper we used for budgetary reasons." The paper was an inexpensive white newsprint. Though the monetary rewards were few, Mabry realized it was important for the school to have an exciting catalog. "I wanted prospective students to be excited by this catalog." But equally important, he says, "I knew that the project would give our studio great visibility."

Art Director: Michael Mabry
......................................
Designer: Michael Mabry
......................................
Client: California College of Arts and Crafts

**Admissions Office
Newsletter**

................................

Businesses and schools often hire outside design firms to establish identity systems that can be easily (yet creatively) maintained by in-house designers. Such is the case with Currents, the quarterly newsletter for the admissions office of Hobart and William Smith College. The original format by the North Charles Street Design Organization of Baltimore, Maryland, was made simple so that it could be printed by a local printer without incurring excessive stripping costs. It was designed to be illustrated with pick-up art, in this case public-domain engravings from Dover Books and the occasional original illustration by the designer. "Currents is only one part of the school's total marketing effort," says Gwen Butler, the in-house designer. "But its appealing look and accessible copy had made it a significant tool in getting students to apply." Each issue costs about $2,600 including design, writing, typesetting, and printing. The design fee, however, is absorbed by the salaries paid to the in-house staff. While the issues shown here have veered only slightly from the original design, the next series will be given a slightly different look and will be printed on recycled paper. This paper (now being made by various mills) will not cut costs, but is consistent with concern for environmental responsibility in the design community.

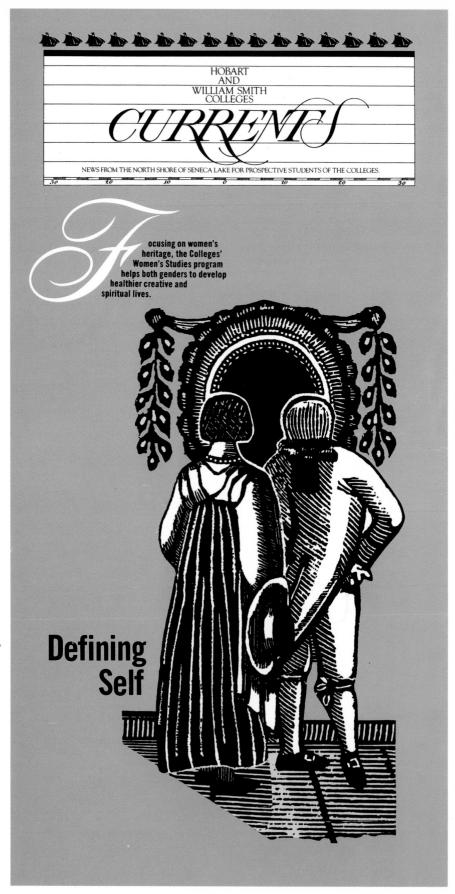

HOBART AND WILLIAM SMITH COLLEGES

CURRENTS

NEWS FROM THE NORTH SHORE OF SENECA LAKE FOR PROSPECTIVE STUDENTS OF THE COLLEGES.

Focusing on women's heritage, the Colleges' Women's Studies program helps both genders to develop healthier creative and spiritual lives.

Defining Self

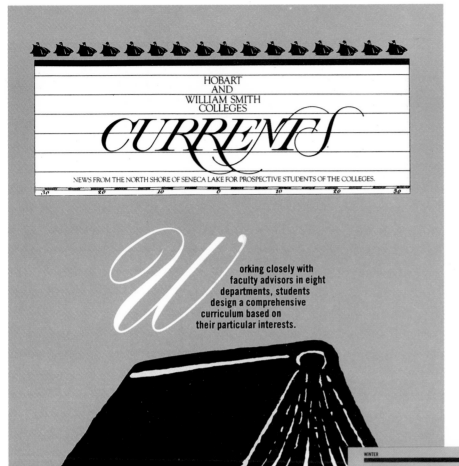

HOBART AND WILLIAM SMITH COLLEGES
CURRENTS

NEWS FROM THE NORTH SHORE OF SENECA LAKE FOR PROSPECTIVE STUDENTS OF THE COLLEGES.

*W*orking closely with faculty advisors in eight departments, students design a comprehensive curriculum based on their particular interests.

Art Director: Bernice Thiebolt

Designers: Elizabeth Clark, Gwen Butler

Client: Hobart and William Smith College

Comparing Literary Worlds

WINTER 1988 WINTER

Helping Hands
THE HPAs

What, you ask, are HPAs? HPAs are Health Peer Advisors, and Health Peer Advisors are Hobart and William Smith students—14 of them this year—trained by the professionals at the Hubbs Health Center. HPAs make health information available to students and tell them about resources at the health center and in the local community. A liaison between the Hubbs staff and the student body, they are important resources to resident advisors and to students.

This past fall, the HPAs came back to campus nine days in advance of other students, for training and four days of orientation. "We met with people from Planned Parenthood of the Finger Lakes to talk about contraception," says Laurie Ann Zavarella '90, a psychology major and a first-year HPA, who works with resident advisors at Comstock House and Rees Hall. "Also, a representative came from the Rape Crisis Service of Ontario County to talk with us about how to be the first-contact person handling calls from rape victims."

As part of their orientation, HPAs also had the opportunity to speak with Dr. Daniel Weinstock, the Colleges' new medical director, and Cheryl Solomon, new William Smith swimming coach, who is developing "a wellness/fitness program for students who want to tone up, lose weight, and get in shape," explains Zavarella.

The HPAs, who are assigned individually to particular residences, frequently work with the resident advisors and fraternity presidents to coordinate lectures and other live presentations for students on an assortment of topics; recent titles include "Reproductive Health and Birth Control," "AIDS and Herpes: The New Epidemics," "Substance Use and Abuse," "Nutrition for Healthy Eating," "Acquaintance Rape," "Promoting Interracial Understanding," "Men and Masculinity," and "Adjusting to College Life."

"In my sophomore year, I asked an HPA to help me put together a one-hour presentation on alcohol awareness for first-year students, because I'm not quite sure they know how to handle it," says Steve R. Omiecinski '88, a resident advisor in Geneva Hall and a co-chair of the Resident Advisors Council. "HPAs can educate us because they have much more training on health-related matters," Omiecinski adds. "They are a great resource."

"I had a seminar for the people in my dorm on sexually-transmitted diseases," says Talley Gerace '88, resident advisor in Blackwell House, also a co-chair of the Resident Advisors Council. "With AIDS and other sexually-transmitted diseases around, I think it is important for students to know as much about them as possible. It's not that the Colleges are condoning premarital sex, but they should teach students how to combat sexually-transmitted diseases." She adds, "I think condom distribution is an excellent idea, and I hope people feel comfortable enough to take them from us if they need them."

HPAs also have been trained as monitors to sit with patients in Hubbs Health Center, and Zavarella says, "We do some counseling, and we've been trained to know what to do in a crisis situation. We also have medical kits with non-prescription drugs, and, of course, we do referrals. Recently I had a student come to me to ask the hours of the infirmary and who to see once she got there. After her appointment she thanked me and said she was feeling better. That made me feel good." □

Experiment in Excellence
BAMPTON HOUSE

Animal House it isn't. In fact, Bampton House is about as far from the fictional Delta House of movie fame as you can get. It may just be the ideal college residence hall.

A group of Hobart College students is part of an experiment that could confirm that assessment, according to Assistant Dean for Residence Life Thomas Truesdell '74. The experiment is called Bampton House and began in September, 1986.

What makes Bampton House unique is not only its high-quality accommodations —better than the other residence halls in terms of room size and facilities—but the qualifications of its students. The 17 upperclassmen selected to live in Bampton House have to go through a tryout process not unlike trying to make the Statesmen's outstanding lacrosse team—only those with special skills make it.

In return for living at Bampton, the students must give something back to the College in the form of hosting lecturers and speakers, being involved in campus leadership positions, and providing a considerable amount of community service.

"It's an experiment in excellence," says Truesdell. "All of the students there have contributed to the College academically, athletically, in student government, or

through a wide range of activities that give them something far beyond the campus. We'd like to conceive an intellectual model for the other colleges.

By housing the Bampton University scholars, we can't do anything but reach our goal and promote scholarship.

The College wants to house the scholars in a Bampton-type center for the next century, after renovations to the proposed site envisioned. We're thinking about an environment and the center and the typical residence hall has very small living quarters.

Hobart College says about 12 percent and 17 seniors maintain the academic standard better, and when we are there in the halls and serve to promote what we call above grade-point averages of the community. The Bampton House serves as a fraternity and basketball court of the Associate....

A member of the Bampton House, Waiser says he wants more money because he has to speak up because of academic requirements. "It's a privilege. But we're also concerned with the social life....

Bampton House has the president of the College council, the treasurer of the newspaper, the chairman of the Dean's Council, members of (Hobart's) community-service leaders of most...

"I think Bampton is a model that could become the norm for the College. The sense of service is based on a sense of responsibility," concludes the Bampton House tour of the residence hall.

Article by Elizabeth C. Shaw, Syracuse, New York. Standard and prepared by...

Admissions Office Newsletter

Newsletters are traditionally produced on low budgets. But even by newsletter standards the $2,500 fee for the design, editing, and production of four yearly issues of *A View from the Hill*, the Western Maryland College admissions office newsletter, is paltry indeed. The publication is intended to make and maintain contact with high school students throughout the admissions cycle by answering the common questions often asked about the college. The material must therefore be accessible, yet presented with a certain flair. The North Charles Street Design Organization of Baltimore devised a format and illustration style that solves the problem. The layout is done on a Macintosh II using Quark Express. Symbolic clip-art from a variety of public-domain sources is used as illustration. Using a limited range of typefaces, *A View from the Hill* has a distinctive personality and an inviting look.

A VIEW FROM THE HILL

August 1987

To sing or not to sing. That is the question to which freshmen often answer yes.

Why do so many freshmen choose the WMC Concert Choir as an out-of-class activity? First, there's the discovery that the guy with the basso profundo voice is dean of student affairs, Philip Sayre, and that booming soloist is James Lightner, professor of mathematics and education. Julie Badiee, associate professor of art history, hits the high notes, while Brenda Rickell, development office secretary, trills the tunes.

"Choir is a good way for freshmen to meet other freshmen and older students and faculty," says Beverly Wells, who is beginning her third year as choir director. A fourth of her 60-member choir consists of freshman voices, she says.

One of those first-year voices last fall was that of Rhonda Mize '90. "I was in the choir in high school, and wanted to carry it on," says the alto. "I liked it because it promotes interaction with professors and provides a common ground. And it's open to everybody. In choir you get involved right away."

The choir performs at college events, such as commencement and convocation, at retirement homes and other places around Westminster. But what Mize liked best was a swing through New Jersey last fall. This year Director Wells plans a similar jaunt through the Mid-Atlantic region.

Not only do freshmen get the chance to sing side-by-side with faculty, administrators and college staff, they can join the choir without proving they can hit b-flat. "There is no audition and no pressure to excel," Wells explains.

The veteran director cites yet another reason for the choir's popularity. "Freshmen join the choir because we are doing a mix of all kinds of music. Some of them come here expecting a college choir to be a high-blown affair where you sing only in Latin. But they find out we do spirituals, folk tunes, Gershwin. We combine the classics (such as "Honor and Glory" by Bach) with other styles of singing."

Wells wastes no time in bringing newcomers into her choral fold. Choir meets the first day of class, Monday, September 7, at 4:30 p.m. in Baker Memorial Chapel. Students may also join at a later date, and they can take choir for class credit.

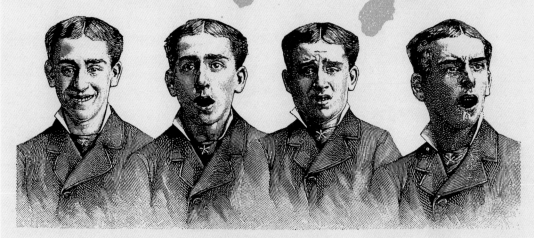

Western Maryland College

A Private College of the Liberal Arts and Sciences in Westminster, Maryland

Art Director: Bernice Thiebolt

Designer: Kelly L. Walsh

Client: Western Maryland College

A VIEW FROM
THE HILL

February 1987

Money may not grow on the leafy trees branching across Western Maryland's campus — but students find there's plenty of green to be gathered, nonetheless.

Students who show financial need can earn up to $1,500 a year while providing needed services to the College. More than a third of Western Maryland's students do just that.

Some help out in athletic training rooms; others prefer clerical work in the academic or administrative offices. Sophomore Pichada Chhay finds tutoring in the Writing Center the best of all possible jobs. She's "very happy" to be one of 10 students chosen to help other students complete writing assignments on the center's 20 Macintosh computer terminals.

Every Western Maryland student-worker is assigned the best available job that matches his or her talents and interests. "I got my job because of my interest in computers and exceptionally good academic record in English," Chhay explains.

A biology major, she enjoys the sheer activity of helping 40 to 50 persons per night structure a sentence or complete a computer command. "I'm always learning new things because people make mistakes and I have to help figure them out," she says.

Another student who puts his skills to work on the Hill is Barry Buckalew '88. On court, he uses his athletic talents as a forward on the junior varsity basketball team; off court, he gives a typewriter a workout logging 100 words a minute as an assistant in the College's sports information office.

During football season Buckalew sat in the press box and followed the action on his typewriter. He recorded every touchdown, every first down, every play. He helped write (and type) the football, volleyball, and basketball programs. A business major, Buckalew also compiles statistics on the teams.

"This job gives me insight into the other side of sports that I wouldn't see from the playing perspective," he explains.

Gathering knowledge along with an income is also a plus for Buckalew. "Any kind of hands-on experience has to help in whatever field I eventually enter. Lecture and theory can only take you so far."

Western Maryland College
A Private College of the Liberal Arts and Sciences in Westminster, Maryland

Summer on the Hill at Western Maryland means Theatre on the Hill.

That's the name of the summer repertory company which presents three or four productions each summer in Alumni Hall, the restored historic theatre at the campus's entrance.

The curtain fell recently — to tremendous applause — on the '86 Theatre on the Hill productions: *Berlin to Broadway*, *Oliver*, and *Charley's Aunt*. Produced by Ira Domser, assistant professor of dramatic art at Western Maryland, the theatre productions give residents of the Carroll County region a chance to see first-rate theatre without traveling to Baltimore or Washington.

For Western Maryland students, Theatre on the Hill provides a chance to become involved in professional theatre — and maybe their first big break into acting. Julie Elliott '87, a dramatic art and communications major, worked as a promotion assistant last summer for advertising and acted in two productions. "It's competitive, professional, and a lot of hard work," she says, "but the experience is invaluable."

Over the past five summers, Theatre on the Hill has attracted both veteran and young actors from New York, Baltimore, and Washington. Members of the cast and crew produce musicals, revues, comedies, and tragedies — and do everything from selling tickets to building sets. "Because we pay our actors a moderate salary plus room and board, we are able to attract some of the most talented actors from New York to North Carolina," says Domser.

In just a few months, Domser and some student helpers will begin working on next summer's Theatre on the Hill productions. The plays for the theatre's fifth season have yet to be chosen, but one thing is certain. According to Domser, "Every year is better than the last."

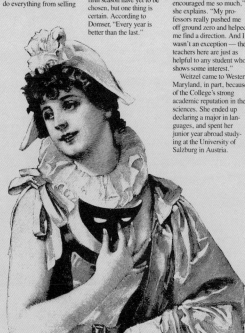

Nancy Weitzel '86, wouldn't say she owes it *all* to her professors at Western Maryland – but they certainly helped.

The German major, who also has minors in Spanish and education, has been awarded a prestigious Fulbright Fellowship for study abroad. "Everybody encouraged me so much," she explains. "My professors really pushed me off ground zero and helped me find a direction. And I wasn't an exception — the teachers here are just as helpful to any student who shows some interest."

Weitzel came to Western Maryland, in part, because of the College's strong academic reputation in the sciences. She ended up declaring a major in languages, and spent her junior year abroad studying at the University of Salzburg in Austria.

There, she lived with an Austrian family for a while and soon fell in love with both the country and its people.

"I really wanted to go back to Austria, so when I found out about the Fulbright competition, I applied — even though I knew my chances of winning were slim." The academic affairs office set up a committee to help her put together her application and proposal: "Tracing the Intellectual Roots of the Revolution of 1848 within Austria."

In February she got the word — she won the Fulbright — and in September she is off on her second year abroad in Salzburg, this time with all of her travel, educational, and living expenses covered. "I never would have thought I would spend my junior year abroad, much less get a Fulbright," she laughs. "I can't wait."

Tennis anyone? How about lacrosse? Or football, softball, swimming, or wrestling?

In all, there are 20 intercollegiate sports teams at Western Maryland, two club teams, a host of intramural teams, and even opportunities for equestrians. A remarkable 39 percent of Western Maryland's 1,200 students play on one of the College's varsity teams; almost all participate in intramurals.

Amateur sports have been popular on the Hill since the late 1800s, when the first bicycle and tennis clubs were established, and the first football and basketball games were played. Today, the College boasts a thriving athletic program. A member of the NCAA Division III, the Middle Atlantic Conference, and the Centennial Conference in football, the Western Maryland Green Terrors compete against Johns Hopkins, Swarthmore, Franklin & Marshall, and Gettysburg, among others.

The volleyball team is an NCAA Division III power, having reached the national championships in each of the past five years. The '85-'86 women's basketball team, led by Academic All-America Cindy Boyer, captured the conference's southwest league title. The men's team had its own Academic All-America in forward Jim Hursey.

The golf team posted a 10-5 record for the past season — and enjoyed the distinction of being the only team in the 26-member conference to have its own on-campus golf course. In fact, virtually all of Western Maryland's athletic facilities are the envy of their competitors: The College's 400-meter all-weather track is generally regarded as the best in the conference. The Gill Physical Education Learning Center, which opened in 1984 at a cost of $6 million, houses a human performance laboratory, three full-size basketball courts, a wrestling room, multi-purpose area, state-of-the-art training room, weight room with Nautilus and Universal equipment, and locker rooms. A 25-yard indoor pool is located adjacent to the Englar Dining Hall. Other facilities include the Scott S. Bair Stadium, the Frank B. Hurt tennis courts, and numerous athletic fields.

Two teams — ice hockey and softball — were recently organized as clubs by students and also compete in varsity matches. Both may be granted varsity status as the programs grow in the coming years. Western Maryland, as a Division III school, does not grant athletic scholarships. However, qualified athletes, like all students, may receive financial aid and academic awards.

If you are interested in the intercollegiate athletic program at Western Maryland, the admissions office can provide you with further information about the following sports:

Men
Baseball
Basketball
Cross-country
Football
Golf
Ice Hockey (club)
Lacrosse
Soccer
Swimming
Tennis
Track
Wrestling

Women
Basketball
Cross-country
Field Hockey
Golf
Lacrosse
Soccer (club)
Softball
Swimming
Tennis
Track
Volleyball

*The golf team is coed.

If you're like and most of you spend shopping malls.

In fact, experts say that outside of home, school, and jobs, people spend more time in shopping malls than anywhere else.

That phenomenon has fascinated Ira Zepp for more than 35 years, ever since he spent his boyhood time "going uptown to see the sights." What attracts people to malls? Why have they become more than a marketplace?

"It's the 'more than' I'm interested in," says Zepp '52, professor of religious studies and author of a new book, *The Religious Images of Urban America: Shopping Mall as Ceremonial Center* (Christian Classics Inc., Westminster, June 1986). "The mall has become a place where people gather and things happen there that have nothing to do with buying," he writes in the book's preface. "It is a ceremonial center, an alternative community, carnival, and a secular cathedral."

Newsletter Promotion

The hardest client to satisfy is oneself, so a self-promotion piece is often a designer's most difficult project. Peterson and Company of Dallas wanted a brochure to inform potential clients at colleges about the need for having an effective newsletter. Since newsletters are usually inexpensive, "Newsletter Newsletter" had to be so too. Since most newsletters are drab and dreary, however, Peterson wanted to spice up the genre within a reasonable budget. The paper (Carnival Groove — a toothy stock that absorbs ink and has bulk) was selected because it is consistent with newsletter stock, but it has a slightly more interesting tactile quality. The paper merchant offered a discontinued color to get further savings. The typography and printing were done at cost ($522 and $1,400 respectively). An ad placed in a college journal offered the "Newsletter Newsletter," and the response determined what the print run would be. A thousand copies were printed, but they were not enough; demand was greater than the supply, and rather than go back to press, photocopied versions were distributed.

Art Director: Scott Paramski

Designer: Scott Paramski

Illustrators: Jan Wilson,
Scott Paramski

Client: Peterson and Company

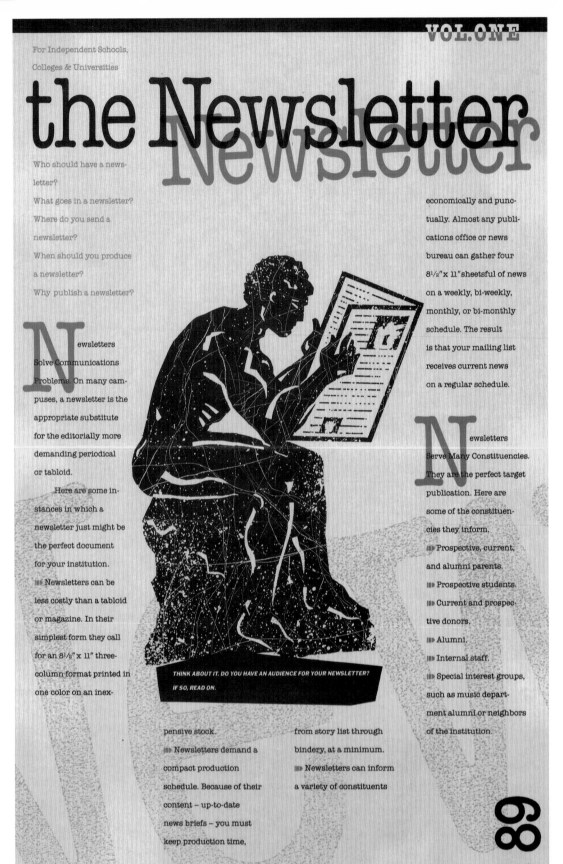

VOL.ONE

For Independent Schools, Colleges & Universities

the Newsletter

Who should have a newsletter?

What goes in a newsletter?

Where do you send a newsletter?

When should you produce a newsletter?

Why publish a newsletter?

Newsletters Solve Communications Problems. On many campuses, a newsletter is the appropriate substitute for the editorially more demanding periodical or tabloid.

Here are some instances in which a newsletter just might be the perfect document for your institution.

▐▶ Newsletters can be less costly than a tabloid or magazine. In their simplest form they call for an 8½" x 11" three-column format printed in one color on an inex-

pensive stock.

▐▶ Newsletters demand a compact production schedule. Because of their content – up-to-date news briefs – you must keep production time,

THINK ABOUT IT. DO YOU HAVE AN AUDIENCE FOR YOUR NEWSLETTER? IF SO, READ ON.

economically and punctually. Almost any publications office or news bureau can gather four 8½" x 11" sheetsful of news on a weekly, bi-weekly, monthly, or bi-monthly schedule. The result is that your mailing list receives current news on a regular schedule.

Newsletters Serve Many Constituencies. They are the perfect target publication. Here are some of the constituencies they inform.

▐▶ Prospective, current, and alumni parents.

▐▶ Prospective students.

▐▶ Current and prospective donors.

▐▶ Alumni.

▐▶ Internal staff.

▐▶ Special interest groups, such as music department alumni or neighbors of the institution.

from story list through bindery, at a minimum.

▐▶ Newsletters can inform a variety of constituents

89

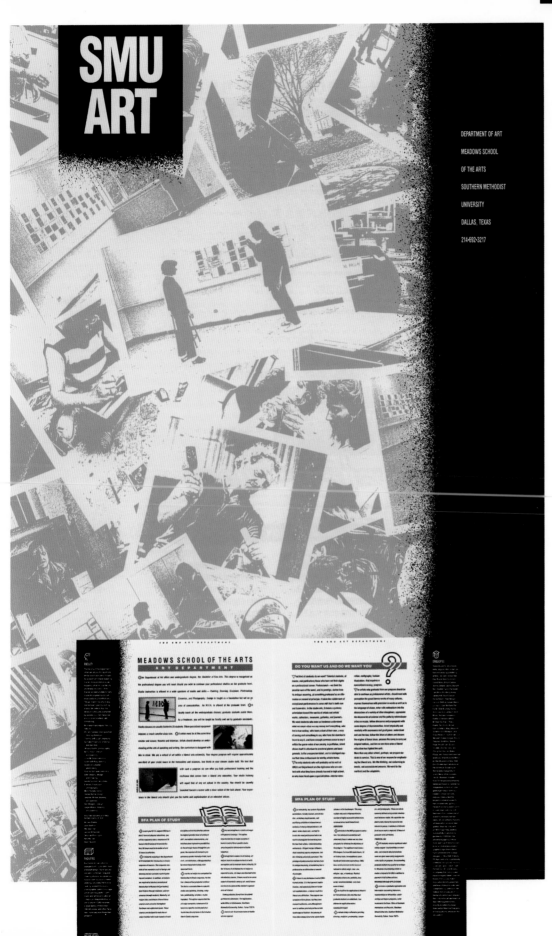

SMU
ART

DEPARTMENT OF ART

MEADOWS SCHOOL

OF THE ARTS

SOUTHERN METHODIST

UNIVERSITY

DALLAS, TEXAS

214-692-3217

Recruitment Brochure

The Southern Methodist University art department needed a brochure for student recruitment purposes. With only enough money to cover the paper and printing, it still wanted something that would stand out among all the other college materials and also reflect the creative exuberance of the department. Peterson and Company decided that the large-scale (11 x 17) format, though not in itself cheaper, would allow for visual "fun," and this combined with a "playful use of type" would result in a distinctive-looking publication. Two easily accomplished, inexpensive graphic tricks, such as the faux paint splatters used as a background texture (which were made in seconds with a flick of a brush) and the creation of a cluttered bulletin board as cover art (which was set up by the designer using found props and then photographed for free), gave this two-color piece the allure that the art department wanted. In addition to the limited printing cost, Peterson and Company billed $840 for design, $500 for mechanicals, $788 for typesetting, and $140 for miscellaneous expenses.

Art Director: David Lerch
...
Designer: David Lerch
...
Illustrator: David Lerch
...
**Client: Southern Methodist
University**

Private School Newsletter

The Episcopal School of Dallas had the idea that a newsletter mailed to parents of prospective students and children currently enrolled would heighten awareness and encourage participation in this private school's activities. But they had virtually no budget to make it happen. Fortunately, Dallas-based designer Stan Richards was a member of the school's board of directors, and in this capacity he was able to help the school by providing the services of his design firm, Richards, Brock, Miller, Mitchell & Associates. The design, a charming take-off on a school notebook with lighthearted illustrations, was donated by the firm; the stats, typesetting, and printing were done at cost. The result: *The Episcopal Eagle* contributed to the school's positive public relations because its professional design signaled sophistication.

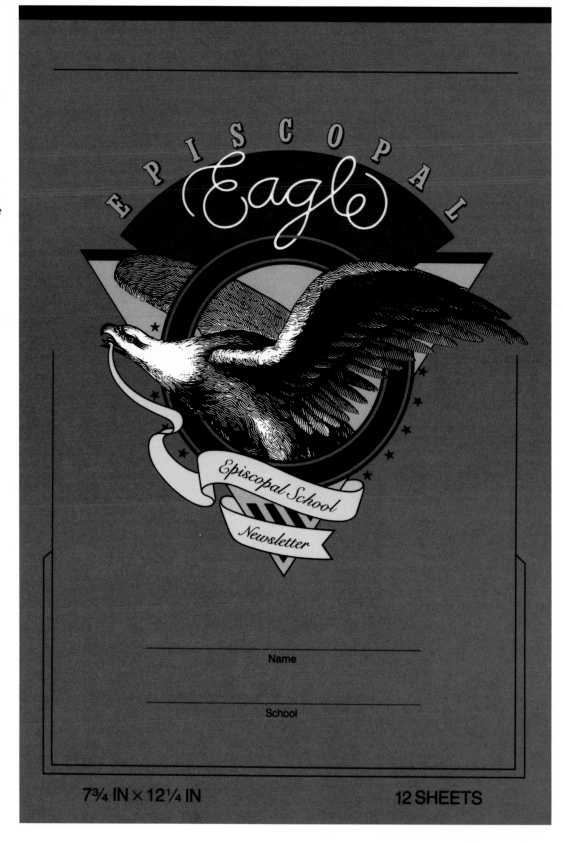

Art Director: Stan Richards

Designer: Brian Boyd

Illustrator: Gary Templin

Client: Episcopal School of Dallas

Profile: Dan Boatwright

At six feet, four inches and 240 pounds, teacher Dan Thomas Boatwright looks as though he must have played left tackle for Texas A&M, his alma mater. Instead, his interests took him into more unusual and less aggressive hobbies, such as trout fishing—he ties his own flies—and falconry.

"I get outdoors every chance I get," says Boatwright, with great enthusiasm. This includes summer trips to Idaho or Yellowstone to hunt and fish with Tom Lutken, Episcopal School's Wilderness Director, as well as weekend walks in the countryside in Duncanville where Boatwright lives. His love of the out-of-doors, and his knowledge about it—gained through academic training and personal experience—contribute greatly to his teaching of upper school Biology and Earth Science classes.

A Dallas native, Dan Boatwright attended Sunset High School, earned his undergraduate degree in Zoology and Microbiology at Texas A&M, and completed an M.S. in Molecular Biology from the University of Texas at Dallas. During the summer between high school and college he was selected to attend the Texas Maritime Academy. Sponsored by A&M, the academy takes students on a 10-week cruise, to distant ports including Oslo, Amsterdam, Gibraltar, and San Juan, Puerto Rico. Boatwright completed two college-level courses in between work in the engine room or on deck and tours of the ports-of-call. "I found out I didn't like sailing very much," he recalls, mentioning a serious case of seasickness provoked by the ship's passage near a hurricane.

Dan Boatwright and his feathered friend

While in high school Boatwright seriously pursued his outdoors interests. He earned the rank of Eagle Scout, and he took up falconry as a hobby. "The idea is to train a bird to come back to you when you call it," he explains. "It's a form of hunting; instead of using a dog, you use a bird of prey."

When Boatwright finished graduate school he worked first as a research technician in

University Studies Catalog
..............................

At Brandeis University projects are budgeted so as not to exceed the previous year's funding. Given that new programs have no previous budget, the allotted funds for them are often minimal — if not miserable. Dietmar Winkler, who was contracted to design seven hundred different publications in one year for the inclusive design fee of $50,000, was responsible for giving the new department of University Studies in the School of Humanities an effective, though budgetless, personality. This, however, was a simpler task than the philosophical problem that arose: It turned out that all the examples of writing in the literature course (the first catalog to be issued) were by men, and the university was making a strong effort to include work by women. To show images of women, Winkler borrowed artworks selected by the school's library to use on the cover and inside pages. This saved on research costs and provided him with copyright-free artwork. The images gave the catalog an appropriate historical sensibility and cost the school nothing in reproduction fees. The same approach was applied to other catalogs in the series. The color of the cover was changed periodically to indicate an updated catalog. The type was set, not by a typesetter, but a small printing concern that had rudimentary typesetting equipment. "I couldn't have afforded to do it with a large typeshop," Winkler says.

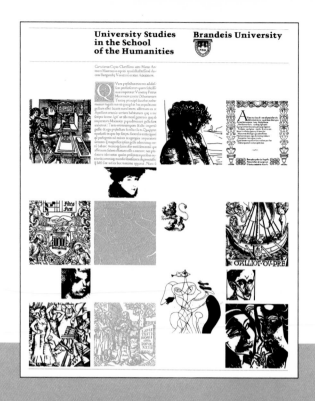

Designer: Dietmar Winkler

Illustrators: Various

Client: Brandeis University

Beaux Arts Posters

The annual Beaux Arts Ball is a tradition among art and architecture students at Pennsylvania State University, and Lanny Sommese, chairperson of graphic design at the university's School of Visual Art, has long been the sole designer of its fanciful and farcical announcements. With the exception of the freelance commission shown here for the Beaux Arts Ball poster for Hope College in Holland, Michigan, all the posters were printed by students as silk screens in limited quantities. The imagery and typography are donated by Sommese. All the posters reflect the festive air of the event through use of traditional iconography. The commission from Hope College came about because Sommese's designs are quite visible, having been reproduced in many design annuals. He was offered a mere $300 for the art and mechanical (including separations for all colors) by Hope College, but he had already done a rough for a rejected magazine cover using a devil motif that he easily adapted to this assignment. The poster was printed on an offset press, so the finish did not have the same artful quality of the silkscreen reproduction. This poster was, however, never posted because the administration of Hope College, a Catholic institution, frowned upon the representation of a devil.

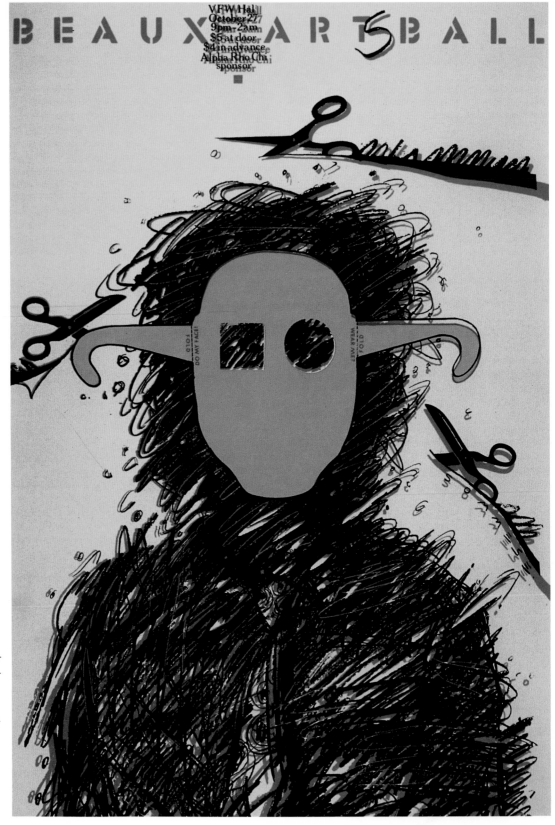

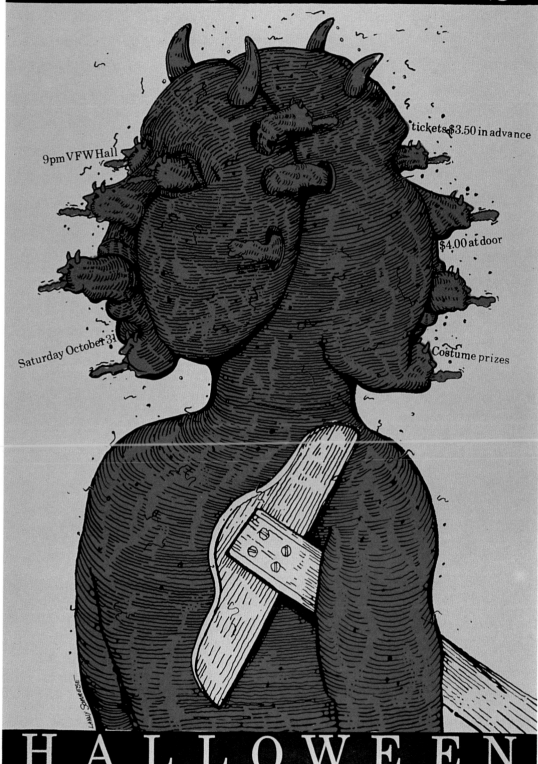

BEAUX·ARTS

9pm VFW Hall

tickets $3.50 in advance

$4.00 at door

Saturday October 31

Costume prizes

HALLOWEEN

Art Director: Lanny Sommese

Designer: Lanny Sommese

Client: Pennsylvania State University

Art Director: Lanny Sommese

Designer: Lanny Sommese

Illustrator: Lanny Sommese

Client: Depree Art Center, Hope College, Michigan

University Bulletins

Before McRay Magleby assumed the post of art director of Brigham Young University's in-house graphic communications department, the various course announcements, catalogs, and bulletins were conventional, if not stale. Through judicious use of his limited funds, and increased reliance on the university's press and student workers, he has developed an outstanding graphic design program and school identity. One example of his imagination was the decision to transcend the constraints of the staid course catalog by inserting booklets of special interest. *The Astronomy Bulletin,* showing astronomy paraphenalia, focuses on one of the unique collections donated by Brigham Young University's alumni. *The Guide to Trees on Campus* sheds light on a special feature within the campus environment. Both were printed separately, allowing for higher production values, and then inserted into the general catalog. They were also used as fund-raising premiums. The original print-run was 27,000 copies of each with a 5,000-copy over-run of each bound with special covers on a better-quality paper for university development and VIP use. A $4,000 budget covered design, illustration, typesetting, and paste-up — much of it done by students. The covers were donated by suppliers in return for samples.

Art Director: **McRay Magleby**

Designer: **McRay Magleby**

Client: **Brigham Young University,** *Astronomy Bulletin*

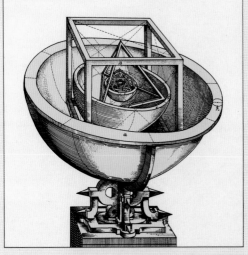

German astronomer Johannes Kepler (1571–1630) was attracted to a study of the heavens by Copernican ideas. While lecturing to his class on geometry, Kepler became excited about using the concept of five perfect solids (proven by Euclid) to explain the existence and orbits of the six known planets. According to Kepler's theory (his model is shown above), the sphere of each planet was separated by one of the perfect solids. Although he later rejected this explanation, his studies ultimately yielded his three famous laws of planetary motion that launched us into modern astronomy. These laws were crucial in the development of mechanics, forming the basis for Newton's universal law of gravitation.

Hans Lippershey, a Dutch optician, gave Galileo Galilei the impetus to try his own ingenious hand at making a telescope. When this Renaissance giant turned his telescope skyward in the first part of the 17th century, a Copernican solar system appeared—in fact a whole new universe revealed itself: the Milky Way, the nature of which had mystified the ancients, was made up of vast numbers of individual stars. The moon had mountains. Jupiter had satellites. Venus passed through phases like those of the moon. Strange spots moved about on the sun's surface. Although Galileo died in 1642, heartbroken by the Inquisition, a new era of astronomy, inspired by the expansive eye of the telescope, was born.

 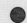 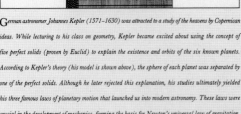

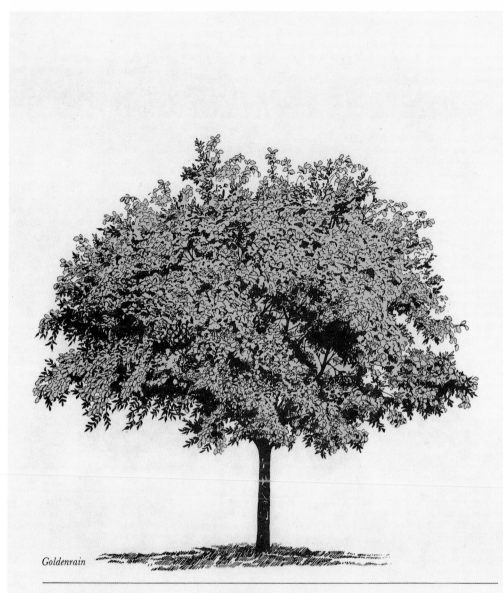

Goldenrain

This handsome, densely foliated, round-headed tree is a native of northern China, Korea, and Japan. It is well adapted to Utah's alkaline soils and dry climate, growing slowly to a height of 25-30 feet with a 10- to 20-foot spread. Long, showy clusters of bright yellow flowers appear in late July and into early August, followed by triangular, bladderlike fruits that change from yellow green to brown and persist into winter. The dried, spent flowers often discolor sidewalks; therefore, this tree is also called the Varnish Tree. Has good resistance to most diseases and pests, but is sometimes injured by late frosts.

11

Art Director: McRay Magleby
.
Designer: McRay Magleby
.
Illustrator: McRay Magleby
.
**Client: Brigham Young
University,
*Guide to Trees
on Campus***

Financial Aid Flyer
. .

When an application for financial aid is hindered by bureaucratic language neither the applicant nor the institution is done a service. Therefore, an inviting and accessible graphic presentation can be invaluable to students who must wade through their financing options. Using a contemporary, faux woodblock illustration, combined with handsome typography, consistent with the identity of Moravian College, North Charles Street Design Organization of Baltimore made the application efficient and easy to use. This piece is part of a larger admissions program for which a $4,500 budget covered design and writing. Since the printing is in two flat colors, costly separations are unnecessary. Because the type is discreetly positioned apart from the illustration, changes can be easily made whenever necessary.

Art Director: Bernice Thiebolt
. .
Designer: Stephanie
Coustenis
. .
Illustrator: Jerry Dadds/
Eucalyptus Tree
Studio
. .
Client: Moravian College

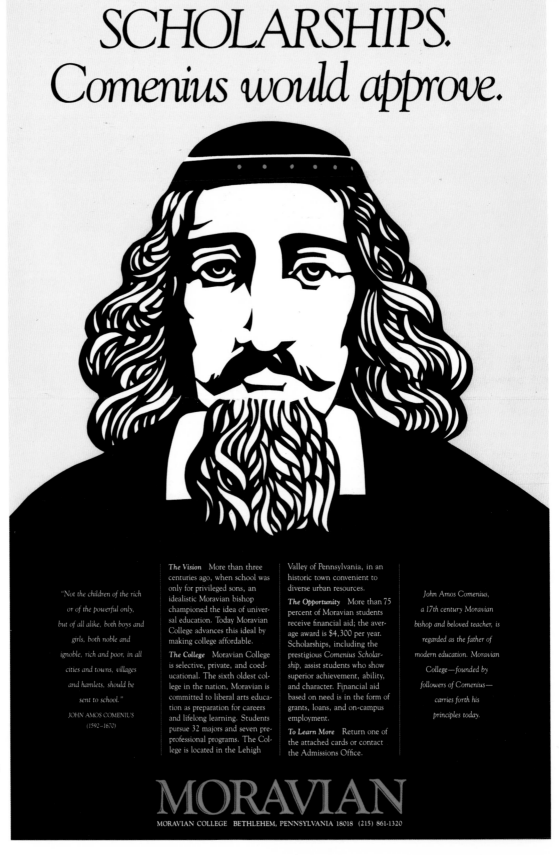

SCHOLARSHIPS.
Comenius would approve.

"Not the children of the rich or of the powerful only, but of all alike, both boys and girls, both noble and ignoble, rich and poor, in all cities and towns, villages and hamlets, should be sent to school."

JOHN AMOS COMENIUS
(1592–1670)

The Vision More than three centuries ago, when school was only for privileged sons, an idealistic Moravian bishop championed the idea of universal education. Today Moravian College advances this ideal by making college affordable.

The College Moravian College is selective, private, and coeducational. The sixth oldest college in the nation, Moravian is committed to liberal arts education as preparation for careers and lifelong learning. Students pursue 32 majors and seven pre-professional programs. The College is located in the Lehigh Valley of Pennsylvania, in an historic town convenient to diverse urban resources.

The Opportunity More than 75 percent of Moravian students receive financial aid; the average award is $4,300 per year. Scholarships, including the prestigious *Comenius Scholarship,* assist students who show superior achievement, ability, and character. Financial aid based on need is in the form of grants, loans, and on-campus employment.

To Learn More Return one of the attached cards or contact the Admissions Office.

John Amos Comenius, a 17th century Moravian bishop and beloved teacher, is regarded as the father of modern education. Moravian College—founded by followers of Comenius— carries forth his principles today.

MORAVIAN
MORAVIAN COLLEGE BETHLEHEM, PENNSYLVANIA 18018 (215) 861-1320

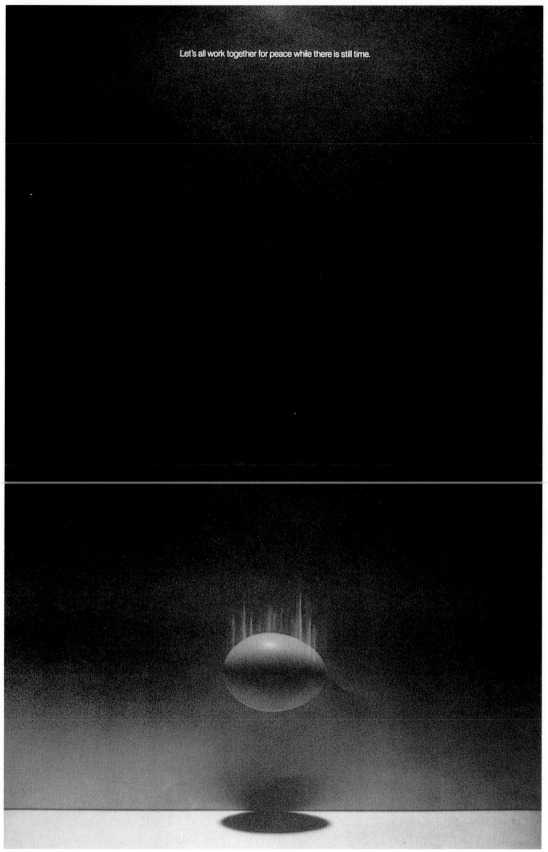

Let's all work together for peace while there is still time.

Peace Poster

To commemorate the bombing of Hiroshima and Nagasaki and to affirm solidarity with the Japanese who suffered its effects the Shoshin Society invited over one hundred American designers and illustrators to contribute a peace poster to be used in a book and exhibition. Each artist had to conceive and print his or her own work. Bob Salpeter's experience represents the process common to most of the contributors: He "twisted" the arm of a printer, who had worked with him on more lucrative projects, to donate the halftones, paper, and printing. Similarly, a typesetter donated the type. Salpeter did his photography, copywriting, and retouching personally, while someone working in his studio did the mechanical. "I found a magician's egg which could hang from an invisible string from a piece of Styrofoam," Salpeter explains. "I focused a source of light from above to cast a shadow. After it was shot I retouched the print with speed lines to make the egg look like it was falling." A thousand copies were printed.

Art Director: Robert Salpeter

Designer: Robert Salpeter

Client: Shoshin Society

Peace Posters

To answer the International Year of Peace theme of the 1986 Warsaw Poster Biennale, invited artists were each required to produce one poster. Lanny Sommese decided to submit an edition of seventy-five silkscreened posters showing the globe sitting peacefully in an old rocking chair. The image is actually a collage of two elements. The glowing aura is achieved by laying the posters on the floor and spray painting each one individually. Additionally he created two rather optimistic images of an "everyman" pointing to the world and black and white arms breaking the shackles of opression. The rough style, Sommese reasons, is owed to the fact that students/apprentices did the printing, and so drawing in the rough style makes the inevitable mistakes less evident. The posters were produced at the Pennsylvania State University campus and are distributed to anyone who requests copies. "I always have felt that the audience for the posters is everyone," explains Sommese. "No matter what their background I want them to respond strongly."

Art Director: Lanny Sommese

Designer: Lanny Sommese

Illustrator: Lanny Sommese

Client: Lanny Sommese

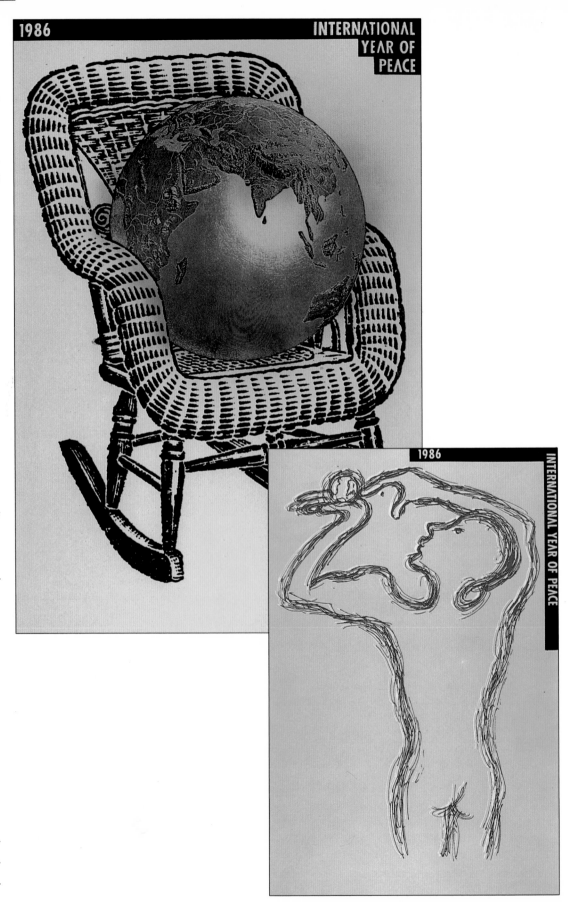

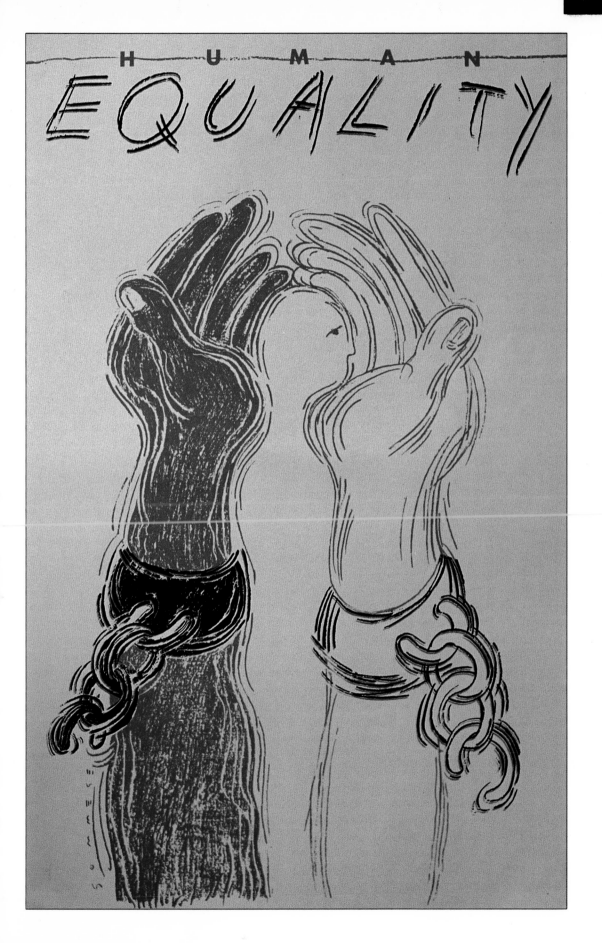

AIDS Research Poster

The Shoshin Society was established by the late Charles M. Helmken to encourage cultural exchanges with the Japanese. Helmken mounted a peace poster show (see page 33) in commemoration of the bombing of Hiroshima and an AIDS poster exhibition that traveled throughout Asia. Rafal Oblinski was one of many graphic designers asked to contribute a poster to the AIDS exhibition. Oblinski's poster was a powerful image that he thought would have a life after the exhibition, and so he decided to print and donate an extra thousand copies to the American Foundation for AIDS Research (AmFar). "I wanted to give them a gift," he says. "I felt an obligation to help, and was pleased that I could do so through my work." Oblinski designed the four-color poster for free and paid to have the extra posters printed. AmFar gave signed posters away to its donors. In 1988 the image won a prize for social posters at the International Poster Salon in Paris.

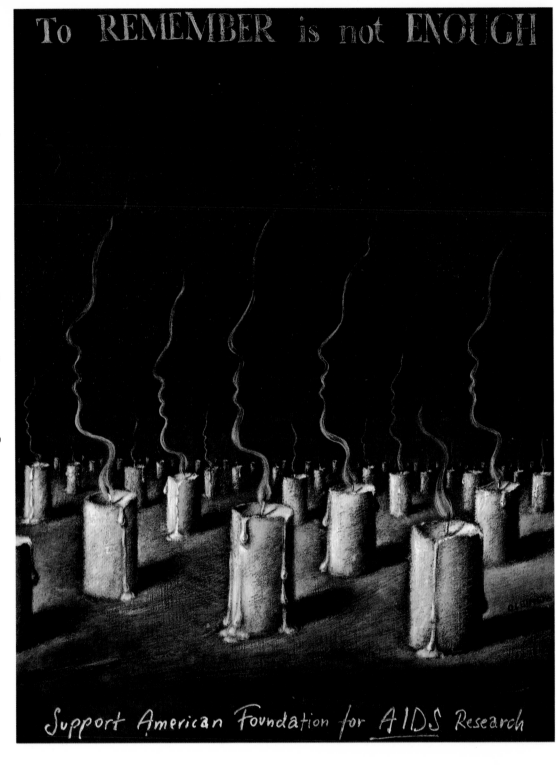

Art Director: Charles M. Helmken

Designer: Rafal Oblinski

Illustrator: Rafal Oblinski

Client: Shoshin Society

An unprecedented effort by 500 artists and 70 galleries to support AIDS research through a Citywide series of sales exhibitions curated by Robert Rosenblum to benefit the **American Foundation for AIDS Research** AmFAR

An extensively illustrated book will accompany the exhibitions, underwritten in full by the employees and shareholders of **Sotheby's.**

Conceived and organized by Livet Reichard Company, Inc. in association with Susan Martin Public Relations.

Sales extend from May to December 1987 For information: 212 431-6850

Opening in New York City

Saturday June 6, 1987

ART
AGAINST
AIDS

Galleries include:

Acquavella
Brooke Alexander
American Fine Arts, Co.
Massimo Audiello
Baskerville + Watson
Blum Helman
Mary Boone
Grace Borgenicht
Barbara Braathen
Bridgewater
Hal Bromm
Diane Brown

Cable
Cash-Newhouse
Leo Castelli
Coe Kerr
Paula Cooper
Charles Cowles
Curt Marcus
Andre Emmerich
Rosa Esman
Richard L. Feigen & Co.
Ronald Feldman
Fischbach
Xavier Fourcade
Allan Frumkin
Larry Gagosian

Germans Van Eck
Barbara Gladstone
John Good
Marian Goodman
Jay Gorney Modern Art
Graham Modern
Greathouse
O.K. Harris
Pat Hearn
Hirschl & Adler Modern
Nancy Hoffman
International With Monument
Sidney Janis
Phyllis Kind
Michael Klein, Inc.

M. Knoedler & Co.
Alexander Milliken
Lorence Monk
Loughelton
Luhring Augustine & Hodes
Gracie Mansion
Marlborough
Stephen Mazoh & Co.
Jason McCoy
David McKee
Louis K. Meisel
Metro Pictures
Robert Miller
Nature Morte
Jeffrey Neale

Daniel Newburg
Oil & Steel
Pace
Anne Plumb
Postmasters
Marisa del Re
Tony Shafrazi
Holly Solomon
Sonnabend
Sperone Westwater
Bette Stoler
303 Gallery
Barbara Toll Fine Arts
John Weber
Wolff Gallery

AIDS-Benefit Package

To announce fund-raising efforts for the American Foundation for AIDS Research, Livet Reichard, a New York consulting firm, created the Art against AIDS auction held at Sotheby's. Dan Friedman designed the simple yet distinctive logo and accompanying poster and program for the New York City event that has subsequently been used for events organized in other American cities. Owing to the enormity of the project and the need for design continuity, Friedman convinced AmFar that a token design fee and production expenses should cover the cost of the announcements, stationery, catalogs, invitations, and so forth and the various changes on each. AmFar paid for printing all the materials except for the 250-page auction catalog, which was underwritten privately by Sotheby's employees who had raised money that was matched by Sotheby's, Inc. Friedman continues to consult, coordinate, and supervise the design format. The New York auction raised $2.5 million. The Los Angeles and San Francisco events have raised a total of $4 million to date.

Art Director: Dan Friedman

Designer: Dan Friedman

Client: American Foundation for AIDS Research

Hunger-Benefit Poster
..................................

During the 1970s the small African nation of Biafra was ravaged by drought and disease and quickly became the focus of intensive international concern and widespread relief efforts. When a consortium of three Boston universities in conjunction with their student organizations decided to sponsor a ball to benefit the survivors, Dietmar Winkler offered to design an announcement. The poster was done within hours without any extra material expense, since everything was in his studio and at his disposal. Though one of the printers who was asked to donate printing told Winkler that Biafra was "not his favorite charity," other suppliers enthusiastically offered their services. The hand-drawn display type, which was inspired by a triangular African motif, was so simple and direct that no one could misinterpret the message.

BIAFRA BENEFIT BALL

Benefit Ball for Biafra

Massachusetts Institute of Technology
Walker Memorial Hall

Champagne Toast, Evening Collation
Dancing and Entertainment
Admission $15.00
Semiformal, National Dress

Proceeds will be donated to the
Biafra Famine Relief Fund

Friday, May 16, 1969
8:00 pm to 12:00 pm

Sponsor
Morris B. Abram
President
Brandeis University

Sponsor
Howard W. Johnson
President
Massachusetts Institute of
Technology

Sponsor
Seavey Joyce, S.J.
President
Boston College

BIAFRA FAMINE RELIEF FUND
P. O. BOX 300, M.I.T. BRANCH P. 8.
CAMBRIDGE, MASS. 02139
Tel.: 267-3202

Art Director: Dietmar
Winkler
..................................
Designer: Dietmar Winkler
..................................
Client: Biafra Relief

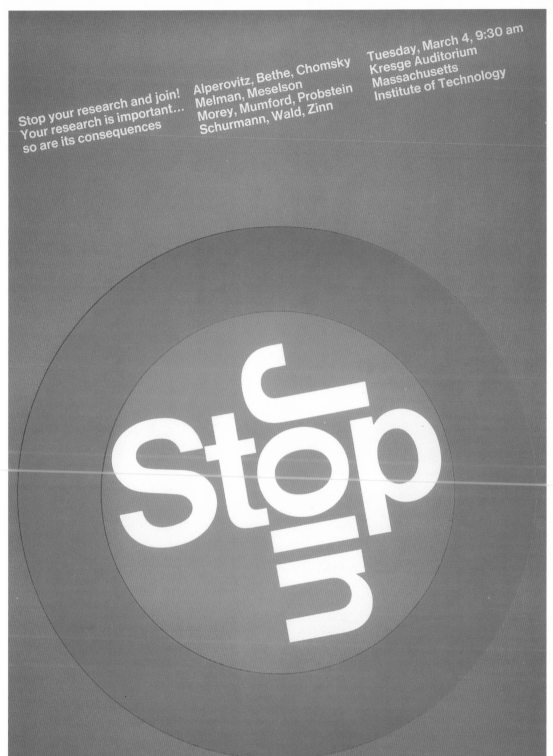

Stop your research and join!
Your research is important...
so are its consequences

Alperovitz, Bethe, Chomsky
Melman, Meselson
Morey, Mumford, Probstein
Schurmann, Wald, Zinn

Tuesday, March 4, 9:30 am
Kresge Auditorium
Massachusetts
Institute of Technology

**Campus Protest
Announcement**

During the late 1960s govern-
ment-sponsored research pro-
grams at M.I.T. were cause
for great alarm among stu-
dents and professors. To
announce its inquiry into the
adverse implications of these
various projects, the Weather-
men arm of the Students for
a Democratic Society organ-
ized an event that included
the "intellectual elite" faculty
and concerned students in a
clarification of their posi-
tions. Dietmar Winkler was
asked to design the announce-
ment for free. Given that this
was the era of student pro-
test, raucous manifestations
abounded. Winkler's under-
stated but very effective de-
sign printed in orange and
light blue, however, was a
stark contrast to the psyche-
delic and underground graph-
ics prevalent on campus at
that time.

**Art Director: Dietmar
Winkler**

Designer: Dietmar Winkler

**Client: Students for a
Democratic Society**

AIDS Awareness Poster
..................................

Artists' representations of
AIDS are hard or soft de-
pending on the targeted
audience. When Seymour
Chwast was asked to donate a
poster image to the Soshin
Society for its AIDS poster
show, he decided to do a
frightening image reminding
people that the AIDS virus is
ever-present. Rather than use
an abstraction, he elected to
personify AIDS through a
human form. The idea for
the red head came from the
classic iconography for death.
He wrote the title, "Mr. AIDS
Would Love to Meet You."
The individual letters were
statted out of a type book,
and pasted together—which
is cheaper than having type
set. The rough letterforms
were then touched up with
pen and brush. The artwork
was given to the printer to
make four-color separations.
The posters were exhibited
and sent to AIDS groups for
free.

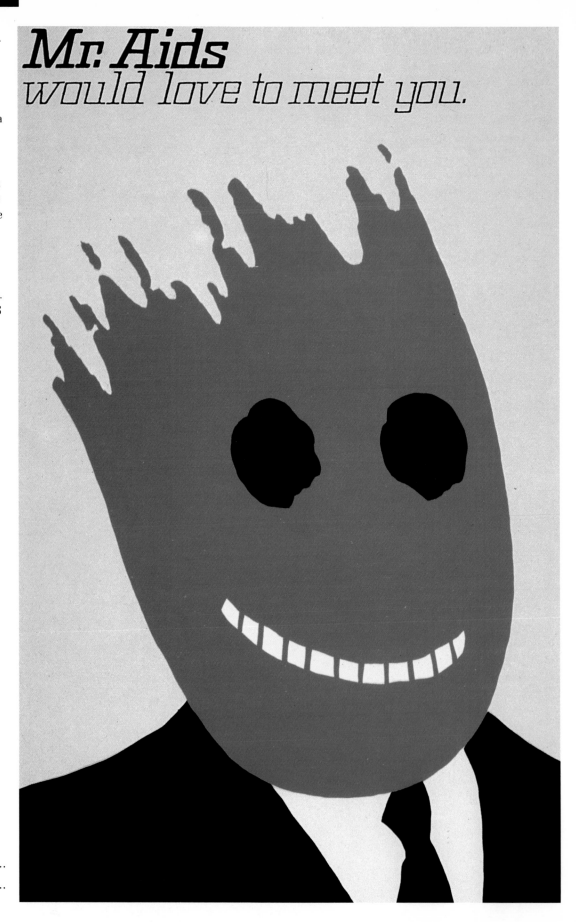

Mr. Aids
would love to meet you.

Art Director: Charles M.
Helmken
..................................
Designer: Seymour Chwast
..................................
Client: Shoshin Society

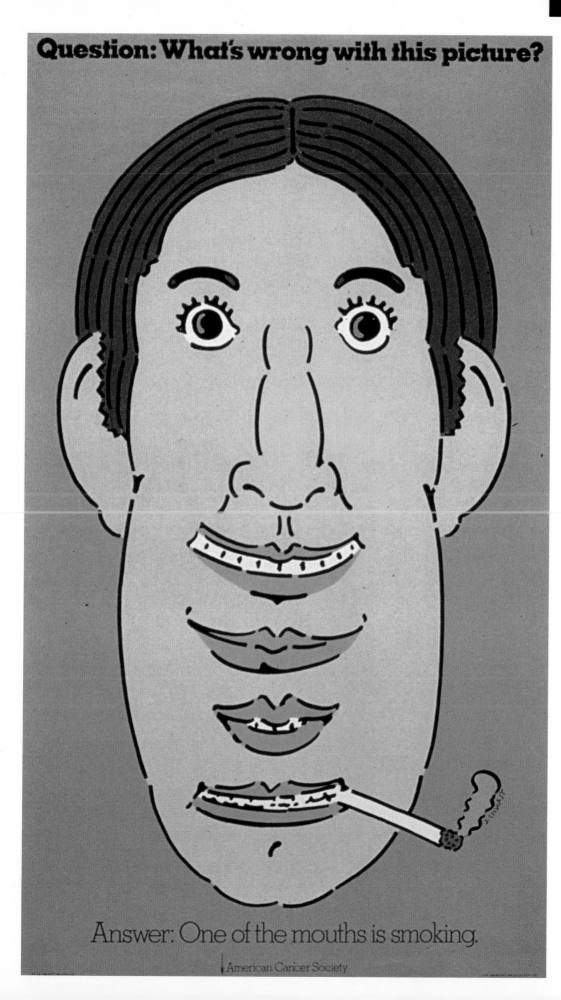

Question: What's wrong with this picture?

Answer: One of the mouths is smoking.

American Cancer Society

Smoking-Prohibition Poster

The American Cancer Society commissioned Seymour Chwast to design and illustrate three posters, two that reminded minority women to have pap tests and one to help dissuade schoolchildren from smoking cigarettes. The budget was minimal, so Chwast took a loss on the design, illustration, and mechanicals. Since he often uses human figures to symbolize complex issues, making a somewhat comic human face was the logical answer to the question posed by the headline. The original art was done as a black outline with overlays for the three colors and the printer placed the color per the overlays. Though this was not expensive to print, the savings for the client was in the design. The poster was hung in government buildings, schools, and was even seen on an episode of "Cagney and Lacey."

Designer: Seymour Chwast

Illustrator: Seymour Chwast

Client: American Cancer Society

Human-Rights Posters

Even with the winds of
democratic change blowing
wildly in Eastern Europe, the
hope of human-rights advo-
cates that all political prison-
ers will be released and that
there will be an end to all
persecution of minorities is
still a dream. For Lanny Som-
mese the promotion of in-
alienable human values
through graphic representa-
tion is a mission. To help
increase the public's aware-
ness of the human-rights
group Amnesty International,
Sommese gave a silkscreen
printing class at Tyler School
of Design the assignment to
create posters on this theme.
No budget existed; the dona-
tions included the design,
paper, ink, and "sweat." With
the silkscreen process, fewer
copies can be produced than
with offset printing, eliminat-
ing both waste and unneces-
sary costs. The posters shown
here — hands as a barbed-
wire fence, hands bolted to-
gether, and a person whose
head is in a vice — were
Sommese's personal re-
sponses to this assignment.
They focused on "the horrific
and negative aspects of the
problems Amnesty was form-
ed to remedy," he explains.
"And all the posters were later
offered to the National Amnesty
Chapter in New York free of
charge, but they never re-
sponded." The posters were,
however, used on campus, and
Sommese says that "judging
from the number of shows in
which they have appeared and
the institutions who have re-
quested copies, I would say
this project has been a
success."

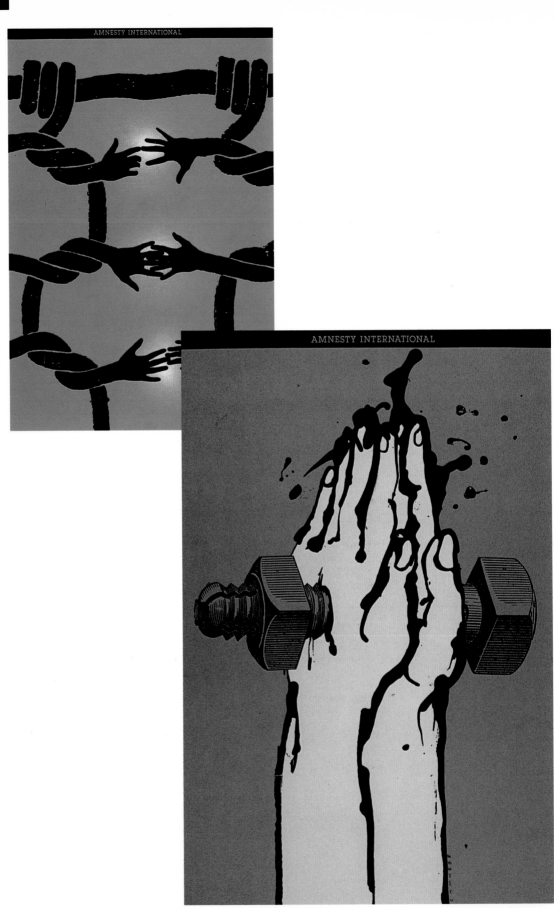

AMNESTY INTERNATIONAL

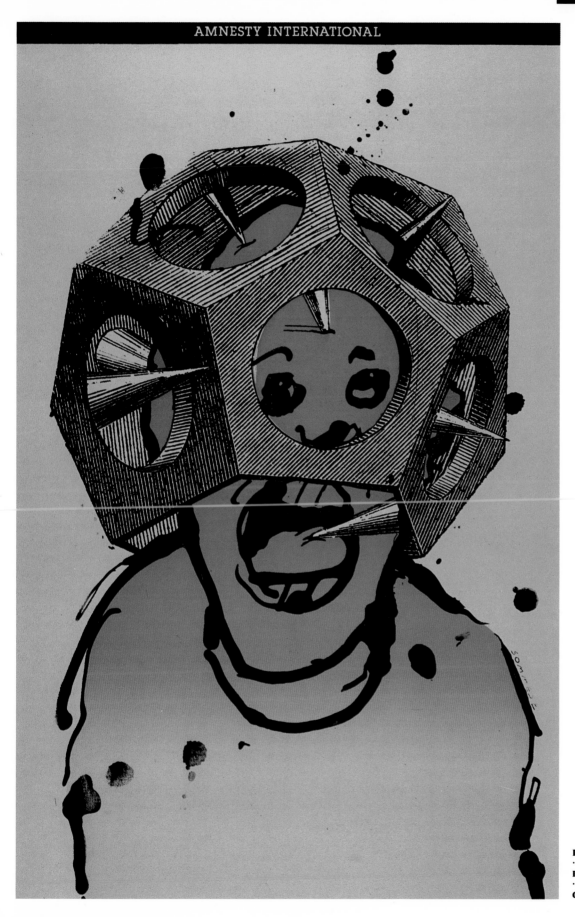

Designer: Lanny Sommese

Illustrator: Lanny Sommese

Client: Amnesty International

Boycott Poster
. .

The grape boycott that lasted well into the late 1970s compelled many to sympathize with the plight of exploited California farm workers. Peter Ross, when he was a design student at Cooper Union College in New York, acted on his compassion by designing a street poster titled "The Boycott Continues" to alert and remind people that the boycott was still going on. The poster was printed on newsprint in one color. Ross photographed the central image, and his father donated the typesetting. The expenses equalled twelve dollars, and the printing of a thousand copies was donated by the United Federation of Teachers.

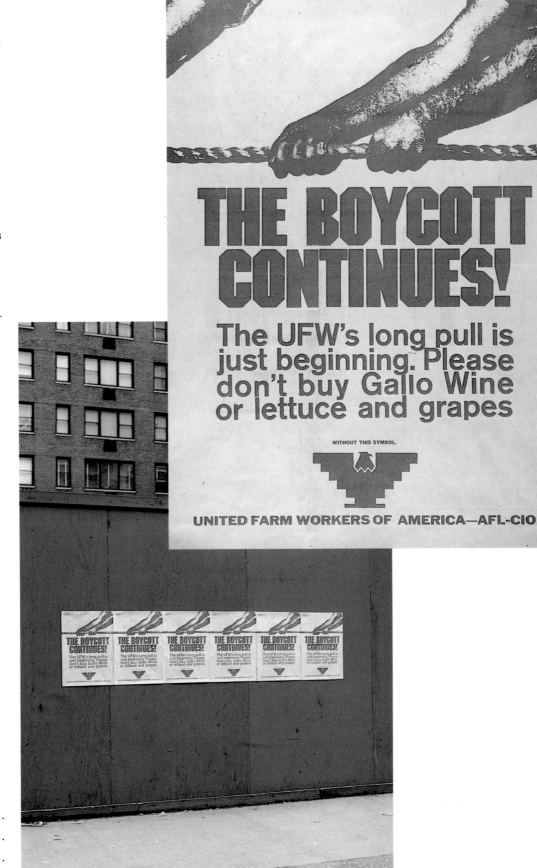

Art Director: Peter Ross
. .
Designer: Peter Ross
. .
Photographer: Peter Ross
. .
Client: United Farm Workers

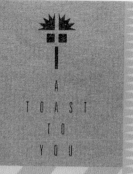

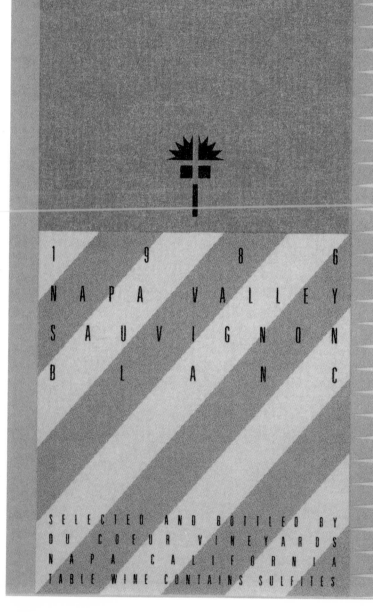

DIFFA

I
A
TOAST
TO
YOU

We at DIFFA, the Design Industries
Foundation for AIDS, hope that you
enjoy this premium quality Napa
Sauvignon Blanc. ■ This elegant
white wine does more than please
the palate: it raises funds to fight
Acquired Immune Deficiency Syn-
drome. ■ By selecting this wine,
you are making a direct contribution
to support much-needed social ser-
vices and education. ■ Together we
can make a difference. We toast you
for your support. ■ To contact your
local DIFFA chapter: 212.371.8299.
To order wine, call: 415.255.1340.

1 9 8 6
NAPA VALLEY
SAUVIGNON
BLANC

SELECTED AND BOTTLED BY
DU COEUR VINEYARDS
NAPA CALIFORNIA
TABLE WINE CONTAINS SULFITES

AIDS Fund-raising Tool

The Design Industries Foun-
dation for AIDS (DIFFA) is a
group of design professionals
from various disciplines who
organize events to raise funds
in support of AIDS research
and education. Among the
unique fund-raising methods
that they've developed, the
sale of donated cases of Napa
Valley Sauvignon Blanc stands
out. Michael Manwaring was
asked to design a direct-mailing
piece offering the wine to
members of the major San
Francisco design associations.
A customized wine label was
based on this design. Man-
warning donated the design,
and his studio paid for the
typesetting and photostats.
The printing and paper were
donated by the suppliers. The
wine had a brisk sale with a
large percentage of the
monies going directly to
AIDS organizations.

**Art Director: Michael
Manwaring**
. .
Designer: Michael Manwaring
. .
**Client: Design Industries
Foundation for AIDS**

Human-Rights Campaign

Brian Collins felt that the 1988 Boston-based Human Rights Campaign Fund Annual Benefit Dinner invitation should have more graphic impact than the staid and unmemorable ones from previous years, so he volunteered to do it better. There was no budget for design, copywriting, or illustration — only out-of-pocket expenses were covered. In addition to the invitation, the design and mechanicals were donated for the stationery, cover, and interior of the evening's programs. Three thousand dollars covered the printing, and the typesetting was a bargain at $750. Collins donated all the camera work and photostats. Without funds to hire an illustrator, he did it himself. The theme was "writers," so he wanted to make the connection between the group's torch logo and a pen; after innumerable roughs he came up with "just the right brush-strokes." Over two hundred more attendees came than were expected, though Collins does not claim that the invitation was the cause for the evening's success.

Art Director: Brian Collins
Design Group
....................
Designer: Brian Collins
....................
Illustrator: Brian Collins
....................
Client: Human Rights
Campaign Fund

THE HUMAN RIGHTS CAMPAIGN FUND
AND HONORARY DINNER CO-CHAIRPERSONS
FRANCIS X. BELLOTTI AND MARJORIE A. CLAPPROOD
CORDIALLY INVITE YOU TO ATTEND THE
1988 NEW ENGLAND DINNER
OUR SEVENTH ANNIVERSARY CELEBRATION
AS WE HONOR NATIONALLY RENOWNED AUTHORS
ARMISTEAD MAUPIN AND FRAN LEBOWITZ
AS WELL AS NEW ENGLAND'S OWN
SASHA ALYSON, BRIAN MCNAUGHT, CINDY PATTON,
ERIC E. ROFES, BARBARA SMITH,
STRAFFORD COUNTY PRE-NATAL AND FAMILY PLANNING
PROGRAM AND WITH SPECIAL RECOGNITION OF
FRANCES PEABODY

FRIDAY, OCTOBER 21, 1988
PARK PLAZA HOTEL, BOSTON

PATRONS $500, SPONSORS $150

INQUIRIES (617) 983-0464

TO KILL A MOUNTAIN LION:

FOR THOSE OF YOU who have never had the singular experience of a mountain lion hunt, imagine this: First set a pack of dogs on the tail of a very large house cat. (The average mountain lion is, of course, bigger, say 75 to 100 pounds.) Have the dogs chase the cat around the neighborhood for several hours until, thoroughly terrified and exhausted, it climbs a tree in desperation. ¶ While the dogs surround the tree, you go find a rifle. A shotgun will do if you're unsure of your marksmanship. Take your time; the cat isn't going anywhere. (In the wild, the interval between treeing the lion and the kill can be as much as a day and a half, and in some instances, the mountain lion is shot in the paws in order to keep it in the tree.) Then from point blank range, you fire away, blowing the animal to bloody lint. ¶ Why, you may ask, would anyone want to do this? The meat isn't edible, the fur is rough and unfashionable and the damage the bullets and dogs do to the carcass usually puts it beyond the taxidermist's art. ¶ As for sport, there is more challenge in setting a mousetrap.

ENOUGH!

WITH DISHEARTENING REGULARITY, the Fish and Game Commission attempts to impose a mountain lion hunting season on a state whose population is clearly opposed to such pointless destruction. Last year, more than 100,000 Californians, through letters, signatures on petitions, and hearings, protested the Commission's proposal, while only 4,000 people applied for hunting permits; only 4,000 potential lion hunters in a state of twenty-five million!

Again, why? There is absolutely no need. Any person who has suffered the loss of livestock or a pet due to a mountain lion attack — a rare event — may either get a permit from the state to kill the offending lion, or let the Department of Fish and Game do the dirty work, free.

That more mountain lions have been recently sighted means only that there are

THE FOX IN THE HENHOUSE

Our state's wildlife is officially "protected" by a five-member commission who set policies to be carried out by the California Department of Fish and Game. All five commissioners have been appointed by the present administration and *all five are avid hunters*. Not one is a wildlife expert.

more of us humans out there than ever before, not more lions. For example, more than three times as many enthusiasts now enjoy our shrinking wilderness than in the 1940s.

The fact is that mountain lions are elusive and solitary and shun human contact whenever possible!

THE SITUATION IS THIS: We don't know how many mountain lions live in the state, nor where they live, nor how they live, nor the extent of any damage, if it is measur-

FLOUTING THE LAW

Just last December, the Fish and Game Commission's mountain lion hunting plan was found to be illegal by a San Francisco Superior Court, even as public opinion had found it to be abhorrent. The Court ruled that until such time as the Department of Fish and Game filed a thorough and accurate environmental assessment on the status of California's mountain lions, *none could be killed for sport.*

The ink was hardly dry on the Court's order when the Department and the Commission were at it again. By hastily recycling the same numbers, they now claim to have answered the court's objections.

Hearings have just been held before the Commission — a kangaroo court — in which the outcome was a foregone conclusion, in spite of overwhelming opposition.

On April 8, in Long Beach, the Commission swept aside all evidence and approved a 1988 hunt *identical* to the 1987 proposal the court had held invalid. Incredibly, earlier on the same day, the Commission filed a lawsuit against us in Sacramento, because we had the audacity to question their ethics and competence.

able, that they do. We only know that the statewide population is hardly overabundant, and that a hunting season is not the answer to wildlife management — as the Department of Fish and Game freely acknowledges. Until all the data is gathered and analyzed, the Commission should not even propose a hunting season on our lions.

That is what the Superior Court ruled early this year, but the Commission is behaving as if it were above the law.

Certainly the wanton slaughter *for fun* of this magnificent animal whose population is unknown and whose behavior is misunderstood, is indefensible. Equally outrageous is the Commission's arrogance in ignoring overwhelming public opinion and the Superior Court's orders.

We are conscious of having presented only our side of this controversy, but we honestly can't figure out the other side. Why, we wonder, do these few men want to set their dogs on a beautiful and harmless wild ani-

MOUNTAIN LIONS POSE NO REAL THREAT

Despite what you may have heard, these are the facts:

[1] In all of California there has never been a single reported human death caused by the mountain lion.

[2] Dogs kill and injure more livestock than do lions. And if you do suffer the loss of livestock, or even a pet, a permit to kill the offending lions may be obtained from the state. Or, the state will come out and kill the cat for you, free.

mal in order to chase it up a tree and blow it away?

For the life of us — and that of the California mountain lion — we don't get it.

— MOUNTAIN LION
PRESERVATION FOUNDATION

MORE LIONS, OR MORE PEOPLE

Proponents of lion hunting hint darkly that more mountain lion sightings indicate a dangerous upward population trend. The facts prove otherwise:

Since 1940, we have lost four and one-half million acres of wilderness to development. During the same period there has been a 75 percent increase in outdoor recreation. So there are three times as many people out there doing the looking. While there may be more sightings, there's certainly not more wildlife.

WE'VE DONE IT BEFORE. LET'S DO IT AGAIN!

Average California citizens, and not private interests, have over the years been pivotal in protecting our mountain lions. In 1963, we played a key role in stopping the slaughter of thousands of mountain lions for bounties. Then, in 1971, concerned over the lion's dwindling numbers, the Legislature and Governor Reagan placed the first ban on trophy hunting of mountain lions. (We're proud to say that California is the first and only state in the West to protect mountain lions from trophy hunting.) You helped us stop last year's hunt. We played it straight and we won. Now in the back rooms in Sacramento, they've taken our victory away. Please help us stop them! Use the coupons below. The first two are for you to register your disapproval. The coupon on the right is for you to help us continue efforts to save this majestic species for future generations. Thank you! Remember we can make a difference!

GOVERNOR DEUKMEJIAN
State Capitol
Sacramento, CA 95814

Dear Governor:
Don't destroy a precious public resource. You can stop the senseless hunting of our mountain lions. Please — don't let the killing begin!

Name: _____
Address: _____
City, Zip: _____

FISH AND GAME COMMISSION
1416 Ninth Street
Sacramento, CA 95814

Dear Commissioners:
For the second straight year, you are defying the public and now a court order! We do not want trophy hunters killing our mountain lions for fun!

Name: _____
Address: _____
City, Zip: _____

MOUNTAIN LION PRESERVATION FOUNDATION
909 12th Street, Suite 110E
Sacramento, CA 95814

Dear Friends:
Here is my donation to help save the mountain lions:*
☐ $20 ☐ $50 ☐ $100 ☐ $_____
☐ Yes, I would like to be added to your mailing list.

Name: _____
Address: _____
City, Zip: _____

*Donations are tax deductible

Kid's Voice Newsletter

In most American cities drugs have exacted a toll on children — not only those who are tragically addicted, but also those whose addicted parents or siblings wreak havoc on their innocent lives. Jeanie Kortum, who works with preschool children at a San Francisco day-care facility, decided to interview a group of children about how drugs affect their lives. She enlisted her husband, Dugald Stermer, to design a broadside comprised of the children's responses. "We put the interviews into a MacPlus," says Stermer, "edited the copy for sense, and set it to measure using one of the standard Mac typefaces. On a photocopier we enlarged some illustrations drawn by our foster daughter, Crystal, and used them to accompany the texts." The Mac type and the drawings were pasted directly onto the mechanical board. The only expense was $1,000 to pay for the printing and mailing of eight thousand copies, and this was contributed by the Coleman Advocates, a lobbying group for children. "It was a great success," continues Stermer. "The project was covered in the local newspapers and on television. For propaganda purposes, we reached one million people for only $1,000.

Art Director: Dugald Stermer

Designer: Dugald Stermer

Illustrator: Crystal Stermer

Client: Coleman Advocates

"Too many people are getting killed; it's like growing up in Vietnam."

VOLUME I, NUMBER 1

"When you're at Log Cabin it's about having fun, going home, selling, coming back and looking good!"

Maurice, age sixteen, a resident of Walden House.

I started using the powder, cocaine, in 1987. I was in a place called Log Cabin Ranch. All the guys would get high back in the laundry room. We would go home on home passes. We would plan like what we would bring back and we would meet each other at the bus stop. We would bring in snacks and I'd put mine in the Ritz Crackers because that would be the last place they would look for them. I would tape it in on the inside and bring it in. We would all find a place to put it like the Captain Crunch box, that was a good place, or make a sandwich and put it in a piece of meat and not eat the sandwich, play like we was full. We would go back in the laundry room or we would get on a certain chore where we could use and ain't nobody find us snorting. Or we would go to the weight room and put it in a cigarette.

I had a friend called Mikie and we did a lot of crime together. Like robbing ladies, snatching purses, robbing stores, anything we could to get crack cause by then we were smoking crack. We were back and forth from Juvenile. At first we would lace our weed with powder (cocaine), and then we had found a way where everybody was rocking it up (smoking crack), and it was kind of crazy and so we laced it with crack one time. Pretty soon we were snatching purses every day.

Once I got sixteen I was in Log Cabin Ranch. On home passes I would sell and I was able to make money. When you're at Log Cabin it s about having fun, going home, selling, coming h͟ and looking good. I had star͟ ͟moking rocks on the ͟

drink alchohol or use crack or coca͟ told him the fast money and the fa͟ it's not in if you haven't got it ho͟ your hair and stuff like that if yo͟ for it. I told him dope is going to ͟ gone and put your mind to it and͟ hard to take it off your mind but ͟ letters I send to him, he's glad ca͟

"When you smoke cra͟ it pretty much blows your head off."

and he's happy just to get a le͟ They don't care what's on the ͟ of the letters.

Everybody I found to hang ͟ trying to climb through some͟ that. I would drink and smok͟ that would make me feel goo͟ wanted to be noticed on the ͟ was wanting to make some ͟ cars. So I started selling wee͟ weed. In one day I would g͟ mine that stayed in Sunnyd͟ for two dollars, a bag for fiv͟ ten. I started making a lot o͟ me. I never was getting ca͟ they would expect to be se͟ money and money to buy ͟ She was totally against it. ͟ ͟h I don't play͟

Our kids talk about crack

steal

"I started stealing from my mother."

FALL 1989

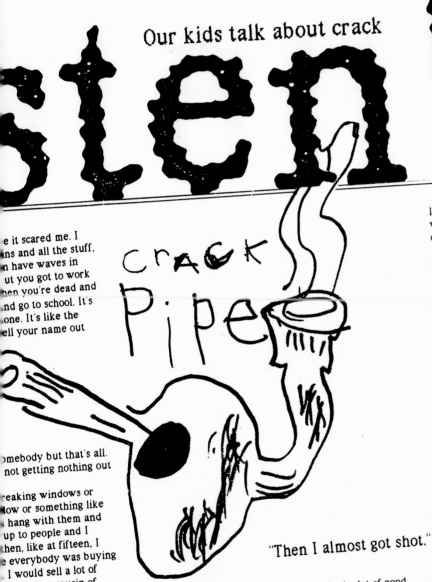

crack
Pipe

"Then I almost got shot."

e it scared me. I
ins and all the stuff,
n have waves in
ut you got to work
hen you're dead and
nd go to school. It's
one. It's like the
ell your name out

omebody but that's all.
not getting nothing out

reaking windows or
low or something like
hang with them and
up to people and I
hen, like at fifteen, I
e everybody was buying
I would sell a lot of
eed from a cousin of
ints at school, Balboa,
d a gram of weed for
erybody was coming to
ing. I was the last person
ol. I would have lunch
my mother didn't know.
like I was against it to.
a I don't do that."

love my sister and I love myself. I still got a piece of myself. I
wanted to do something good and I just needed help. But I
couldn't stop.

Then I almost got shot. I had sold this guy something fake. I
knew it was fake but I needed some money to get some more.
And when I sold it to him he found out I was faking. He got a
shotgun and he chased me and he shot at me. He was real off. I
think he wasn't trying to aim at me, he was trying to scare me.
It was a real boom sound. I took off my shoes and I picked
them up and I kept running once I hit the corner. He didn't
know where I lived since Hunter's Point is kind of big. And I
ditched a few corners and went into my house and I hid under
my couch and I was crying. It was early Sunday and I had to
see my PO Tuesday and I said, "I'm going to tell my PO that I'm
gone and I'm smoking and I just can't deal no more." And so
Monday I stayed in the house all day and ate and ate and ate
and I told my mom my decision. She was crying.

If I didn't have my probation officer I would still be doing it.
I told him I was gone, my mind was gone, I was a person who
was gone on crack. I was a crack monster. You know, I was so
far gone, I would say my soul was gone.

My PO said, "Tell the judge you is using drugs," and I said,
"Alright," and he said, "You know, you're going to have to be
locked up for awhile." He locked me up. My mother was real
happy. She was over happy. And I was happy. I rested a lot.

I came here (Walden House), because they felt that this
program had more love for me and more time and there was
more people to take care of me. The residents talk and talk to
me and give me feedback and a lot of different stuff.

A lot of kids they don't know where to turn because most of
their mothers is crazy. The mothers don't care what they do
they do care, but they don't know how to tell their kids so that
they'll listen. Most kids feel, "I listen to you all my life and it's
harder to do what you say." When they go to a program and
stuff they get to meet different kids. When they come to
programs like this they listen to kids. They're real straight up
things like if your mama tell you what

I started stealing from my mother. She had a lot of good
furniture and whatnots they call them, little brass pieces, and I
would sell them. She started knowing what I was doing. I would
go sell my sister's clothes.

I was smoking at least three hundred dollars worth of dope in
one day. All my days was spent hanging out at the crack house.
At Log Cabin I weighed 207 but I nt down to 140 and it was
 e I couldn't breath
 d lower

Hearing Disability Brochure

To augment a television series called "To Hear," narrated by Joel Grey and conceived to educate people about hearing disabilities, Ellen Shapiro was commissioned to design a format for a series of study guides, which would be distributed to schools, libraries, schools for the hearing impaired, and hearing conservation organizations. Although the brochures were funded by W. R. Grace and KOCE-TV, the budget was tight. To save costs on this ambitious project the insides of all six brochures were printed in one color and all together on one sheet of uncoated paper, which was then trimmed and made into separate booklets. The six covers were printed in one different color each. "We made the job look good," says Shapiro, "by splurging on a laminated, two-color slipcase." A typesetter and printer were used from outside the New York area because their prices were less than those of comparable city suppliers. The slipcase printer had a long-standing relationship with W. R. Grace, which helped bring the price down. Most of the photography was donated, and the illustrator worked for well below the usual rate. "Because we were all committed to the message of the project," says Shapiro with pride, "this became a semi-pro bono job for everyone involved."

SOME DEVICES THAT HELP THE HEARING IMPAIRED TO BE MORE INDEPENDENT

	How It Works	Benefit
TDD (Telecommunication Device for the Deaf)	Keyboard is coupled to telephone; you dial number and type message	Recipient (with similar device) gets message—either on print out or screen
Alarm Clock	Digital clock hooks to vibrator that is attached to bed; you set time	Bed vibrates and wakes you up
Warning Devices	Attachments for smoke-alarm, doorbell, telephone, crib	Lights flash when smoke alarm goes off, phone rings, baby cries, etc.
Television Captioning	Television has frequency adaptor that picks up captioning channel	Written captions (subtitles) appear on screen

The Hurt That Does Not Show

A supplement to the series
on hearing conservation
produced for public television

Art Director: Ellen Shapiro

Designer: Ellen Shapiro

Illustrator: Steven Guarnaccia

Photographers: Various

**Client: KOCE-TV, Newport
Beach, California**

The Hurt That
Does Not Show

Interfaith Report

When Jerry Herring donates the total resources of his firm (from design to production) there is a hidden cost: he requires total freedom. "If they don't pay me, I have full control," he says. "The client must know that I have a feeling of social commitment and will, therefore, do the best job possible." Such is the case with the Houston Metropolitan Ministries, a broad-based, interfaith agency addressing community issues, providing services (such as meals on wheels, administration in prisons, and youth programs), and acting as an umbrella for Protestant, Catholic, and Jewish charitable organizations. Their annual reports are mailed to community leaders, funding sources, service organizations, and the press. The report has to be eye-catching and authoritative yet inexpensive. Herring imbues this publication with all the character of an extremely high-priced corporate annual report without the frills. He saves by eschewing color printing in favor of black and white, and on photography and writing costs through personal arrangements with his creative suppliers. The result is a handsome, accessible, information-packed report that exudes confidence and does not obfuscate the ministries' need for continuous funding.

Art Director: **Jerry Herring**

Designer: **Jerry Herring**

Photographer: **Jim Sims**

Client: **Houston Metropolitan Ministries**

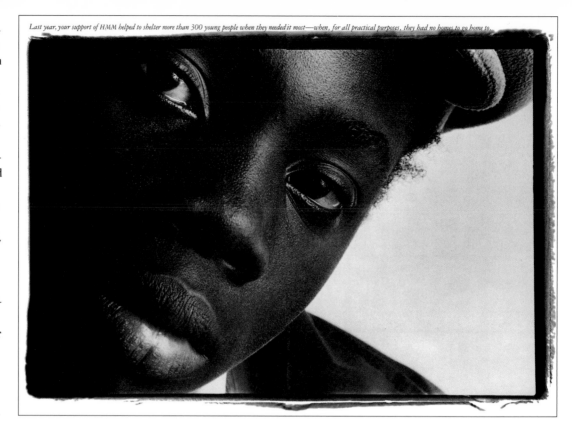

Last year, your support of HMM helped to shelter more than 300 young people when they needed it most—when, for all practical purposes, they had no homes to go home to.

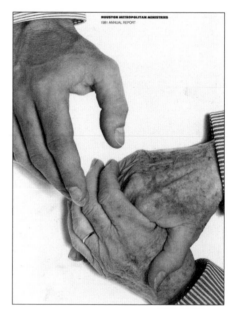

HOUSTON METROPOLITAN MINISTRIES
1981 ANNUAL REPORT

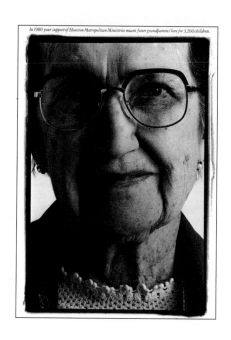

In 1980 your support of Houston Metropolitan Ministries meant foster grandparents' love for 3,200 children.

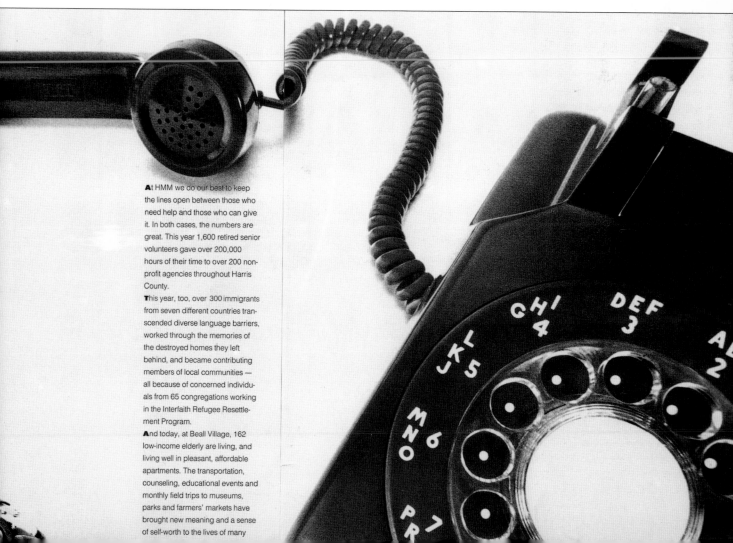

At HMM we do our best to keep the lines open between those who need help and those who can give it. In both cases, the numbers are great. This year 1,600 retired senior volunteers gave over 200,000 hours of their time to over 200 non-profit agencies throughout Harris County.

This year, too, over 300 immigrants from seven different countries transcended diverse language barriers, worked through the memories of the destroyed homes they left behind, and became contributing members of local communities — all because of concerned individuals from 65 congregations working in the Interfaith Refugee Resettlement Program.

And today, at Beall Village, 162 low-income elderly are living, and living well in pleasant, affordable apartments. The transportation, counseling, educational events and monthly field trips to museums, parks and farmers' markets have brought new meaning and a sense of self-worth to the lives of many

United Way
Fund-raising Poster

Marty Neumeier was given $600 to design and print a poster that could potentially generate millions in donations to the United Way of Santa Barbara County. A concept was required that would be easy for him and a production person — both of whom were donating their time — to produce. He decided to use a "split-fountain," a printing technique that many printers use to approximate a full-color look by using only two colors blended together on the press. This technique has a rainbow effect, and to the designer it suggested a symbolic representation of the various people whom the United Way helps. And from this idea developed the image he used of smiling people holding hands. The title "Make Someone Happy" fit the paper-doll solution. The photographer donated a shot of white dolls on a white background with shadows. The printer, who also worked for free, did an excellent job of blending the color and black inks. The only expenses were for film, plates, and paper. Was the United Way happy? Well, the poster was brought in under budget.

Art Director: Marty Neumeier

Designer: Sandra Kigashi

Letterer: Marty Neumeier

Photographer: Barrie
 Schwartz

Client: United Way of Santa
 Barbara County

MINNESOTA PUBLIC RADIO

1988 REPORT TO FUNDERS

THE FACES OF PUBLIC RADIO

Public Radio Report

..................................

As avid fans of Minnesota Public Radio (MPR), the Larsen Design Office welcomed the opportunity to design their 1988 annual report. In lieu of a fee they agreed to a *trade-out* for a year of news-programming airtime sponsorship (equivalent to $6,830). Beyond the trade-out the remaining alotted budget was $15,000 for printing two thousand copies of the report. MPR wanted the focus on the relationships between the users and producers of public radio. Working within the financial constraints, Gayle Jorgens, the designer, hired a local photographer (who reduced her set fee by half) to shoot an array of people and used their testimonials as text. The design format was based around these pictures and quotes. Out-of-pocket expenses were minimal ($400), and the trade-out was to cover design, production, and typesetting (done in-house), but the expenses for services were equivalent to $10,000, the balance of which was donated by Larsen to MPR.

MERRITT CHAPMAN

Rural Mail Carrier/KCRB Member
Bemidji

EILEEN STANKAVICH

KCRB Station Manager
Bemidji

"I enjoy lots and lots of things about public radio — especially classical music. In my particular case, I have absolutely no musical background. The only instrument I play is the radio. And I'm pretty good at that."

"I usually listen from my car, although the radio's usually on wherever I am, unless I'm asleep, and it's almost always on 88.5, which is our station here in Bemidji."

Merritt Chapman

Minnesota Public Radio is a partnership between the people who make radio and the people who listen to it. Most of the time, these people have only an abstract view of each other. The announcer in the studio can't see the audience, and the listener can't see the person behind the voice. Yet both are essential to MPR's existence.

This year you were one of those people. And as you read through this summary of the network's activities during Fiscal Year 1988, you'll have an opportunity to meet a few of the others face to face, as we tell the story of MPR through people on both sides of the radio.

The Mission

The mission of Minnesota Public Radio is to produce and to acquire radio programming of community value; to combine these programs into a nonprofit radio service of the highest quality for broadcast through a network of regional radio stations to the people of Minnesota and its border communities; and to reflect the culture, events, issues and ideas of Minnesota and its people in radio broadcasts designed for national and international audiences.

Art Director: Tim Larsen
..................................
Designer: Gayle Jorgens
..................................
Photographer: Robyn Stoutenberg
..................................
Client: Minnesota Public Radio

Literacy Billboard

Brooklyn 7 is a group of junior and senior design students from Otis/Parsons School of Design, Los Angeles, who, under the direction of Shiela Levrant DeBrettville, meet twice weekly to do pro bono work for a wide range of needy causes. One of their regular assignments is to think about those issues that need to be (or haven't been sufficiently) addressed by mainstream media and then develop, either as a group or individually, print materials that contribute to a better understanding of that cause. In this case, the issue is literacy and the idea was to design a billboard that would "advertise" a local literacy group. Patrick Media (specialists in outdoor advertising) agreed to hang the billboard if a cosponsor could be found. An idea was decided upon and accepted by the sponsors. Four sights were selected in areas with illiterate populations. To avoid incurring large printing expenses, four billboards were hand-painted with labor donated by Patrick Media. The result was stupendous; the literacy group was deluged with phone calls. The cost was minimal. Brooklyn 7 requires that the client pay for type and stats while the students pay for the prep-work, as they would with any school project. Brooklyn 7 tries not to impinge on fee-paying projects that might go to other professional designers.

Art Directors: Sheila Levrant DeBrettville, Ave Pildas

Designer: Diana Cain

Client: Brooklyn 7

patrick

Youth-Group Campaign

Sometimes the most lavishly produced materials are the least expensive owing to a combination of donations and commitment. When the Duffy Design Group of Minneapolis was asked by that city's mayor's office to donate the design of the logo, brochure, membership card, T-shirt, and related campaign matter for Fresh Force Youth for a Change, they jumped at the opportunity. Fresh Force is an inner-city aid program that encourages kids to partake in city services rather than join street gangs. The mayor's office paid for stats, and Duffy Design donated all other services, including original photography for use on train-station posters. Charles Spencer Anderson based his design on a nostalgic theme, using free advertising art from the 1930s found in old books (which he altered by adding drawn elements, such as expressions or clothing) as a graphic counterpoint to the conventional inner-city images Printing was going to be the major problem until it was learned at a photo session that the uncle of one of the little girls being photographed owned Rainbow Sign, a silkscreen company. Rainbow donated their printing services for the posters and the brochures, and the spiral binding was donated too. Anderson spent many hours supervising the printing process to ensure its high quality. Five thousand posters and ten thousand brochures were printed.

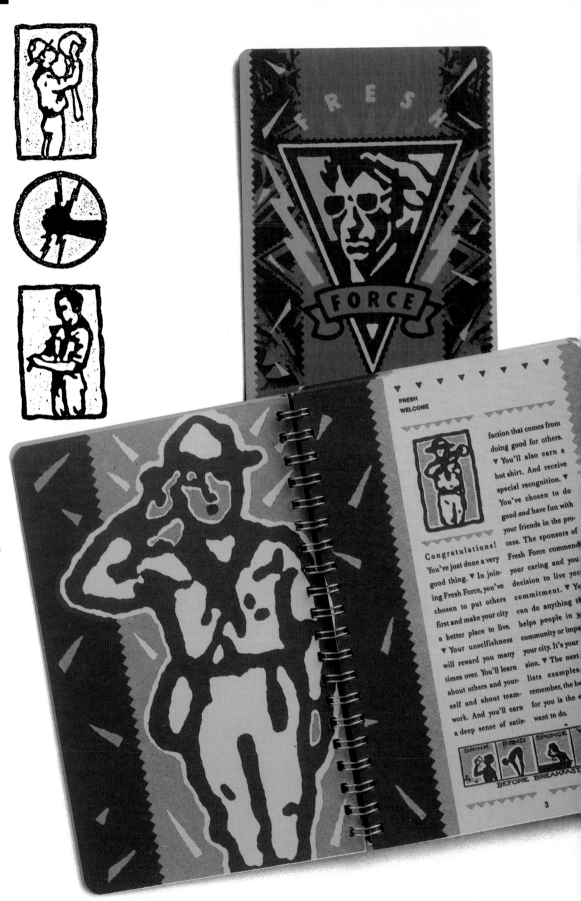

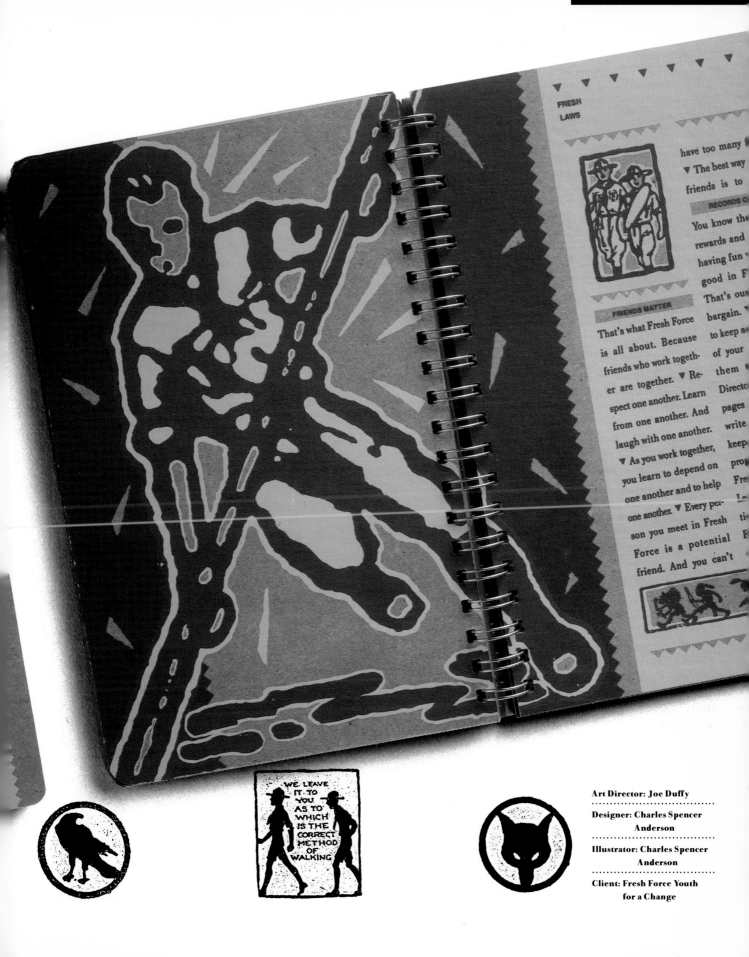

FRESH
LAWS

have too many ▮
▼ The best way
friends is to

RECORDS O

You know th
rewards and
having fun ▼
good in F
That's ou

FRIENDS MATTER

That's what Fresh Force
is all about. Because
friends who work togeth-
er are together. ▼ Re-
spect one another. Learn
from one another. And
laugh with one another.
▼ As you work together,
you learn to depend on
one another and to help
one another. ▼ Every per-
son you meet in Fresh
Force is a potential
friend. And you can't

bargain. ▼
to keep a
of your
them
Directo
pages
write
keep
pro
Fre
L
Fre
tie
F

WE LEAVE
IT TO
YOU
AS TO
WHICH
IS THE
CORRECT
METHOD
OF
WALKING

Art Director: Joe Duffy
.................................
Designer: Charles Spencer
Anderson
.................................
Illustrator: Charles Spencer
Anderson
.................................
Client: Fresh Force Youth
for a Change

59

YMCA Report

Every year the YMCA of Metropolitan Toronto commissions a different design firm to produce its annual report (the goal of which is to give financial information while promoting the YMCA's programs and achievements). The 1984-85 report was designed by Taylor & Browning Design Associates in Toronto on what would appear, at first glance, to be a generous total budget of $30,000. In fact, the available funds were almost ten times less than corporate annual reports and very low for a project of this dimension. To ease the financial crunch Paul Browning donated all the firm's design and production time, and he requested that the suppliers either donate services or provide them at less than market value. The photography was done for $6,500, the writing for $2,500, and film and printing came in at $18,000, with $3,000 disbursed for various out-of-pocket expenses. The signature close-up photography, including those pictures of toddlers, teens, and the elderly, presents the full spectrum of YMCA program recipients. The testimonials from users support the organization. The photographs are printed as black and white quadratones, which does not substitute for full color, but does allow for very warm black-and-white tonal reproduction. The entire package succeeded at communicating the strategic objectives of the YMCA.

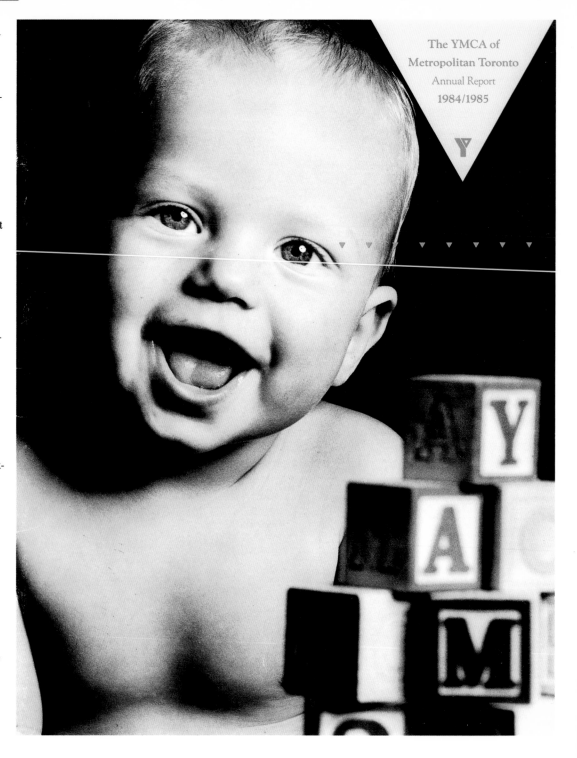

The YMCA of
Metropolitan Toronto
Annual Report
1984/1985

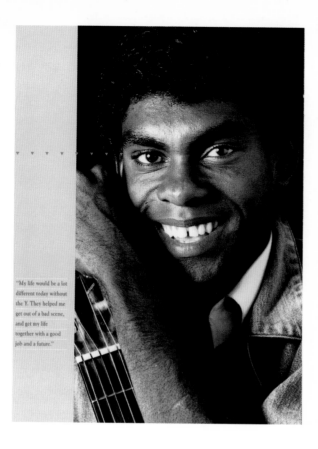

Community and
Youth

Maintaining its long-standing
traditions, the Y makes a
special commitment to those
in our population who face
major barriers to their full
participation in society.

A recent consolidation of all com-
munity and youth programs has
created a renewed focus on devel-
opments in this area. As part of
Toronto's network of social ser-
vices, the Y provides youth employ-
ment services as well as other
programs and services for senior
citizens, various low-income groups
and the handicapped.

"My life would be a lot
different today without
the Y. They helped me
get out of a bad scene,
and get my life
together with a good
job and a future."

Older Adults

With the proportion of our
population in older age
groups steadily increasing, the
Y is placing more emphasis
on unique programs to meet
the varying requirements of
older adults.

The upward trend in the number of
members over 55 is now running at
about 15% per year. To accommo-
date the needs of members up to age
75, programs are being created to
include a full range of exercise and
recreational options, as well as
lectures, films and special courses.

"Staying active at the
Y keeps me fit and
healthy, but at my age,
the social contacts are
equally important.
The Y helps me to feel
that I'm part of my
community."

Art Director: Paul Browning
...................................
Designer: William Lam
...................................
Photographer: Rob Watson
...................................
**Client: YMCA of Metropolitan
Toronto**

Fund-raising Invitation

This invitation for a gala dinner to benefit a kidney-donors organization is not as direct as other Brooklyn 7 advocacy projects, but it does represent one of their prime functions — to give communications to those groups who need it. The rather wealthy people who direct this charity came to Brooklyn 7 because they did not want to squander any money on incidentals that would not go to the children. Design of the invitations was a class project with one piece ultimately selected. One hundred dollars is paid to Brooklyn 7 for material expenses. The organizers got the typesetting and printing donated.

Art Director: Sheila Levrant DeBrettville

Designer: Ingrid Fink

Client: National Kidney Foundation of Southern California

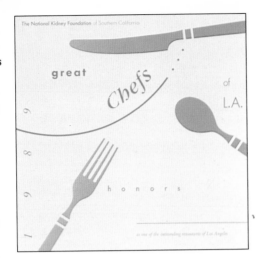

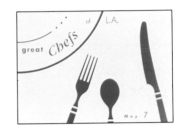

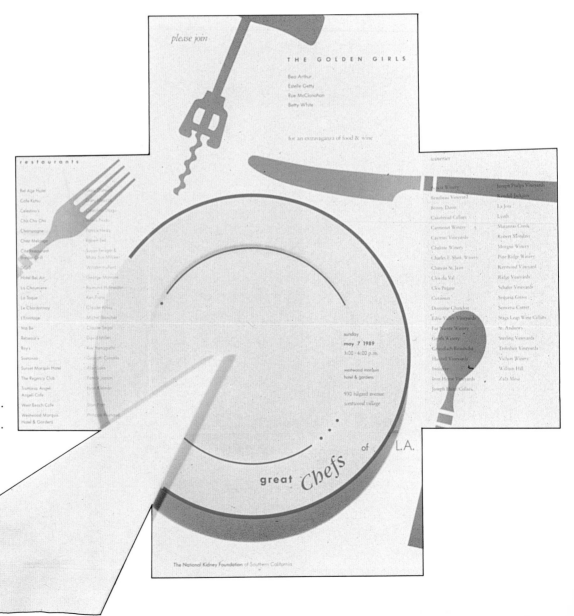

Exhibition Announcement

Brooklyn 7 has an annual exhibition to promote its work and the causes it has helped through providing pro bono design. This poster is designed by a student who used inexpensive typography that she keyboarded herself on a computer and then set on a laser printer. Though the quality of the type is not as good as that from a typeshop, the results were adequate for this kind of printing. The printing is done on a web-offset newspaper press at a cost of $250 for two thousand two-color posters. It's hard to get it any cheaper. The trade-off, however, is that it is hard to get perfect color registration. The poster is used as a general promotion piece and mailed to schools and other designers around the nation.

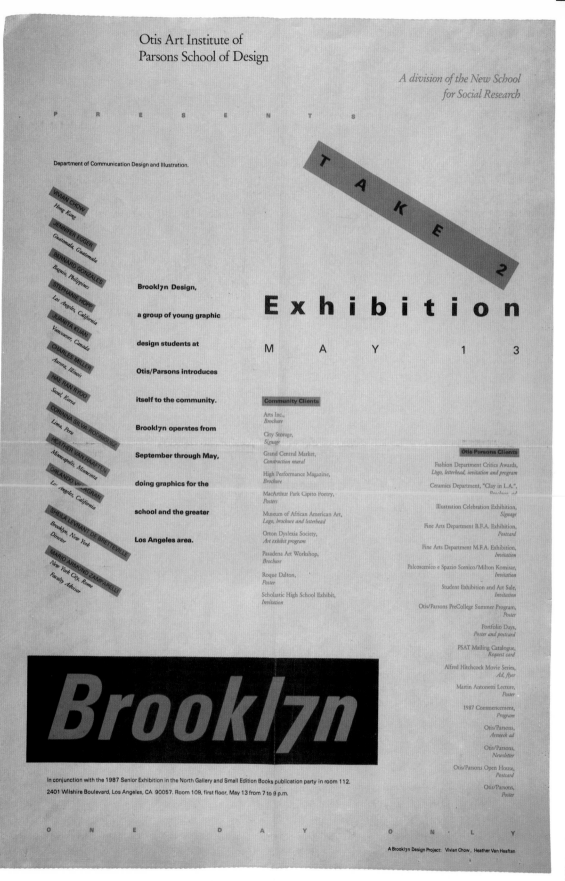

Otis Art Institute of
Parsons School of Design

A division of the New School for Social Research

P R E S E N T S

Department of Communication Design and Illustration.

VIVIAN CHOW
Hong Kong

JENNIFER EGGER
Guatemala, Guatemala

BERNARD GONZALES
Baguio, Philippines

STEPHANIE HOPP
Los Angeles, California

JUANITA KUAN
Vancouver, Canada

CHARLES MILLER
Aurora, Illinois

HAE RAN RYOO
Seoul, Korea

CORINNA SILVA RODRIGUEZ
Lima, Peru

HEATHER VAN HAAFTEN
Minneapolis, Minnesota

ORLANDO VERAGHAN
Los Angeles, California

SHEILA LEVRANT DE BRETTEVILLE
Brooklyn, New York
Director

MARIO ARMOND ZAMPARELLI
New York City, Rome
Faculty Advisor

Brookl7n Design,

a group of young graphic

design students at

Otis/Parsons introduces

itself to the community.

Brookl7n operates from

September through May,

doing graphics for the

school and the greater

Los Angeles area.

T A K E 2

Exhibition

M A Y 1 3

Community Clients

Arts Inc.,
Brochure

City Storage,
Signage

Grand Central Market,
Construction mural

High Performance Magazine,
Brochure

MacArthur Park Cipito Poetry,
Posters

Museum of African American Art,
Logo, brochure and letterhead

Orton Dyslexia Society,
Art exhibit program

Pasadena Art Workshop,
Brochure

Roque Dalton,
Poster

Scholastic High School Exhibit,
Invitation

Otis Parsons Clients

Fashion Department Critics Awards,
Logo, letterhead, invitation and program

Ceramics Department, "Clay in L.A.",
Brochure, ad

Illustration Celebration Exhibition,
Signage

Fine Arts Department B.F.A. Exhibition,
Postcard

Fine Arts Department M.F.A. Exhibition,
Invitation

Palcoscenico e Spazio Scenico/Milton Komisar,
Invitation

Student Exhibition and Art Sale,
Invitation

Otis/Parsons PreCollege Summer Program,
Poster

Portfolio Days,
Poster and postcard

PSAT Mailing Catalogue,
Request card

Alfred Hitchcock Movie Series,
Ad, flyer

Martin Antonetti Lecture,
Poster

1987 Commencement,
Program

Otis/Parsons,
Artwork ad

Otis/Parsons,
Newsletter

Otis/Parsons Open House,
Postcard

Otis/Parsons,
Poster

Brookl7n

In conjunction with the 1987 Senior Exhibition in the North Gallery and Small Edition Books publication party in room 112.

2401 Wilshire Boulevard, Los Angeles, CA 90057. Room 109, first floor, May 13 from 7 to 9 p.m.

O N E D A Y O N L Y

A Brookl7n Design Project: Vivian Chow, Heather Van Haaften

Art Director: Sheila Levrant DeBrettville

Designer: Hugo Espinoza

Client: Brooklyn 7

**Educating the
Media Package**

For a major television advertising campaign exploring the causes of anger in children and adolescents, the advertising agency for the Institute for Mental Health Initiatives asked Ellen Shapiro to donate the design for a sign-off logo. The campaign, called "Channeling Children's Anger," intended to provide viable models showing healthier ways of expressing anger than are routinely seen on television shows. The logo was the idea of Terri Bogaards, who brilliantly captured the sense of rage in children whose intimate personal needs fail to be met. It was such a powerful image that the institute asked Shapiro for additional materials designed with the logo for publicity purposes, including press-kits, dinner programs, reply card, and T-shirts. Shapiro donated all her services, as did Korey Kay, the advertising agency. The paper used for the entire project was given by Simpson Paper Company. The institute had to only pay for typesetting and printing, which were billed at close to cost.

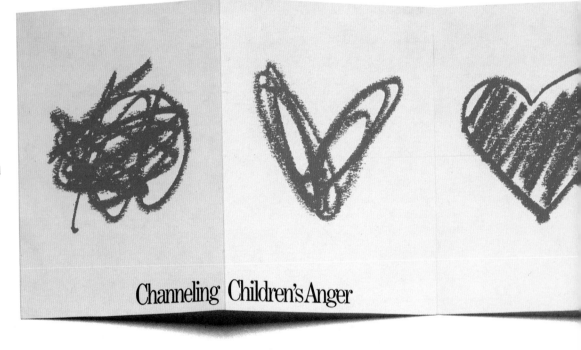

Channeling Children's Anger

Art Director: Ellen Shapiro

Designer: Terri Bogaards

Logo: Terri Bogaards

Photographer: Peggy Barnett

**Client: Institute for Mental
Health Initiatives**

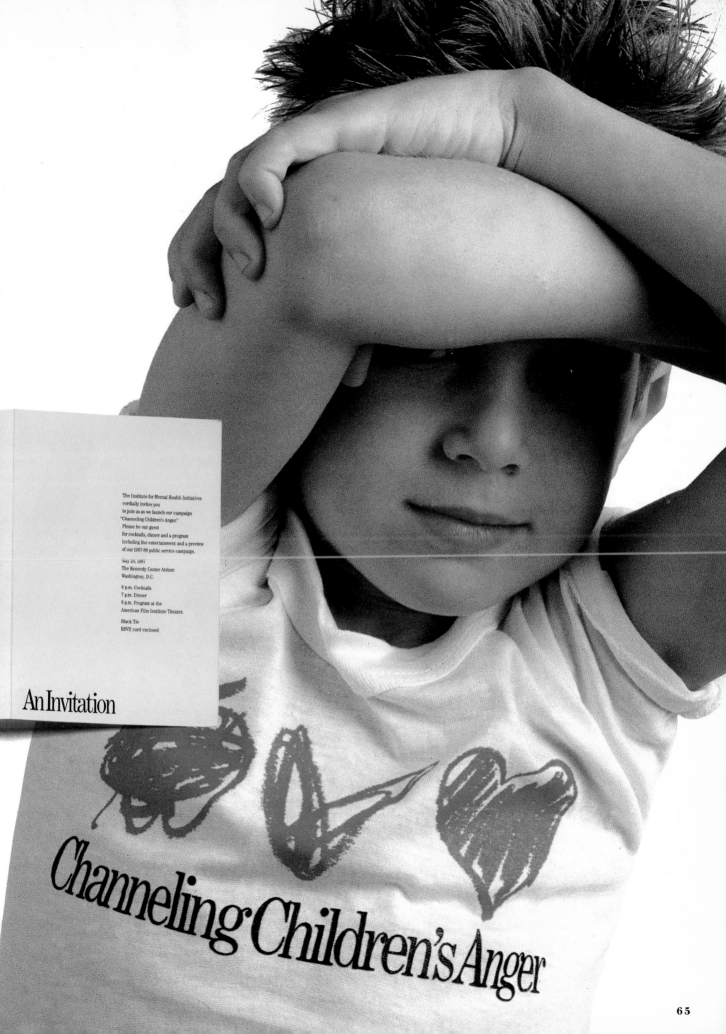

The Institute for Mental Health Initiatives
cordially invites you
to join us as we launch our campaign
"Channeling Children's Anger."
Please be our guest
for cocktails, dinner and a program
including live entertainment and a preview
of our 1987-88 public service campaign.

May 20, 1987
The Kennedy Center Atrium
Washington, D.C.

6 p.m. Cocktails
7 p.m. Dinner
9 p.m. Program at the
American Film Institute Theater.

Black Tie
RSVP; card enclosed

An Invitation

Channeling Children's Anger

Rehab-Center Report

Cenikor is a high-visibility drug and alcohol rehabilitation center in Houston, Texas. Like many other privately and publicly funded care providers and self-help groups, Cenikor must present a good face to its contributors, potential donors, and the press. Jerry Herring Design has donated the design and production of these annual reports for the past few years. The printer, typesetter, and photographer have also provided their labor. In exchange, each has received free services from residents at the center. "They have painted my house, fixed my car, and helped move my studio," says Herring. The reports are superlative, both in reflecting the energy of the center and reporting on its good works. "Cenikor is run by past and present program members," adds Herring. "Many of them, in fact, are not as savvy as other non-profit fund-raising executives, so I feel we have positively represented the group to prospective donors and the community. As evidence, President Reagan and other VIPs have been encouraged to take heed of Cenikor."

Art Director: Jerry Herring

Designer: Jerry Herring

Photographer: Michael Hayne

Client: Cenikor

Jeff Chuber, first stage, Auto Maintenance Department

Keeping up with the rapid rate of technological change in vocational courses is vital to the preparation of our residents for re-entry. Students in the automotive program learn the intricacies of catalytic converters and of diesel as well as internal combustion engines. And they master the tiny computers that control so many functions of modern cars. Study of periodicals and bulletins keeps them alert to current developments in the automotive industry. With relevant and marketable training, they graduate with greater confidence that they have the personal and professional skills to lead new lives and to make an important difference in society.

Seniors' Program Brochure

When Judy Kirpich, creative director of Grafik Communications Washington, works with a nonprofit organization, her design fee is reduced by $10 per hour. The client, in turn, is asked to assume as much of the research and secreterial work as possible and is usually encouraged to buy the typesetting and printing services directly from vendors to avoid the conventional agency or studio markup. When asked by the B'nai B'rith to develop a brochure aimed at showing the public and key government leaders its role in providing quality housing for senior citizens, cutting corners was the only way to create an impressive document. The client had budgeted $5,600 to cover everything. Kirpich used $4,000 for creative services, including art direction, design, writing, and a small percentage for studio overhead. The balance went to typesetting, photostats, and photography. Costs for the latter were minimized by using existing location photographs, which were given to the designer at a reduced rate in exchange for an overrun that could be used for the photographers' promotional purposes. The senior citizens brochure was comparable to higher-priced corporate reports, and it effectively represented the goals and image of the B'nai B'rith.

Art Director: Judy F. Kirpich

Designer: Claire S. Wolfman

Photographers: Bill Aron, Rikki Rosen

Client: B'nai B'rith

"THE PLACE IS GORGEOUS—VERY FRIENDLY. WE HAVE MALLS ONCE A WEEK . . . LIKE THIS ELSEWHERE." JE

providing a much-ne
individual communi
enthusiasm generate
B'nai B'rith.
 Sponsorship of
with the ceremony
It begins there.
nelled into prog
projects and ac
dents and B'n.
Lodge membe
overseeing ev
to general r
unusual fou
events like
groups. B
that our
indepen
need ev
 Whe
visits

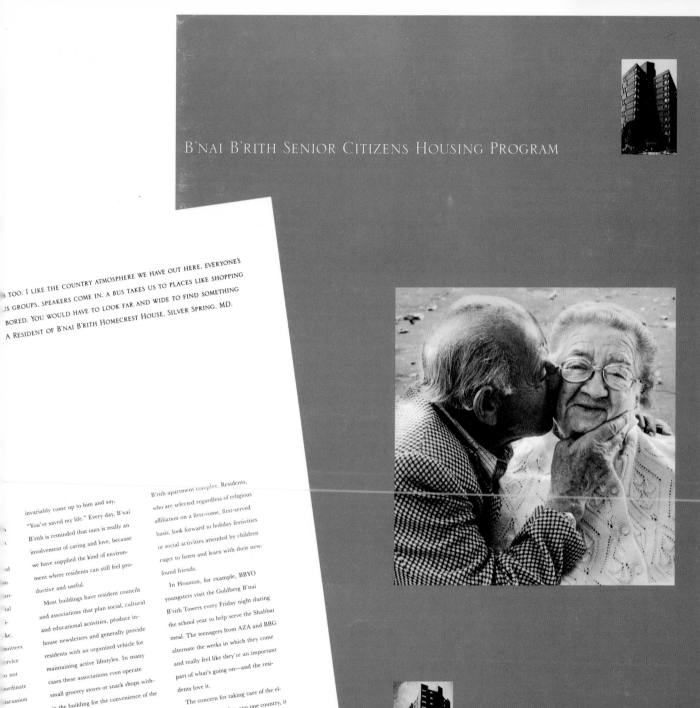

B'NAI B'RITH SENIOR CITIZENS HOUSING PROGRAM

S TOO. I LIKE THE COUNTRY ATMOSPHERE WE HAVE OUT HERE. EVERYONE'S
JS GROUPS. SPEAKERS COME IN. A BUS TAKES US TO PLACES LIKE SHOPPING
BORED. YOU WOULD HAVE TO LOOK FAR AND WIDE TO FIND SOMETHING
A RESIDENT OF B'NAI B'RITH HOMECREST HOUSE, SILVER SPRING, MD.

invariably come up to him and say,
"You've saved my life." Every day, B'nai
B'rith is reminded that ours is really an
involvement of caring and love, because
we have supplied the kind of environ-
ment where residents can still feel pro-
ductive and useful.

Most buildings have resident councils
and associations that plan social, cultural
and educational activities, produce in-
house newsletters and generally provide
residents with an organized vehicle for
maintaining active lifestyles. In many
cases these associations even operate
small grocery stores or snack shops with-
in the building for the convenience of the
residents.

Visits by local lodge members or
youngsters from the B'nai B'rith Youth
Organization—AZA and BBG—add a
warm family atmosphere to each B'nai

B'rith apartment complex. Residents,
who are selected regardless of religious
affiliation on a first-come, first-served
basis, look forward to holiday festivities
or social activities attended by children
eager to listen and learn with their new-
found friends.

In Houston, for example, BBYO
youngsters visit the Goldberg B'nai
B'rith Towers every Friday night during
the school year to help serve the Shabbat
meal. The teenagers from AZA and BBG
alternate the weeks in which they come
and really feel like they're an important
part of what's going on—and the resi-
dents love it.

The concern for taking care of the el-
derly is not limited to any one country, it
is a universal problem. The B'nai B'rith
Senior Citizens Housing Network recog-
nizes this. The commitment to the needs

**Election Campaign
Brochure**

Even politicians deserve good
design, but judging from the
evidence of national elec-
tions, good design does not
necessarily provide the win-
ning edge. In this case, the
Duffy Design Group was
asked to create a leaflet to
persuade voters that school-
board candidate Jim Lindstrom
was best for a difficult job. A
touch of wit was called for to
separate this from conven-
tional election propaganda,
and so Sharon Werner decid-
ed to use a 1940s image to
represent the idea of family.
A bold typeface was used for
emphasis and a bright color
for excitement. The budget
was under $200. The Duffy
Design Group donated the
design, illustration, and me-
chanicals. The printing of
five thousand leaflets was
donated, as was the printing
supervision (to ensure that
no mistakes occurred). The
only costs were for typeset-
ting at $150, and fifty but-
tons at $25, bringing the
total job in at $25 under
budget. Lindstrom won the
election, perhaps thanks to
this brochure.

Art Director: Joe Duffy

Designer: Sharon Werner

Illustrator: Sharon Werner

**Client: Lindstrom for
School Board**

JIM LINDSTROM

1595 TROLLHAGEN DRIV

FRIDLEY, MN 55421

IF YOU DON'T VOTE, WE COULD BOTH LOSE. Many people don't bother to vo
When this happens, everyone loses. And a candidate you like can be pushed
supported by a low percentage of eligible voters. Please vote. And I ho
Our schools are facing tough challenges and opportunities this year. We must p
immediate solutions and lay out a strategy for long-term success. As you'll disc
of issues below, our pressing problems need experience and leadership. **OUR SC
ISSUES:** This year's biggest issue is how public education is financed. This works
Because of this method of funding, we've had to give notices of lay-off to many te
professional people and we run the risk of losing good teachers. It also affects th
students. We are seeing declining enrollments in grades 9-12. At the same
ment is beginning to increase. This combination of events causes a funding crunch b
on *pupil units* (PU): 1 PU for elementary and 1.4 for 9-12. We are having
this happen. These are courses that many students would benefit from.
to improve the quality of education in Columbia Heights. This accountability mus
must account to you, our administration must account to the board, staff must be
students must account to staff and to their families (parents). We need high
This must begin with you and the schools working as a team to raise our expecta
children and our students. The more we work together, the more our stud
academic achievement, being a part of a fun, exciting school environment, and a re

Lindstrom

for SCHOOL BOARD

FROM MY EXPERIENCE
AS FATHER OF TWO,
I KNOW THAT
EDUCATING CHILDREN
IS A FAMILY'S
GREATEST RESPONSIBILITY.
A SCHOOL BOARD MUST
MAKE SURE THAT
SCHOOLS MEET THE
EDUCATIONAL NEEDS
OF ONE AND
TWO-PARENT FAMILIES
AS THEY HELP THEIR
CHILDREN PREPARE
FOR THE WORLD
OF WORK OR
HIGHER EDUCATION.

M LINDSTROM.
9 YEARS
EXPERIENCE;
9 YEARS
OF VISION.
■
HOOL BOARD
MEMBER
SINCE 1978.
ARD DIRECTOR
IN 1979.
ARD CLERK
1980, 1986.
ARD CHAIR
81-83, 1987.
ICE-CHAIR
1984-85.
ESIDENT OF
ISTRICT #13
FOR OVER
0 YEARS.

I FAVOR SOUND FINANCIAL MANAGEMENT. My career has given me valuable management experience in business operations—Human Relations, Budgeting, Planning, Profit and Loss, Cost Management, and Industrial Relations. My experience has given me a balanced point of view on financial matters and the wisdom to know that sometimes we must start programs before we have the funding.

I FAVOR HIGH EDUCATIONAL STANDARDS. My son Jimer and daughter Nancy graduated from Columbia Heights High School. Their educations provided them an excellent base of knowledge and skills to compete at the college level. Nancy graduated from Augsburg in 1982 and Jimer is a student and employee of 3M. I'm proud of how their educations helped them and have done my best to build even higher educational standards within our district. Every Columbia Heights student should have the opportunity to achieve personal academic goals and feel a sense of accomplishment. I hope you will support my re-election. Either way, please vote.

Senior Citizens Announcement

To help the nonprofit East Dallas Senior Citizen Network announce its services, including meals on wheels and home health care, Sullivan Perkins Design in Dallas was asked to design a small, but eye-catching, information-packed brochure. No budget was available, so in addition to the waiving of design and illustration fees, the printing of five thousand copies and typesetting were donated by local suppliers. The sturdy, matte paper stock was bought at wholesale cost ($500) and was the only expense incurred by the client.

Art Director: Ron Sullian

Designer: Jennifer Long

Illustrator: Jennifer Long

Client: East Dallas Senior Citizen Network

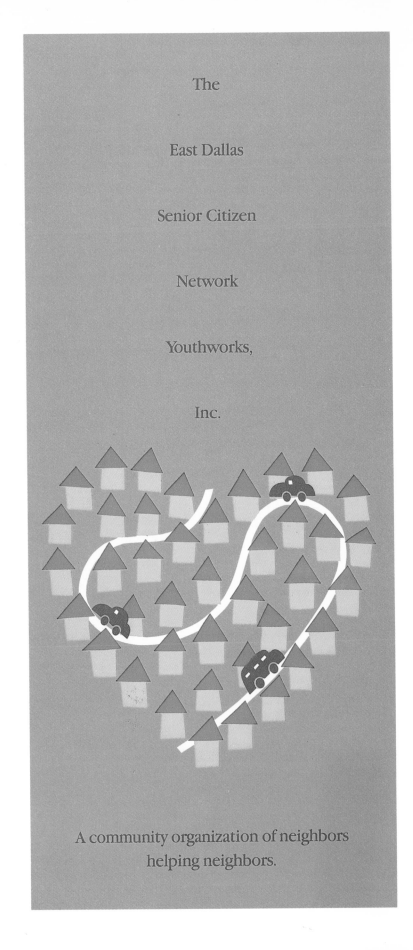

The

East Dallas

Senior Citizen

Network

Youthworks,

Inc.

A community organization of neighbors helping neighbors.

CITY SITES
ARTISTS & URBAN 10 STRATEGIES

Ten internationally prominent artists speak on strategies and issues in their work — homelessness, racism, aging, waste disposal, mass media, education and ecology — at various sites throughout Oakland.

Sponsored by the California College of Arts & Crafts in collaboration with the Oakland Arts Council, this series is a response to Oakland's Cultural Plan.

7:00PM, Thursday evenings, free (seating is limited)

Funded in part by the National Endowment for the Arts and the California Arts Council. For more information, call 653-8118.

▶ **NEWTON & HELEN HARRISON**
March 2
Scott's Restaurant – Harbor View Side
73 Jack London Square

Based at the University of California in San Diego, the Harrisons explore ecological and urban situations throughout the world. Their proposals design urban promenades, reclaim waterways and debris basins, and develop aquaculture systems for third world countries.

▶ **JOHN MALPEDE**
March 9
First Unitarian Church
685 14th Street

Performance artist, paralegal, and advocate for the homeless, Malpede founded the Los Angeles Poverty Department (LAPD) in 1985. He will discuss the energetic performances — "barely controlled chaos" — of this ensemble of street people, whose work reflects the social, psychological, and political forces shaping the lives of the homeless.

▶ **LYNN HERSHMAN**
March 16
KTVU Channel 2
2 Jack London Square

San Francisco conceptual artist Hershman explores the intersection between personal reality, mass audience empowerment, and contemporary media. Her talk will be preceded by public service announcements designed as artworks on local television.

Lecture Series Announcements

Citysights was a series of lectures by ten internationally prominent artists addressing the strategies of and issues in their work, including homelessness, racism, aging, waste disposal, mass media, education, and ecology. Each lecture was held on a different city sight that proved relevant to the artist's work. The organizer, a dean of fine arts at the California College of Arts and Crafts, asked Michael Manwaring, a teacher there, to design the mailers and posters. The lack of funds was a determing factor in Manwaring's decision to use simple geometric graphic forms. The color was changed to indicate a different program. Two thousand dollars covered the printing of three thousand postcards and seven hundred each of four different posters. A $500 fee and $500 for expenses in no way equalled Manwaring's studio costs.

Art Director: Michael Manwaring

Designer: Michael Manwaring

Client: California College of Arts and Crafts

Architecture Series Announcement

To gauge the egos of creative people one needn't use sensitive measuring devices, and one could argue that architects are no exception to this rule. For nine successive years, the San Francisco Museum of Art and the American Institute of Architects have conducted a lecture series featuring six or seven of some of the most creative contemporary architects in the world. Rather than produce an announcement that attempts to focus on each individual artist, Michael Vanderbyl is asked to "graphically translate" the theme of the series into one image. He has done this with imagination and aplomb. "I donate the design year after year because I have always been interested in architecture," says Vanderbyl. "But more important, it is good for the museum to recognize all design disciplines." Each year his imagery is used for both a limited-edition, silkscreened poster (500 copies) and an upsized postcard (23,000 copies), together costing between $5,000 and $7,000 (paid for by the client). Though the silkscreeen effect gives the poster the patina of original art, this process can also be cheaper than a comparable run of offset posters, because the small silkscreen printer does not have to waste time and money gearing up presses for small runs.

Art Director: Michael Vanderbyl

Designer: Michael Vanderbyl

Illustrator: Michael Vanderbyl

Client: American Institute of Architects

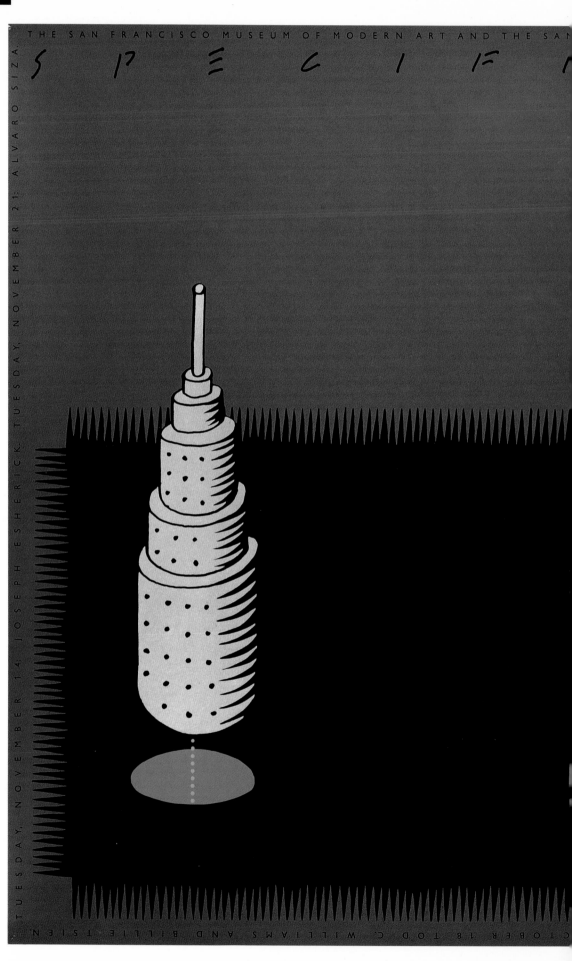

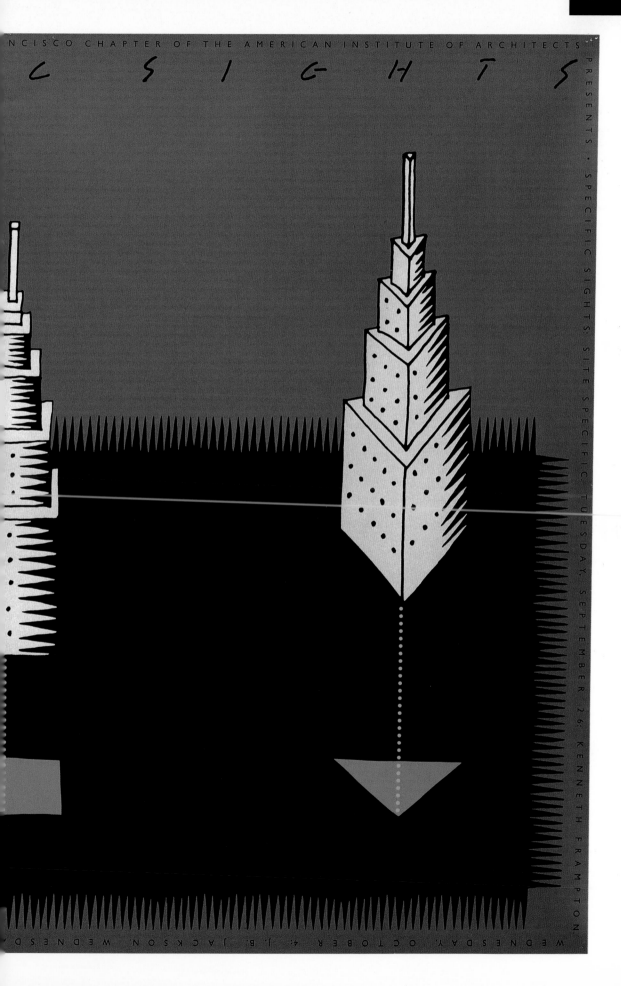

NCISCO CHAPTER OF THE AMERICAN INSTITUTE OF ARCHITECTS

C S I G H T S

PRESENTS · SPECIFIC SIGHTS: SITE SPECIFIC TUESDAY, SEPTEMBER 26: KENNETH FRAMPTON

WEDNESDAY, OCTOBER 4: J.B. JACKSON WEDNESD

Design-Competition
Poster

The Architectural League of
New York sponsors an annual
thematic competition for
young architects who have
been practicing for five years
or less. One such theme was
metaphorically devoted to
"bridges — not the kind one
designs and traverses, but the
emotional and philosophical
links between different aspect
of, for example, professional
and personal life. Michael
Bierut has for a number of
years designed these calls for
entry on a shoestring budget.
For this one, he originally
took the theme literally,
using a "lush engraving" of
an old-time bridge as the
central image. Though beau-
tiful, the image gave the
wrong signal, and Bierut was
compelled to rethink the
design concept. One of the
league's directors told him
about a bizarre old photo-
graph showing a number of
men forming a kind of sus-
pension bridge. Often client-
provided images are dreadful,
but in this case the photo-
graph resolved all the
problems inherent in the
metaphorical theme. The
photograph was statted from
a book, which caused the
halftone dot pattern to
enlarge, giving it a raw qual-
ity. Bierut simplified the
image by painting out
unnecessary back-and fore-
ground elements. Five thou-
sand of the two-color poster
were printed for $1,000. The
type and design were free.

Art Director: Michael Bierut

Designer: Michael Bierut

**Client: Architectural League
of New York**

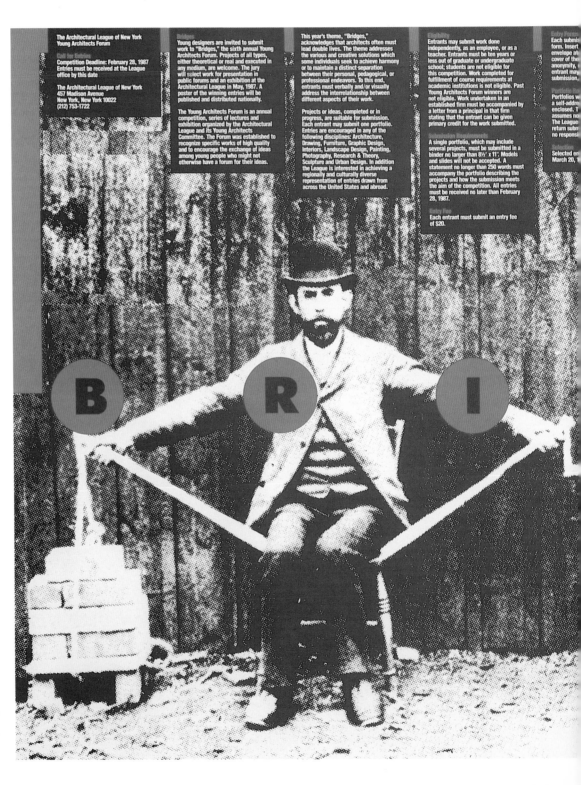

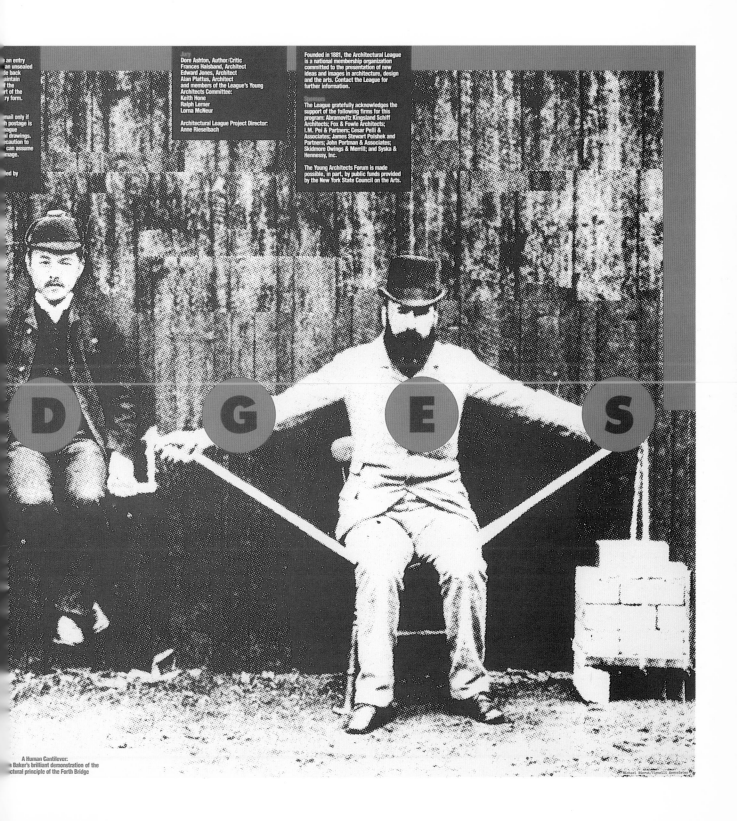

Jury:
Dore Ashton, Author/Critic
Frances Halsband, Architect
Edward Jones, Architect
Alan Plattus, Architect
and members of the League's Young
Architects Committee:
Keith Hone
Ralph Lerner
Lorna McNeur

Architectural League Project Director:
Anne Rieselbach

Founded in 1881, the Architectural League
is a national membership organization
committed to the presentation of new
ideas and images in architecture, design
and the arts. Contact the League for
further information.

The League gratefully acknowledges the
support of the following firms for this
program: Abramovitz Kingsland Schiff
Architects; Fox & Fowle Architects;
I.M. Pei & Partners; Cesar Pelli &
Associates; James Stewart Polshek and
Partners; John Portman & Associates;
Skidmore Owings & Merrill; and Syska &
Hennessy, Inc.

The Young Architects Forum is made
possible, in part, by public funds provided
by the New York State Council on the Arts.

A Human Cantilever:
Baker's brilliant demonstration of the
ctural principle of the Forth Bridge

D G E S

Culture-Week Poster

In 1985 the City of
Pasadena's Cultural Heritage
Commission decided that its
citizens should be made
aware of its architectural
treasures and so announced a
annual Preservation Week.
Wayne Hunt Design, Inc., of
Pasadena was asked to create
a poster called "Preservation,
the People's Choice" to in-
crease public knowledge of
the various events. His first
poster was done in 1985; the
one shown here was done in
1988. The city required fif-
teen hundred posters on the
meager budget of $1,000.
Hunt completely donated the
services of his firm. Three
hundred dollars covered vari-
ous out-of-pocket production
expenses, while $700 went to
the printer, who gave the city
a 20 percent discount. Hunt's
metamorphic face was a
rather simple piece of prese-
parated artwork made from a
combination of screen tints.

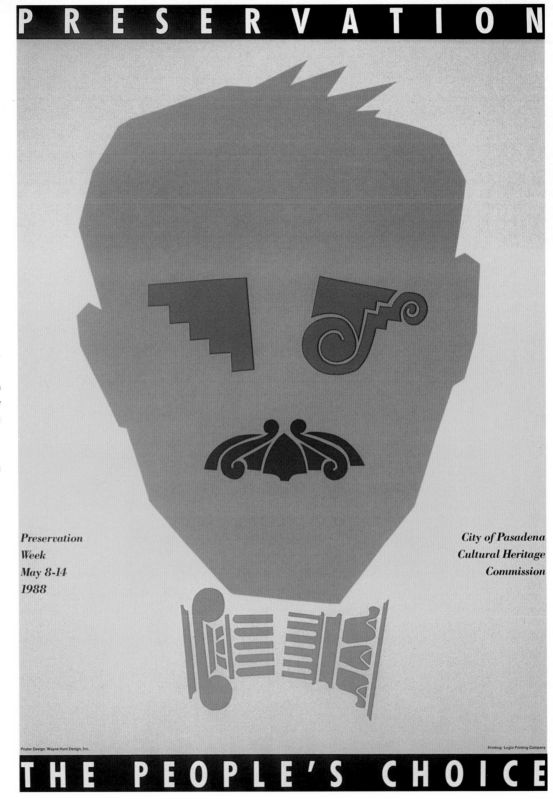

Art Director: Wayne Hunt

Designer: Wayne Hunt

Illustrator: Brian Deputy

Client: City of Pasadena

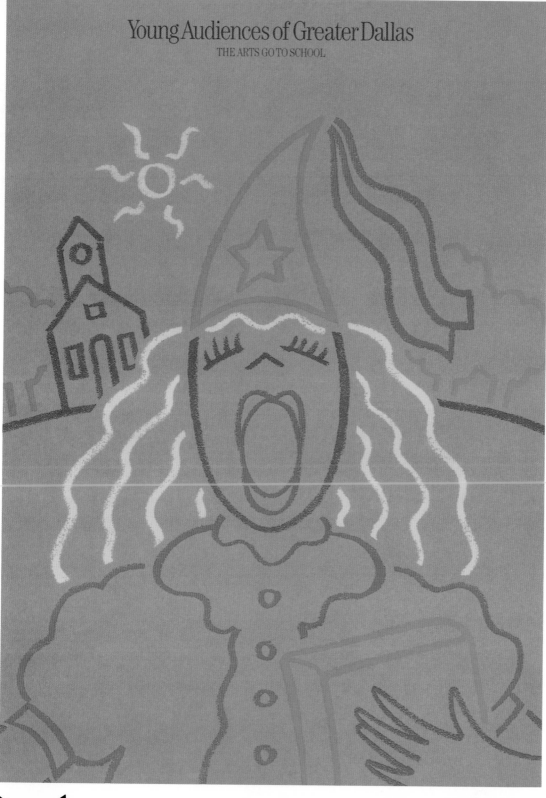

Young Audiences of Greater Dallas
THE ARTS GO TO SCHOOL

Art for Kids Brochure

Young Audiences of Greater Dallas offers workshops and performances for children. This brochure, designed by Peterson and Company, promotes the organization to potential corporate sponsors. The purpose was to give Young Audiences a professional image yet retain its homespun personality. The client had $10,000 to spend, and also requested that Peterson and Company use their "lemon-yellow, process blue, and black," as well as amateur performance snapshots—the biggest hurdle to overcome. Once the client was convinced to use a professional photographer (who offered to shoot for the cost of the film) and the color issue was resolved, Peterson set about cutting other costs. Two paper stocks were deemed necessary (uncoated for text and illustrations, coated for photos) and were obtained at wholesale prices. The typesetter donated services. And the client found a writer, Marsha Coburn, for half her normal fee. Peterson billed $2,000 for design and production (much less than their standard rate) and donated the illustration. Printing and paper together came in around $7,000, half the normal cost for 3,500 copies of a four-color, sixteen-page brochure (with a pocket). Successful fund-raising followed.

Art Director: Scott Ray
Designer: Scott Ray
Illustrators: Bryan Peterson,
Scott Ray
Client: Young Audiences of
Greater Dallas

Circus Poster

The Big Apple Circus is one
of New York's most popular
family entertainments. Ivan
Chermayeff was commission-
ed to produce a friendly image
that could be used on all its
promotion and advertising. A
$10,000 fee was paid for the
artwork in all its versions,
including use on posters, pro-
grams, paper cups, napkins,
T-shirts, and in newspaper
ads. Adaptions for holiday
themes—Thanksgiving,
Christmas, and New Year's
Day—were also included in
this fee, which, given its
usage and effectiveness, was
way below the usual fees
charged by Chermayeff and
Geismar. The juggling ele-
phant motif was so successful
that the circus acquired its
own baby elephant. "The next
year, for their Wild West
theme, I put the elephant on
a baby buffalo," says Cher-
mayeff. "And the circus
bought a baby buffalo! If ever
graphics influenced content,
this is it."

Art Director: Ivan Chermayeff

Designer: Ivan Chermayeff

Illustrator: Ivan Chermayeff

Client: Big Apple Circus

New York's very own circus in a magical all new show with the Nanjing Acrobatic Troupe under the Trump Tent at Lincoln Center Oct. 27–Jan. 2

BIG APPLE CIRCUS

WCBS
NEWS
88
listen to
the official
Big Apple Circus
Radio Station

Crafts Show Poster

To promote a crafts exhibit sponsored by the Hastings Creative Arts Council in New York, one of its board members, Steff Geissbuhler (who is also a partner at Chermayeff and Geismar), volunteered to design, illustrate, and produce an announcement, invitation, and promotional poster. To keep his expenses reasonably low, the main illustration and title were made by hand from black construction paper at the actual size needed. The presentation comp was done as a blue photocopy on yellow stock. The type was specified to fit, and the corrections were knifed in by hand. Color was indicated on a black-and-white mechanical. The flat color printing was arranged and paid for by the client.

Art Director: Steff Geissbuhler

Designer: Steff Geissbuhler

Illustrator: Steff Geissbuhler

Client: Hastings Creative Arts Council

Arts Catalog

The Center for Contemporary Arts in Seattle provides alternative means of presenting art to a constituency who finds the traditional museum too staid or inaccessible, as well as serving as an outlet for artists who are out of the mainstream. Each season it issues an unconventional catalog announcing scheduled exhibits and performance-art events. A thematic structure is developed within which the festivities loosely conform. For the catalog with the thematic concept dubbed "Sold Out" (a reference to artworks that are shown in such commercial centers as shopping malls), Art Chantry made the least-expensive booklet imaginable—one that looked a bit like a shopping center catalog. "The intent was to make it a cross between an art periodical, *Popular Mechanics* magazine, and a mail-order catalog," says Chantry. "In fact, the back pages actually sold ready-made artifacts." Some of the illustrations were snapshots of artworks, but the dominant images were ads swiped from old *Popular Mechanics* magazines, enlarged on a photocopier, then manipulated and combined with donated-type. Printed on a web-offset newspaper press, it was bound with glue (not staples) to give it a tacky feeling. "It was extraordinarily cheap to produce, but even so, I lost money on the deal," admits Chantry. For the entire seasonal job, which included a series of announcement postcards and the catalog, Chantry received $1,200.

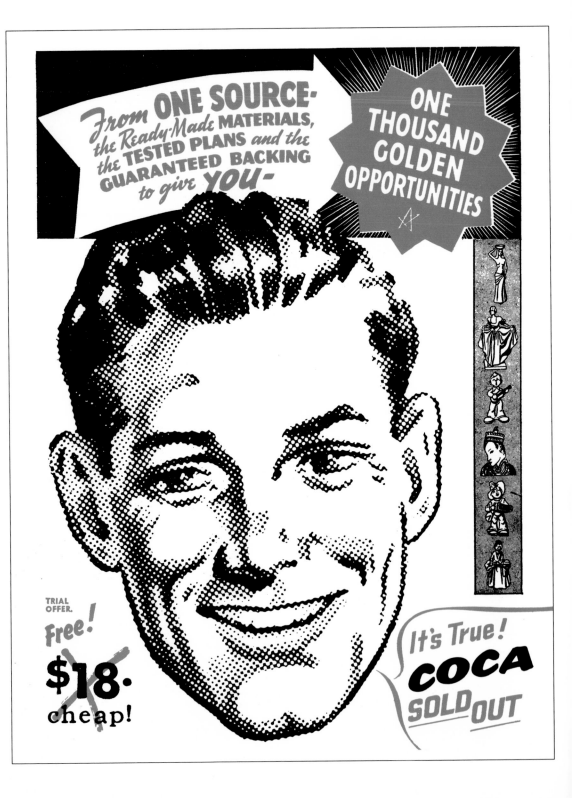

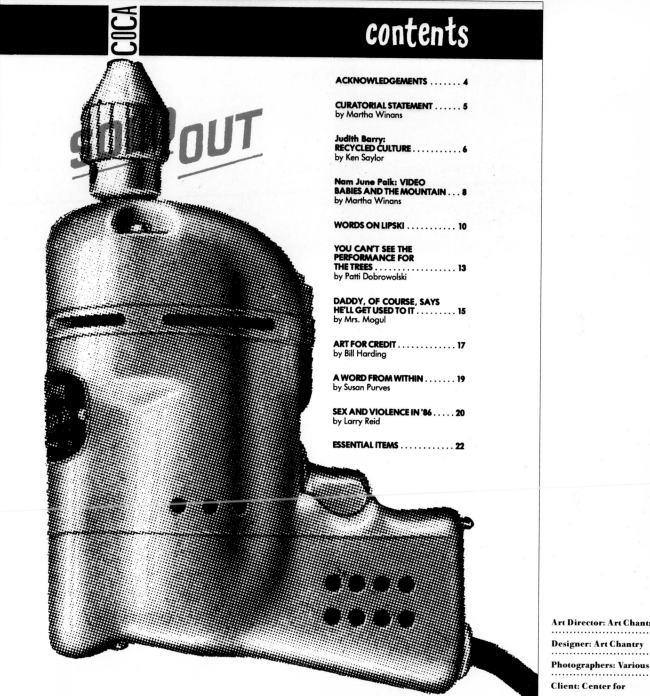

COCA

SOLD OUT

contents

Art Director: Art Chantry
.....................................
Designer: Art Chantry
.....................................
Photographers: Various
.....................................
Client: Center for
Contemporary Arts

COCA CABANA!

YOU CAN'T SEE THE PERFORMANCE FOR THE TREES

How much or how little national coverage has the perfor-
mance scene in this town gotten? Well, as I scanned *High
Performance* magazine, issues one through thirty, I dis-
covered only four small and one large article about the
Seattle area. First, I found a story on a performance series
held at and/or gallery (1981) accompanied by an old snap-

(to showcase works-in-progress) and their Northwest New
Works series, and New City Theater's annual Director's
Festival offers an opportunity for any and all directors to
show work. The performance spaces are receptive, and
there are numerous grant programs offering funding for
works-in-progress as well (Seattle Arts Commission, Wash-

Art News

Real Art Ways (RAW) is a Connecticut-based **organiza**tion that introduces **people** to new and contem**porary art**. The targeted aud**ience are** young people who **do not** regularly attend conventional cultural events. **R**obert Appleton designed **the** RAW schedules and newsletters, unconventionally emphasizing a rough look to appeal to this constituency. "The materials I used lacked sophistication," he says. "I hoped that the finished pieces would create a code." The design was donated, the photography was made available for free, and in addition to paper and printing, RAW paid a small fee for mechanicals. Though Appleton found the computer "hard to manipulate," he used the Macintosh for its immediacy as an imaging system. "I knew [the look of the Mac] would speak to our audience. I also knew by using the Mac we could save costs." The computer allowed him to make otherwise laborious layouts in minutes, thus saving studio and mechanical time and money. In many instances he used rough paper printouts as camera-ready art, thus saving on costly film work. Though he could not get the paper contributed, he was able to hire a printer who worked for small fees (and still made a modicum of profit). The directors of RAW allow Appleton the freedom to develop design ideas, "never halting me, always letting me take the next step, letting me design without preconceived ideas of what a good program should be. And I have used this freedom to extend my vocabulary — experimenting

Produced by Real Art Ways

THE ORNETTE COLEMAN FESTIVAL

June 30–July 6, 1985, Hartford, Connecticut /June 30, Ornette Coleman and Prime Time, Bushnell Park, 2pm /July 2, Ornette: Made in America, Cinestudio, Trinity College, 8pm
July 3, Chamber Music of Ornette Coleman, Real Art Ways, 8:30pm /July 6, Ed Blackwell/Don Cherry Duo, Center Church, 2pm. James 'Blood' Ulmer Quartet, Center Church, 8:30pm

Thanks to United Technologies for this poster

with transparency, for ex-
ample — learning to design
through and around the paper
surface, thinking of the two
dimensional as sculptural,
considering its total depth as
well as its height and width."

Art Director: Robert Appleton
.....................................
Designer: Robert Appleton
.....................................
Client: Real Art Ways

Repertory Theater
Funding Brochure

The Dallas Repertory Theater had for years been faithfully supported by senior citizens. Realizing that this was a diminishing base, its directors decided also to appeal to a younger audience. Without a budget, the theater approached Peterson and Company of Dallas to "frugally" conceive and design a fund-raising brochure. "We developed the theme called 'Keep Us In the Spotlight,'" says Bryan Peterson, "and had a writer develop a text." It was an effective fund-raising slogan that also worked in concert with the design, because a spotlight became the primary visual element. To save money on illustration, existing performance photographs were reproduced on a photocopier and then made into collages. The letterhead is a spinoff of the brochure. Mary Kay Cosmetics contributed the cost of printing. Peterson and Company donated the design and production, billing only for stats and photocopies ($100). The Curtis Tuscan Terra paper stock was sold to them wholesale ($650) because suppliers often want to have their names attached to worthy public-service projects. The result was an improved image that successfully attracted the additional audience.

Art Director: Scott Ray

Designer: Scott Ray

Illustrator: Scott Ray

Photographer: Keith Nichols

Client: Dallas Repertory
Theater

THE BENEFITS OF A GOOD REP

The Dallas Repertory Theatre occupies a unique position in the world of local artistic entertainment: > The Theatre itself is designed to create a feeling of intimate participation between actor and audience. It is located in North-Park with unlimited free parking that is well-lighted, actively patrolled. Safe. A variety of restaurants and fabulous shopping are close at hand. > DRT takes great pride in its role as a "home town" professional theatre. Most of all of the talent is local. Our agreement with Actors' Equity Association permits us to use a mixture of Equity and non-Equity players, thus providing a showcase for the many aspiring talents available in Dallas. We work closely with local colleges, giving their students a chance to work and learn in this inspiring atmosphere. > DRT acts as a library for classic, ever-popular productions. Here you can find the musicals and plays that will live forever. Great books can be reread – great theatre must be experienced. DRT provides that experience combined with a fresh and original approach.

Theater Poster

Seattle is a big poster town because of the numerous public spaces available on which to post bills and the variety of legitimate and alternative theater companies requiring such advertising. Art Chantry is one of Seattle's foremost cut-rate poster designers, a master of graphic trickery and conceptual magic. For the Empty Space Theater's production of Moliere's classic satire *Tartuffe*, he designed a contemporary icon with political overtones. The artwork was taken from both old and relatively new photographs, photocopied and collaged together. The lettering was blown up from his initial rough sketch. The poster is printed in two colors on remnant paper stock found in the printer's shop, which accounts for the relative low cost of $300 for three hundred copies. The third color on the face of televangelist Jerry Falwell is actually printed with a rubber stamp that Chantry had made for $15, and it was applied to each poster by hand, thanks to a group of enthusiastic volunteers. Chantry admits that most ticket sales in Seattle are the result of direct-mail campaigns, with posters accounting for only 5 percent of sales. This one, however, drew 35 percent of the audience.

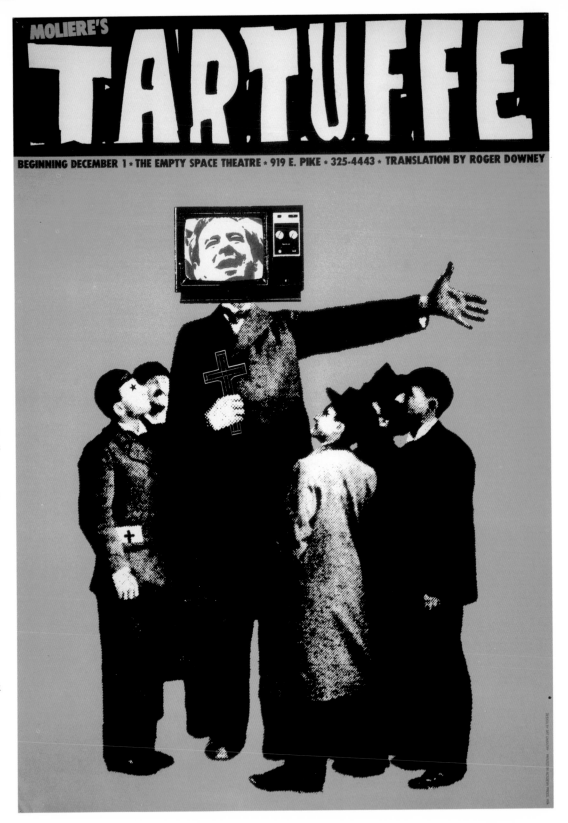

Art Director: Art Chantry

Designer: Art Chantry

Client: Empty Space Theater

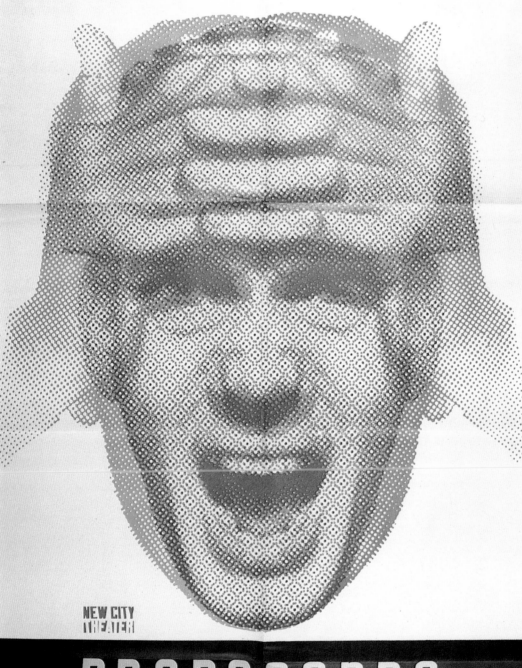

POSTER DESIGN BY ART CHANTRY

Theater Poster

The New City Theater Company is Seattle's most avant-garde independent theater group, and its production of *Propaganda* was a bold experiment. Although the play opened to lukewarm reviews and closed soon afterward, the poster designed by Art Chantry leaves an indelible image. For this decidedly low-budget job, Chantry mustered all his extensive printing knowledge. He knew that the cheapest way to print was on a web-offset newspaper press, because it is geared for high-speed printing on inexpensive paper. He also learned that the cost of film negatives were included in the overall printing fee, and therefore, he designed and produced the original artwork on a smaller scale than the finish, allowing the printer to enlarge it five times, thus avoiding costly film charges from an outside supplier. The face is from a 1950s clip-art book (collections of copyright-free advertising and editorial art available at any artbook store). It was enlarged and then printed twice, slightly off-register, to give a sense of three dimensions. The theater needed only three hundred posters, but since the minimum run on a web press is three thousand copies, Chantry had the surplus folded and used as a promotional piece.

Art Director: Art Chantry

Designer: Art Chantry

Client: New City Theater Company

Theater Poster

In Chicago, postering is not as effective a means of advertising as are newspapers and television, but posters are nevertheless used to reinforce advertising campaigns, especially for cultural events. Therefore, minimum funds were available when the Organic Theater Company of Chicago asked Art Chantry of Seattle to design the announcement for *Little Caesar*. Chantry, who is known for his effective low-budget communications, cut corners at every turn. Helvetica was used because it is available from any inexpensive typeshop, and if type changes were necessary, they could thus be done easily. The headline was "lifted" from an old type book, photocopied, and touched up. Chantry was given a prehalftoned postcard of Edward G. Robinson, which he enlarged in two stages — one for the black plate and a slightly larger version that printed over the black in a second color. Chantry's only production extravagance, it would seem, are the bullet holes that cut through the poster; but rather than a costly dyecut, he had the printer make them quickly and cheaply with a printing drill. The total printing budget: $300. The total fee: $175.

Art Director: Art Chantry

Designer: Art Chantry

Client: Organic Theater Company

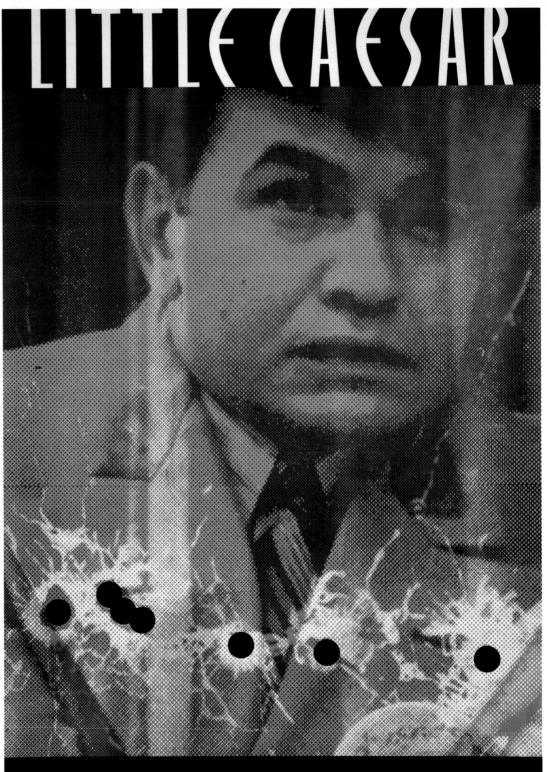

THE CLASSIC GANGSTER TALE
Opens June 20th
at the
Organic Theater Company
3319 N. Clark St., Chicago
Tickets: 327 5588

Novel by W.R. Burnett
Adapted by Michael Miner & Thomas Riccio
Directed by Thomas Riccio
Music Composed by Charles Wilding-White
Set Design by Greg Mowery
Light Design by James Card
Costume Design by Malgorzata Komorowksa
Prop Design by Brendon deVallance
Multimedia by Mark McKernin
Poster design by Art Chantry (Seattle)

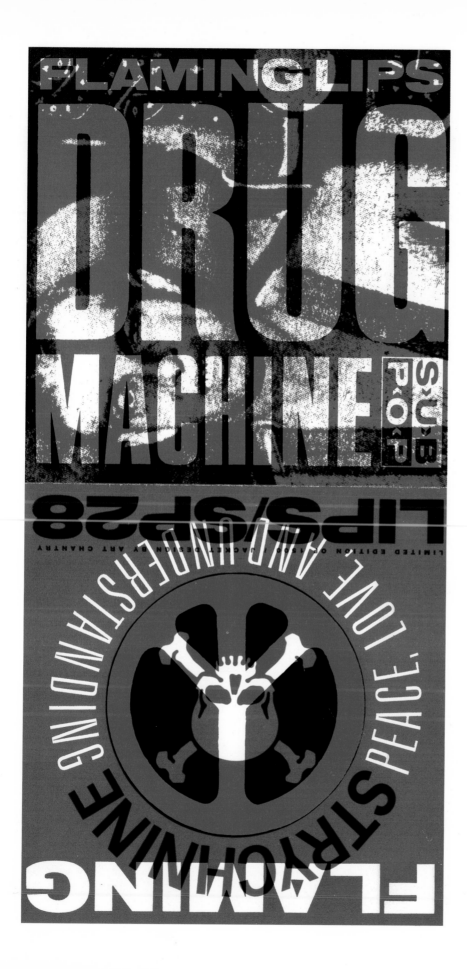

Record Sleeves

Small, independent record companies often find that, although they can afford to print cover art, fabricating record sleeves for small pressings is cost-prohibitive. Loose Lips, a Seattle-based "sub-pop" record label usually packages its 45 rpms in ersatz covers — printed paper covers are sandwiched inside a plastic bag. To save money, at least two different covers are also printed simultaneously on the same sheet of paper and then trimmed by the printer (included in the printing cost). Design is an important selling tool, but fees are profoundly limited. Art Chantry was given $400 in total for the design of Stryohnine and Drug Machine with the mandate to "max it out as much as possible." For both, he made his own illustration from printed scraps and photos he'd found in books and on his desk. Drop-outs (type, for example, printed in white out of a black or colored image) give the impression that more graphic wizardry is taking place than actually is. The colors red and green were selected because when mixed they make a dark brown, which can be used to approximate a black and thus give the effect of more than three colors.

Art Director: Art Chantry

Designer: Art Chantry

Client: Flaming Lips Records

Symphony Program
...................................

"There is junk mail and then there is sexy junk mail," says Michael Cronan, whose San Francisco design firm had been working on the San Francisco Symphony's graphics for almost a decade. "I believe that if I can make a graphic piece exciting enough it becomes a kind of gift to the recipient to hold this thing for only five seconds longer, then I'm really successful." "The Summer Nights Delights" announcements for 1988-89 are, if one is to judge based on its sold-out performances, success stories. But for all their achievement, the symphony has huge operating expenses and must do its promotion on what amounts to a shoestring. For these full-color brochures Cronan was given $6,500 for design, type, illustration, mechanicals, and "handholding." The printing was $18,000 for 150,000 copies — admittedly a ridiculously low price for such a production. Cronan believes that "cultural people are willing to accept an interpretative, rather than literal, piece." He therefore, created rather abstract design motifs playing with summer images and colors, using mostly free or pick-up art. The art was so spontaneous that he could do the finishes in record time (and not incur much studio expense). Since he couldn't afford complicated stripping in the narrow time frame in which this had to be finished (programs were never decided upon until the last minute), Cronan ganged his four-color separations together. "The photos were not God's gift to western civiliza-

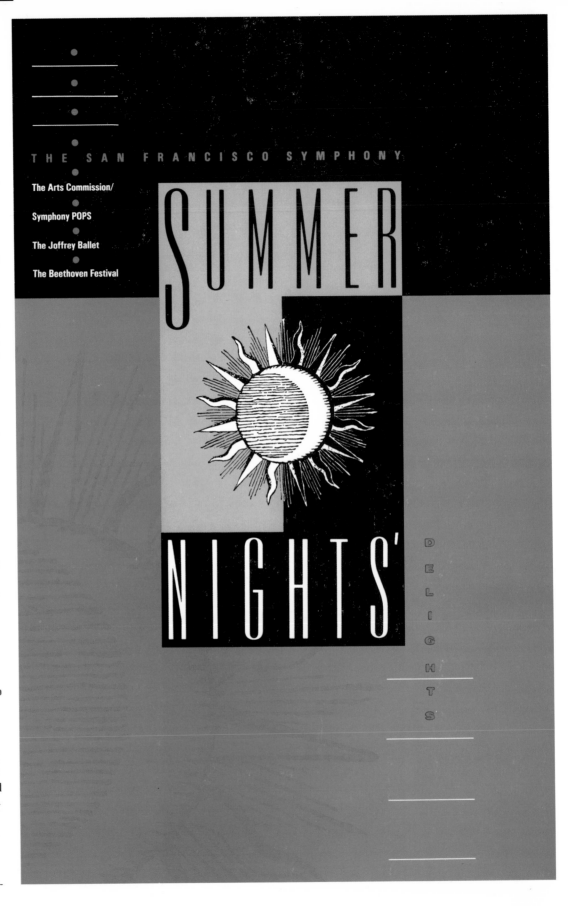

THE SAN FRANCISCO SYMPHONY

The Arts Commission/

Symphony POPS

The Joffrey Ballet

The Beethoven Festival

A Nijinsky Tribute

"Nobody can afford to miss this extraordinary experience." —San Francisco Examiner

LE SACRE DU PRINTEMPS

Nijinsky/Stravinsky

"By all accounts, there was a riot on the evening of May 29, 1913, at the Theatre des Champs-Elysees. *Le tout-Paris* had come to the first performance of a new ballet by the adored Ballets Russes of Serge Diaghilev. With decor by the Russian painter Nicholas Roerich, a score by that bright, young Igor Stravinsky, and choreography by everyone's favorite male dancer, Vaslav Nijinsky, how could *Le Sacre du printemps* fail to be exciting?"—The Village Voice

The 1913 premiere was the most scandalous in ballet history. Its revival is the most important dance event of the year.

PETROUCHKA

Fokine/Stravinsky

As a dancer, Nijinsky immortalized the title role of a puppet yearning for human love and freedom. With its colorful carnival masqueraders and mysterious Old Showman, *Petrouchka* has been a world favorite since its premiere in 1911.

L'APRES-MIDI D'UN FAUNE

Nijinsky/Debussy

Léon Bakst's brilliant decor and costumes are still breathtaking. Nijinsky's legendary first ballet is still erotically beautiful.

Thurs July 14 8:00pm
Fri July 15 8:00pm
Sat July 16 2:00pm
Sat July 16 8:00pm
Sun July 17 2:00pm

LE SACRE REDISCOVERED
Free Pre-Performance Lectures

Millicent Hodson, dance scholar, and **Kenneth Archer**, art historian, are the amazing magician-detectives responsible for *Le Sacre's* rebirth. Prior to each performance, they'll tell the story of how this ballet was given a second life. Join them from 7:00-7:40pm each evening and 1:00-1:40pm prior to matinee performances.

tion, so an exact separation was unnecessary," he says. Incidently, ganging color work does not usually insure high quality, but generally it brings the cost down. Though the project is bearly profitable (until recently Cronan was losing money with each project), he does reach a quarter million people.

The San Francisco Symphony Beethoven Festival

Herbert Blomstedt, Music Director

Davies Symphony Hall

Herbst Theatre

Flint Center

June 13-July 2

FESTIVAL

"Herbert Blomstedt restored the faith ...not in Beethoven...but in ourselves through Beethoven..."—San Francisco Chronicle

Herbert Blomstedt is acknowledged around the world as a master in the interpretation of Beethoven. This summer, San Francisco has the opportunity to hear the Maestro lead his orchestra in some of the composer's greatest music. Soviet emigrant pianist Vladimir Feltsman, who made his U.S. debut at the White House this past fall, joins the Orchestra in the Fourth Piano Concerto. The Guarneri Quartet, consistently hailed as the world's premiere chamber ensemble, performs Beethoven's string quartets.

This is your chance to share in a celebration of the diversity and depth of Beethoven's art. The San Francisco Symphony's 1988 Beethoven Festival.

Mon June 13 8:30pm
Herbst Theatre
Guarneri Quartet

Beethoven/Quartet in D major, Op. 18, No. 3
Beethoven/Quartet in B-flat major, Op. 18, No. 6
Beethoven/Quartet in A minor, Op. 132

Wed June 15 8:30pm
Herbst Theatre
Guarneri Quartet

Beethoven/Quartet in F major, Op. 18, No. 1
Beethoven/Quartet in F major, Opus 135
Beethoven/Quartet in C major, Op. 59, No. 3

Wed June 22 8:00pm
Flint Center, Cupertino†
Fri June 24 8:30pm
Davies Symphony Hall
Herbert Blomstedt, conductor
Vladimir Feltsman, piano

Beethoven/Piano Concerto No. 4
Beethoven/Symphony No. 3, *Eroica*

†Charge by Phone (408) 246-1160

Sat June 25 8:30pm*
Davies Symphony Hall
Herbert Blomstedt, conductor
Raymond Kobler, violin

Beethoven/Violin Concerto
Beethoven/Symphony No. 5

*Limited Availability

All programs subject to change.

Thur June 30 8:30pm
Davies Symphony Hall
Herbert Blomstedt, conductor
Elizabeth Knighton, soprano
D'Anna Fortunato, mezzo-soprano
Kenneth Riegel, tenor
John Cheek, bass-baritone
San Francisco Symphony Chorus
Vance George, director

Beethoven/Symphony No. 9

Wed June 22 10:00am
Free Open Rehearsal
Davies Symphony Hall
Herbert Blomstedt, conductor

Tickets are limited and must be obtained in advance at the Symphony Box Office. Limit two per person.

MORE SUMMER NIGHTS'
DELIGHTS

Mon July 4 8:00pm
The Symphony at Shoreline
American POPS Concert &
Fireworks
Shoreline Amphitheatre
Andrew Massey, conductor

Tickets: Reserved $19.50/$16.50,
Lawn $12.50
Shoreline Phonecharger (415) 967-4040
or BASS: (415) 762-BASS,
(408) 998-BASS

Sun July 24 2:00pm
Free Concert
Stern Grove
Andrew Massey, conductor

All-Tchaikovsky Program

Sponsored by BankAmerica Foundation

Art Director: Michael Cronan

Designers: Michael Cronan,
Irene Morris

Illustrator: Michael Cronan

Client: San Francisco
Symphony

SAN FRANCISCO SYMPHONY

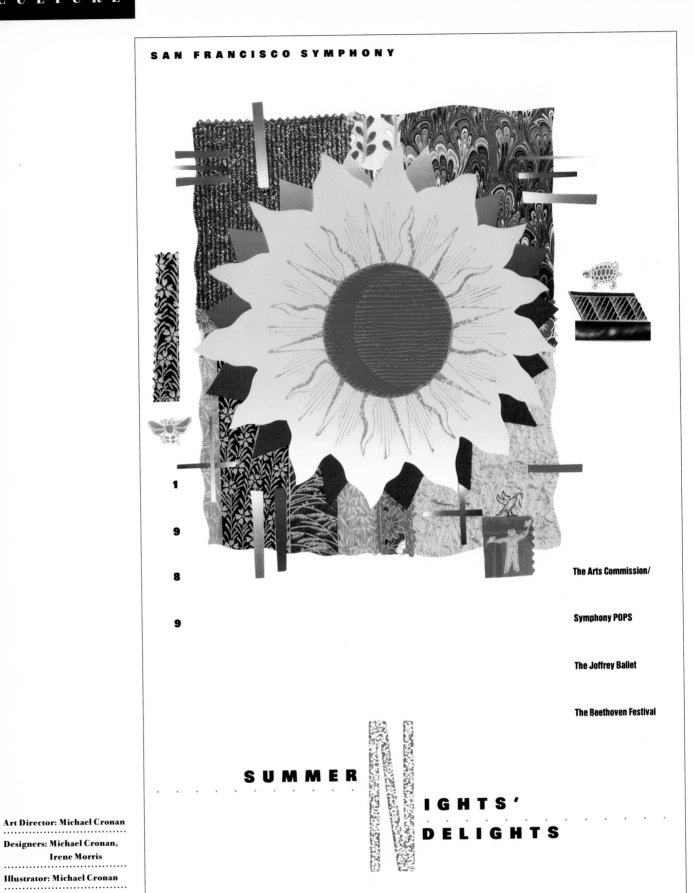

1
9
8
9

The Arts Commission/

Symphony POPS

The Joffrey Ballet

The Beethoven Festival

SUMMER NIGHTS' DELIGHTS

Art Director: Michael Cronan

Designers: Michael Cronan,
Irene Morris

Illustrator: Michael Cronan

Client: San Francisco
Symphony

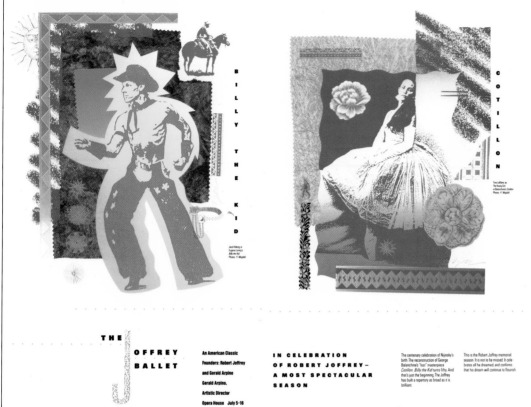

B I L L Y T H E K I D

Jewel Walking in
Eugene Loring's
Billy the Kid
Photo: © Migdoll

C O T I L L O N

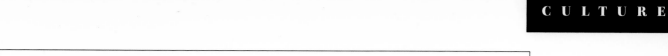

Tina LeBlanc as
The Young Girl
in Balanchine's *Cotillon*
Photo: © Migdoll

THE JOFFREY BALLET

An American Classic

Founders: Robert Joffrey
and Gerald Arpino

Gerald Arpino,
Artistic Director

Opera House July 5-16

IN CELEBRATION OF ROBERT JOFFREY – A MOST SPECTACULAR SEASON

The centenary celebration of Nijinsky's birth. The reconstruction of George Balanchine's "lost" masterpiece *Cotillon*. *Billy the Kid* turns fifty. And that's just the beginning. The Joffrey has built a repertory as broad as it is brilliant.

This is the Robert Joffrey memorial season. It is not to be missed. It celebrates all he dreamed, and confirms that his dream will continue to flourish.

Nijinsky's *Le Sacre du printemps*

"Nobody can afford to miss this experience."

San Francisco Examiner

The phenomenal dance experience returns!

A NIJINSKY TRIBUTE

Petrouchka
Fokine/Stravinsky

As a dancer, Nijinsky immortalized the title role of a puppet yearning for human love and freedom. With its colorful carnival masqueraders and mysterious Old Showman, *Petrouchka* has been a world favorite since its premiere in 1911.

L'Après-midi d'un faune
Nijinsky/Debussy

Léon Bakst's brilliant decor and costumes are still breathtaking. Nijinsky's legendary first ballet is still erotically beautiful.

Le Sacre du printemps
Nijinsky/Stravinsky

"By all accounts, there was a riot on the evening of May 29, 1913, at the Theatre des Champs-Elysees. *Le tout-Paris* had come to the first performance of a new ballet by the adored Ballets Russes of Serge Diaghilev. With decor by the Russian painter Nicholas Roerich, a score by that bright young Igor Stravinsky, and choreography by everyone's favorite male dancer, Vaslav Nijinsky, how could *Le Sacre du printemps* fail to be exciting?"
The Village Voice

CELEBRATE THE JOFFREY BALLET SEASON

Wed July 5 8:00pm
Cotillon Program I
Cotillon*/Love Songs/Viva Vivaldi**

Thur July 6 8:00pm
All-American Choreographers Program
Cloven Kingdom**/Sea Shadow*/L'Air d'Esprit**/Suite Saint-Saëns

Fri July 7 8:00pm
Sat July 8 2:00pm+
Sun July 9 8:00pm
Billy the Kid Program
Billy the Kid*/Monotones II**/Touch Me*/Suite Saint-Saëns

Sat July 8 8:00pm
Cotillon Program II
Cotillon*/Untitled**/Remembrances Pas de Deux**/Viva Vivaldi**

Sun July 9 2:00pm
Cotillon Program III
Cotillon*/Untitled**/Remembrances Pas de Deux**/Light Rain

Thur July 13 8:00pm
Fri July 14 8:00pm
Sat July 15 2:00pm+
Sat July 15 8:00pm
Sun July 16 2:00pm
A Nijinsky Tribute
Petrouchka/L'Après-midi d'un faune/Le Sacre du printemps

THE JOFFREY BALLET SUMMER SERIES
Subscribe to The Joffrey and see *Le Sacre* free!

We're making the Joffrey extra-affordable with this special series offering three incredibly exciting programs for the price of two!

Cotillon Program I
Cotillon*/Love Songs/Viva Vivaldi**
Wed July 5 8:00pm

Billy the Kid Program
Billy the Kid*/Monotones II**/Touch Me*/Suite Saint-Saëns
Sun July 9 8:00pm

A Nijinsky Tribute
Petrouchka/L'Après-midi d'un faune/Le Sacre du printemps
Sun July 16 2:00pm

L'Air d'Esprit
Arpino/Adam
A pas de deux in loving tribute to the lightness and purity of classical technique of the great prima ballerina Olga Spessivtseva, who was known especially for her portrayal of Giselle.

L'Après-midi d'un faune
Nijinsky/Debussy
Léon Bakst's brilliant decor and costumes are still breathtaking. Nijinsky's legendary first ballet is still erotically beautiful.

Billy the Kid
Loring/Copland
"...a Robin Hood with no mercy, a Richard the Lion-Hearted who feasted on blood ...the master criminal of the American southwest." In his twenty-one years, Billy had killed twenty-one men. And when he died in 1881, a legend had been launched, like a rocket. Eugene Loring and Aaron Copland (his first major ballet score) joined forces in 1938 with Lincoln Kirstein (libretto) and Jared French (costumes and decor) to produce this classic American frontier story.

Cloven Kingdom
Taylor/Corelli & Cowell & Miller, art. by McDowell
Paul Taylor's witty look at how our social foibles bring out the beast in us.

Cotillon*
Balanchine/Chabrier
With sets and costumes by the French painter Christine Bérard, *Cotillon* is a ballet of "perfumes and whispers" that evokes the aura of French social decadence of the 1920s and '30s. The choreography is technically brilliant, with a thread of the macabre that underlies the gaiety—it displays qualities which later became Balanchine trademarks. The reconstruction is created by dance and art historians Millicent Hodson and Kenneth Archer, fresh from their success with the company in recreating Nijinsky's "lost" *Le Sacre du printemps*. Like *Sacre* in 1988, *Cotillon* promises to be one of the major dance events of 1989.

Sea Shadow*
Arpino/Ravel
This lyric work is "one of the most beautiful duets in all ballet." Created by Gerald Arpino in the 1960s, *Sea Shadow* is a pas de deux inspired by the romantic Ondine fable.

Light Rain
Arpino/Adams & Gauthier
"*Light Rain* is a design in gleaming movement, beginning and ending on a shimmering cluster of a dozen dancers." – *San Francisco Chronicle*

Love Songs
Forsythe/Songs sung by Aretha Franklin & Dionne Warwick
Forsythe's riveting work about lovers—the forces that pull them apart and hold them together—is one of tremendous sensual power.

Monotones II*
Ashton/Satie
"As perfect a 12 minutes of dance as exists," said one critic of Ashton's magical pas de trois danced to Erik Satie's mysterious *Trois Gymnopédies*.

Petrouchka
Fokine/Stravinsky
A burlesque ballet in one act, *Petrouchka* has been called the most perfect of all the ballets created for Diaghilev.

Remembrances Pas de Deux*
Joffrey/Wagner
With this excerpt from Joffrey's beautiful work, danced to a song from Wagner's "Wesendonck Lieder," Gerald Arpino and the Company wish to pay homage to the Joffrey's late and much loved Founder, Robert Joffrey.

Le Sacre du printemps
Nijinsky/Stravinsky
Long considered a "lost" masterpiece, Nijinsky's *Rite of Spring* has been painstakingly reconstructed in both its startling choreography and brilliant Nicholas Roerich designs through the efforts of Millicent Hodson and Kenneth Archer and under the artistic supervision of Robert Joffrey. No one else in the arts can afford to miss *Le Sacre*.

Suite Saint-Saëns
Arpino/Saint-Saëns
Arpino's "signature work" for The Joffrey captures the youthful zest of the company with its deft combination of classicism and contemporary flair.

Touch Me*
Arpino/Rev. J. Cleveland
A virtuoso tour de force for solo dancer is created from the richly inspired rendition of the gospel in the song of the same name by Rev. James Cleveland, as performed by Cleveland and the Charles Fold Singers.

Untitled*
Pilobolus/Dennis
Untitled was the first dance from the Pilobolus repertoire to be added to the works of The Joffrey Ballet. For two Victorian ladies and the four men with whom they cavort, the dance is a dreamlike, mysterious excursion into rituals of courting, mating, and birthing.

Viva Vivaldi*
Arpino/Vivaldi
At times romantic, soulful and pyro-technical, this Arpino classic, created in the '60s, returns to challenge a bright new cast of Joffrey dancers of the '80s.

Opening Night Celebration Party!
Prime theater seating and post-performance party with Gerald Arpino and The Joffrey dancers. Sponsored by the San Francisco Friends Of The Joffrey. For information please call (415) 864-8478.

All programs subject to change.

The Joffrey Ballet's 1989 National Tour is sponsored by Philip Morris Companies Inc.

Additional support for this engagement has been provided by the National Endowment for the Arts and the California Arts Council.

*Joffrey San Francisco premiere
**Revival
+The presentation of this performance is made possible by Merrill Lynch.

Symphony News

..............................

For the premiere issue of *Symphony*, the seasonal newsletter of the San Francisco Symphony, Michael Cronan exacted a promise: "That I would be the ad-hoc editor, selecting, rejecting, and suggesting stories." While the symphony has some very knowledgeable and talented writers on its staff, they are also a bit too insulated by their special world. If the newsletter was going to fulfill its goal of "creating a wider awareness of and greater loyalty to the symphony in the minds of subscribers and patrons," then the product had to be accessible and enjoyable. Since the budget was tight, Cronan's proposal was accepted. The decision to use a tabloid format was both budgetary and design-driven. A tabloid is usually run on a web-offset newspaper press that is geared for high-speed printing on inexpensive paper. Page formatting and makeup were simplified for the MacIntosh, using programs such as Page-Maker, Quark Express, Adobe Illustrator, and Studio 8 (a paint program that allows for interesting visual effects). Pages were output on a Lino-tronic machine (a high-speed and high-quality typesetting device for digital composition) and pasted down on mechanical boards. Interns who worked on the newsletter earned $5 an hour, a savings when compared to full-time studio designers, who earn considerably more. For illustration, Cronan made collages using public-domain art and photos supplies by the client. Much of the art and type were scanned into

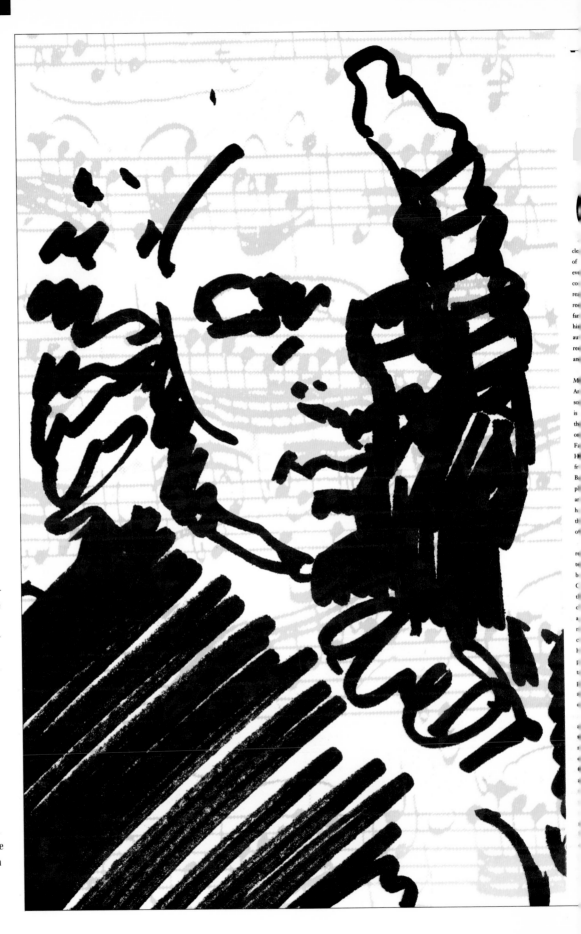

the computer and reproduced using the Linotronic. A fee of $20,000 per issue covers everything, leaving $7,000 for design, type, and mechanicals. Thirty thousand copies are printed (issue no. 1 was twenty pages and issue no. 2 was twenty-four pages). Cronan says that he failed to make any money on these first two issues, but for the third there's light at the end of the tunnel—a projected earning of $1,000.

SAN FRANCISCO SYMPHONY

e was stubborn, he had a temper, he had the reputation of being a hard person to get along with. His pupils, and most likely his children, may have feared this stern figure. He was a religious man, a practicing Lutheran whose library contained an extraordinarily (for the day) large number of ec-
He seems to have been obsessed with the idea
about it far more than his contemporaries
when Heaven and Hell were not abstract
truth He once said that the aim and final
ld be none else but the glory of God and the
nd." That he had a strong sexual drive, his
d twenty children, of whom nine survived
s the reproof handed him by the Arnstadt
Thereupon ask him further by what right he
range maiden to be invited into the organ loft
ic there"
n] Bach was born in Eisenach, Germany, on
youngest of the eight children of Johann
was the son of Christoph Bach, who was the
, and so back to Veit Bach, whose birth date
died in 1619. Johann Sebastian, who like all
pride in the accomplishments of the family,
logy named "Origin of the Musical Bach
t back to Veit, "a white bread baker in
e sixteenth century was compelled to escape
e of his Lutheran faith." In this genealogy,
g picture of old Veit, who "found his greatest
ern which he took with him even into the mill
grinding was going on. (How pretty it must
er! Yet in this way he had a chance to have
him.) And this was, as it were, the beginning
n in his descendants...."
a's father, Johann Ambrosius, was a highly
ist in Eisenach. He died when Sebastian was
lied the preceding year). Sebastian and his
taken in by their older brother Johann
ganist at Ohrdruf. Not much is known about
n spent there. He must have been a gifted
would call a senior in the local school at the
t that time the average age of seniors was
o was a good organist and clavier player (the
term for keyboard stringed instruments:
rd, spinet), a singer, a good violinist,
composer. But we are not discussing any
n. We are discussing Johann Sebastian Bach,
ndously gifted figure in the history of music,
more we would like to know about his
ain external events of his life. We know that
vent to Saint Michael's school in Lüneburg;
g; that already he was a contentious young
eries of positions in the service of the court
t, Mühlhausen, the ducal court of Anhalt-
on, which he held for twenty-seven years,
aint Thomas's Church in Leipzig. We know
ected in his day, though more as an organ
cian than as a composer. Bach, who carried
to its peak, lived during a time when radical
ermining the edifice that to a large extent
phony. Indeed, Bach lived to find himself
oned composer, a pedant, whose music was
f the lighter, homophonic, melodic music
elegant, graceful, rather superficial music
n Christian, so popular in London.

BACH SANS HALO
by Harold C. Schonberg

The chances are that this did not bother Bach very much. He lived before the romantic notion of art for art's sake, of music composed for eternity. Bach was as practical and as level-headed a composer as ever lived. Like all composers of the day, he regarded himself as a working professional, one who ordinarily wrote to fill a specific need — a cantata for Sunday, an organ piece to demonstrate a particular instrument. He did publish certain pieces of which he was especially proud, but by and large he fully expected the bulk of his music to disappear after his death. When he became cantor in Leipzig, he disposed of all his predecessor's music, and he knew that his successor would just as summarily get rid of whatever Bach manuscripts were around. It was a cantor's job to present music that *he* had composed, not the music of another man.

Of course, he knew his worth. He must have known from the beginning, and if there was anything that drove him out of his mind it was slovenly musicianship, or musicianship of a kind that did not meet his own standards.... His whole life is dotted with episodes that attest to his determination to make music on his own level. As early as 1705, in Arnstadt, he got involved in an argument with a student named Geyersbach. The upshot was that Bach drew his

dagger and went for Geyersbach; and, in a trice, the f
composer of the *Saint Matthew Passion* was rolling on the gro
attempting mayhem on his opponent. On examination it turne
that Bach had once disdainfully called his colleague a *Zippelfag*
— a bassoonist who produced sounds like those of a nanny-
Bach was reproved, especially as he "already had the reputatio
not getting along with the students...."

Bach was not a man to be pushed around, and he carrie
attitude into his music-making. How he chafed at the medio
with which he was surrounded! This complete musician,
incomparable executant, this composer whose vision embrace
then-known musical universe, this titan had to work in Leipzig
wretched students and with personnel far below the streng
needed and wanted....

Bach did his best with the raw material. He could prob
play most of the instruments of the orchestra, and he took his f
in charge much as a modern conductor does. Generall
conducted from the violin or the harpsichord. Very little scho
work has been done in the early history of conducting, an
general assumption is that not until the nineteenth century
leader actually beat time. Yet there is plenty of evidence from
own day that the person in charge of an ensemble most defi
did beat time....

Exactly how he conducted, we do not know. What wer
tempos? Ideas about rhythm? Expressive devices? Today ma
the fine points of Bach performance practice have been lost
can only speculate about things like pitch, instruments, ornam
embellishments, balances, even the rhythms and tempos. Tak
subject of pitch. Scholars have determined that it was often as
as a full tone lower in Bach's day than it is in ours. But ther
also organs of Bach's day, still in operation, in which the pit
higher. How Bach himself tuned his instruments we do not k
As for embellishments, books have been written on the subje
written-out embellishments in Bach's music, and other
authorities disagree. Which is not surprising, for authoriti
Bach's own day disagreed. In addition there seem to have been
conventions that were not written out, such as holding notes
longer length of time than they were actually written. At bes
conscientious musician can, after much specialized study, make an informed guess....

Bach... was... learned in all music. He certainly was one of the most cultured musicians of his day, with a tremendous knowledge of what was happening in the European scene. He had

a sheer lust to know and to assimilate all of the music then available, ancient and contemporary. It was not that he was a scholar, interested in musical history. There is no evidence that he made any great effort to unearth medieval music, for instance. That probably would not have interested him. What did interest him, overwhelmingly and even compulsively, was technique. How did composers put things together? What was the quality of their ideas? In matters like these, Bach seems to have had insatiable professional curiosity. Was it because, consciously or unconsciously, he wanted to measure himself against other composers? He went to hear new music, wherever it was possible for him to attend, and was constantly reading what he was not able to hear in

Bach on the Podium

From all eyewitness accounts, Bach at the head of an orchestra was a dominating figure. He was a brilliant score reader. "His hearing was so fine that he was able to detect the slightest error even in the large ensembles." While conducting, he would sing, play his own part, keep the rhythm steady, and cue everybody in, "the one with a nod, another by tapping with his feet, the third with a warning finger, giving the right note to one from the top of his voice, to

symphonies). Rifkin is one of this country's pioneers of the early music movement, a man who was arguing the validity of original performance practice for Bach and his contemporaries at a time when most other conductors thought it folly to play the works of those composers with anything less than a hundred-piece orchestra.

7

Symphony

Second Issue
Summer 1989

Preview of the 1989-1990 Season

News, words, and ideas about music from the San Francisco Symphony for its audience, its musicians, and its friends

Herbert Blomstedt on Conducting

The Inexhaustible, Ever-Reinventable Violin

Talking to Isaac Stern

Getting to Know Arnold Schoenberg

Remembering Brahms

Oboe Reeds in Eighteen Steps

The Coming Season on Records

Art Director: Michael Cronan

Designers: Michael Cronan, Terry Lim

Photographers: T. Mike Fletcher, Terry Lorant

Illustrator: Michael Cronan

Client: San Francisco Symphony

**Noontime Concerts
Mini-Posters**

To announce a regular series of noon-hour concerts at the M.I.T. campus, Dietmar Winkler was assigned the task of creating a new mini-poster each week. He used the least-expensive materials available; stock photography from the university's files was printed in black (one-color printing is the cheapest, and black ink is the most common) on the printer's paper remnants (printers usually save their unused paper for small jobs). To save even further time and money, Winkler designed eight different pieces at once that would be ganged up on one sheet of paper and then trimmed. "It's difficult for most people to believe that a prestigious private institution like M.I.T. [especially known for the high quality of its graphic identity] would always be hunting for design and printing donations," says Winkler, "but that was standard procedure."

Art Director: Dietmar Winkler
..
Designer: Dietmar Winkler
..
Client: Department of Humanities, M.I.T.

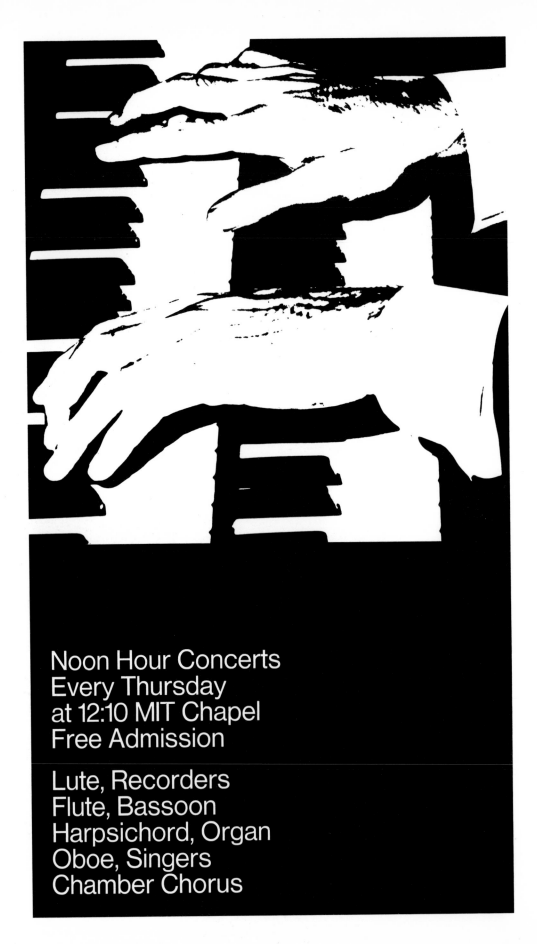

Noon Hour Concerts
Every Thursday
at 12:10 MIT Chapel
Free Admission

Lute, Recorders
Flute, Bassoon
Harpsichord, Organ
Oboe, Singers
Chamber Chorus

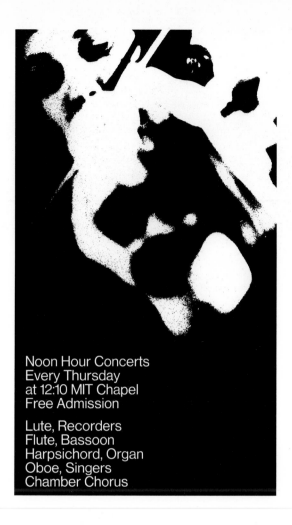

Noon Hour Concerts
Every Thursday
at 12:10 MIT Chapel
Free Admission

Lute, Recorders
Flute, Bassoon
Harpsichord, Organ
Oboe, Singers
Chamber Chorus

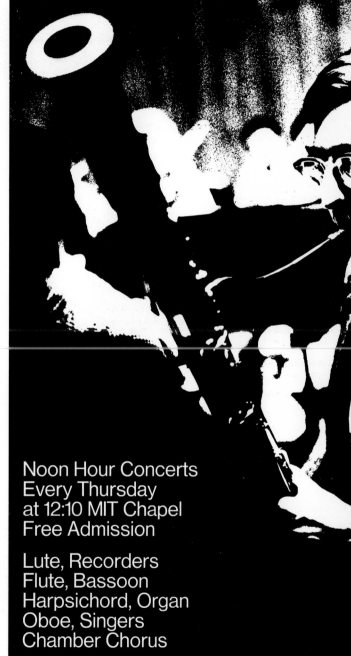

Noon Hour Concerts
Every Thursday
at 12:10 MIT Chapel
Free Admission

Lute, Recorders
Flute, Bassoon
Harpsichord, Organ
Oboe, Singers
Chamber Chorus

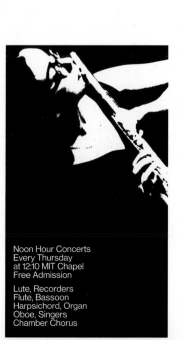

Noon Hour Concerts
Every Thursday
at 12:10 MIT Chapel
Free Admission

Lute, Recorders
Flute, Bassoon
Harpsichord, Organ
Oboe, Singers
Chamber Chorus

Dance Program

Often a theme or subject, not the budget limitations, dictate how a design problem will be solved. For Double-space's Jane Kosstrin and David Sterling, the experimental and expressionistic style of German dancer Pina Bausch suggested a decidedly "raw, personal vision." The Brooklyn Academy of Music's Next Wave Festival has introduced avant-garde performances in the past, but with Bausch's American premiere, they wanted a mailer that would signal a unique cutting-edge experience. Kosstrin and Sterling were very sympathetic to Bausch's work, and they used this opportunity to show how far they could push graphic design as a kind of complimentary "self-expression." The budget of $15,000 included design, production, stats, type, and the printing of 250,000 copies. Black and white stock performance photographs were available for free. Eye-catching images were concocted through the close cropping of interesting photographic details—gestures, expressions, and so on. The long, accordian fold (printed by a printer who usually does billboards) heightened the visual drama. Two colors (red and black) were selected to give the piece immediacy. Likewise, IBM Selectric typewriter type was used, in part to save money because professional typesetting was unnecessary, but the inherent roughness of the typewriter letterforms was deemed consistent with Bausch's work. Given the large quantity of stats needed to get the type just right, the

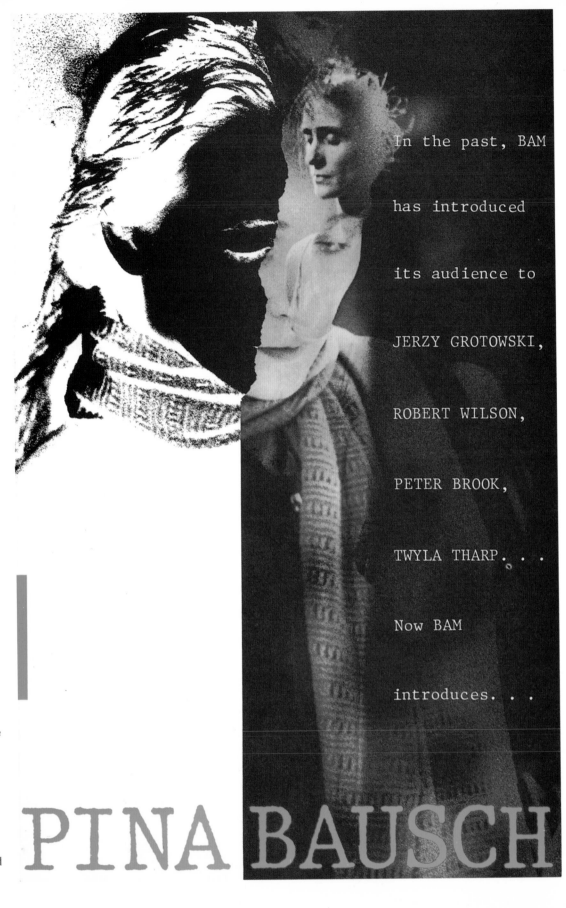

In the past, BAM

has introduced

its audience to

JERZY GROTOWSKI,

ROBERT WILSON,

PETER BROOK,

TWYLA THARP. . .

Now BAM

introduces. . .

PINA BAUSCH

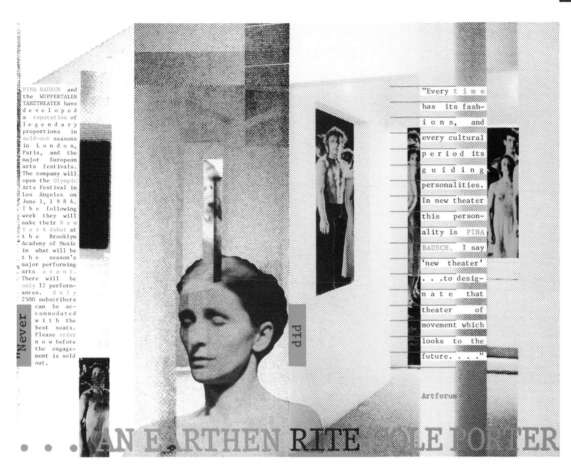

PINA BAUSCH and the WUPPERTALER TANZTHEATER have developed a reputation of legendary proportions in sold-out seasons in London, Paris, and the major European arts festivals. The company will open the Olympic Arts Festival in Los Angeles on June 1, 1984. The following week they will make their New York debut at the Brooklyn Academy of Music in what will be the season's major performing arts event. There will be only 12 performances. Only 2500 subscribers can be accommodated with the best seats. Please order now before the engagement is sold out.

"Never

"Every time has its fashions, and every cultural period its guiding personalities. In new theater this personality is PINA BAUSCH. I say 'new theater' . . .to designate that theater of movement which looks to the future. . . ."

Artforum

did

. . . . AN EARTHEN RITE COLE PORTER

ultimate cost of the type was not cheap. The pair experimented with different configurations for five straight weeks—a disproportionate amount of time given that what remained of the budget for a design fee was aprox $1,500. Since they could not give the printer any complicated or costly stripping work, the time-consuming special effects were all done in the mechanical stage. The result was that Pina Bausch's performance sold out within two weeks—a record for a relative unknown—and Doublespace created a masterpiece of direct-mail promotion.

Art Directors: Doublespace
.................................
Designers: Jane Kosstrin,
David Sterling
.................................
Photographers: Various
.................................
Client: Brooklyn Academy
of Music

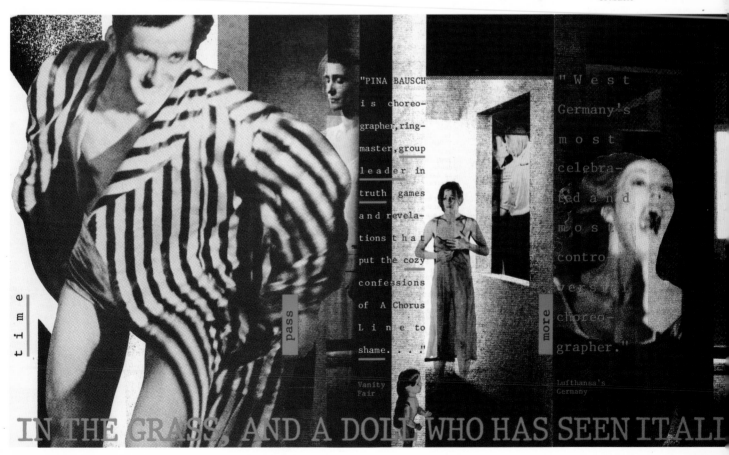

"PINA BAUSCH is choreographer, ringmaster, group leader in truth games and revelations that put the cozy confessions of A Chorus Line to shame. . . ."

Vanity Fair

"West Germany's most celebrated and most controversial choreographer."

Lufthansa's Germany

time

pass

more

IN THE GRASS, AND A DOLL WHO HAS SEEN ITALI

Avant-Garde-Theater Guide

Being blessed with a high budget does not mean that corners cannot be cut to achieve an even more ambitious design result. Design fees are often sacrificed if the designer is passionate about a project. Such is the case with Doublespace's design for the Brooklyn Academy of Music's 1989 New Wave Festival. Peter Brook's *Mahabharata*, the American premiere of which was the centerpiece of the festival, suggested a "sense of intense color and movement." Moreover, to introduce its new home in the Majestic Theater, the Brooklyn Academy of Music (BAM) wanted a four-color program. Jane Kosstrin and David Sterling developed an overall theme, basing their concept on the references to fire, earth, air, and water prevalent in Brook's performance. After collecting research on the archetypical symbolism of these forms, they keyed the design on the entire program (which included a number of other significant performances) around the use of astrological, alchemical, mythical, and biblical icons and images. The budget of $65,000 for design, production, type, and printing was insufficient to cover the time, energy, and all the materials used. Eight thousand alone went for the color stats that were made from the color performance photographs. Kosstrin and Sterling devoted six straight weeks of virtually uninterrupted time to the project, and after all the bills were paid they received approximately $3,500 for the design. They spared no expense in

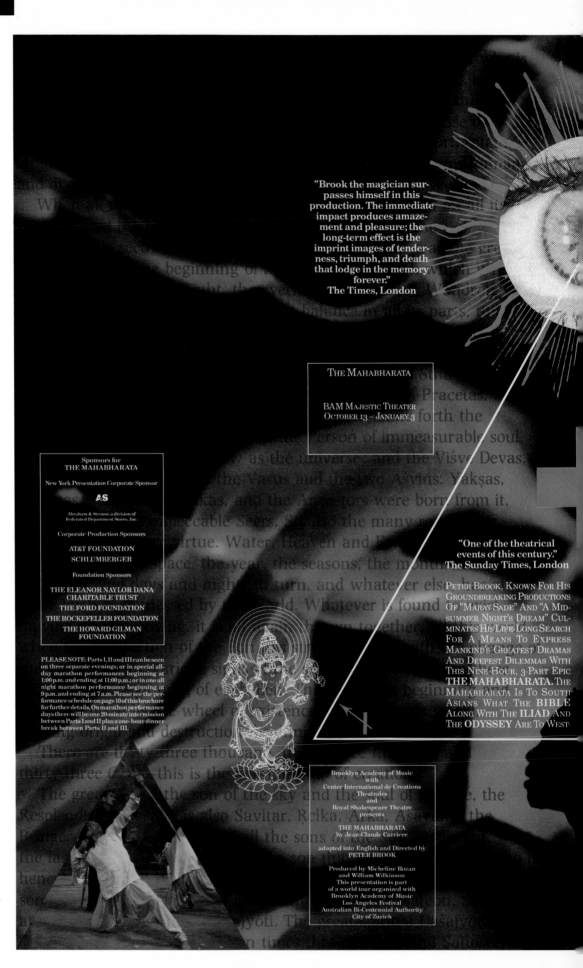

"Brook the magician surpasses himself in this production. The immediate impact produces amazement and pleasure; the long-term effect is the imprint images of tenderness, triumph, and death that lodge in the memory forever."
The Times, London

THE MAHABHARATA

BAM MAJESTIC THEATER
OCTOBER 13 – JANUARY 3

"One of the theatrical events of this century."
The Sunday Times, London

PETER BROOK, KNOWN FOR HIS GROUNDBREAKING PRODUCTIONS OF "MARAT-SADE" AND "A MID-SUMMER NIGHT'S DREAM" CULMINATES HIS LIFE-LONG SEARCH FOR A MEANS TO EXPRESS MANKIND'S GREATEST DRAMAS AND DEEPEST DILEMMAS WITH THIS NINE-HOUR, 3-PART EPIC THE MAHABHARATA. THE MAHABHARATA IS TO SOUTH ASIANS WHAT THE BIBLE ALONG WITH THE ILIAD AND THE ODYSSEY ARE TO WEST-

Sponsors for
THE MAHABHARATA

New York Presentation Corporate Sponsor

A&S

Abraham & Strauss, a division of
Federated Department Stores, Inc.

Corporate Production Sponsors

AT&T FOUNDATION
SCHLUMBERGER

Foundation Sponsors

THE ELEANOR NAYLOR DANA
CHARITABLE TRUST
THE FORD FOUNDATION
THE ROCKEFELLER FOUNDATION
THE HOWARD GILMAN
FOUNDATION

PLEASE NOTE: Parts I, II and III can be seen on three separate evenings; or in special all-day marathon performances beginning at 1:00 p.m. and ending at 11:00 p.m.; or in one all night marathon performance beginning at 9 p.m. and ending at 7 a.m. Please see the performance schedule on page 10 of this brochure for further details. On marathon performance days there will be one 20-minute intermission between Parts I and II plus a one-hour dinner break between Parts II and III.

Brooklyn Academy of Music
with
Center International de Creations
Theatrales
and
Royal Shakespeare Theatre
presents

THE MAHABHARATA
by Jean-Claude Carriere

adapted into English and Directed by
PETER BROOK

Produced by Micheline Rozan
and William Wilkinson
This presentation is part
of a world tour organized with
Brooklyn Academy of Music
Los Angeles Festival
Australian Bi-Centennial Authority
City of Zurich

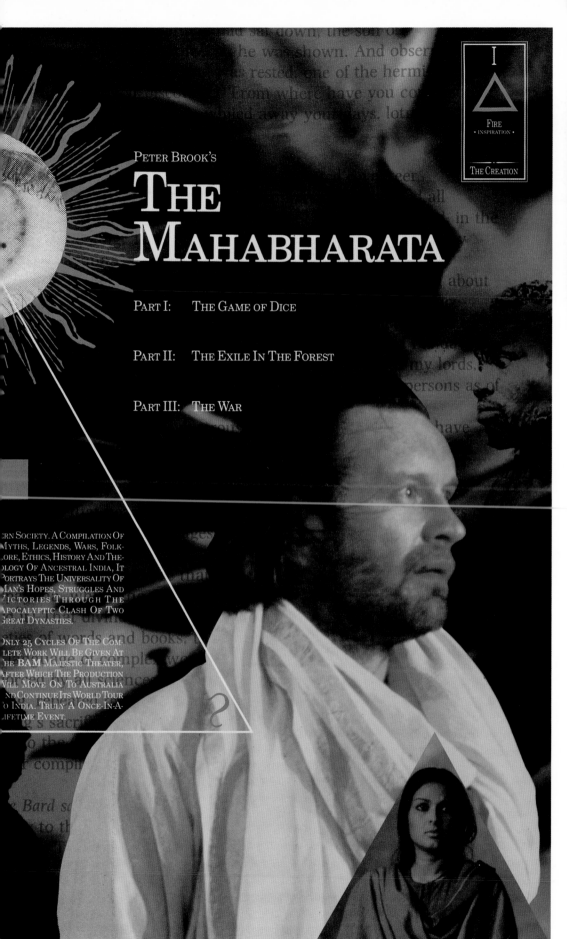

I

△

FIRE
• INSPIRATION •

THE CREATION

PETER BROOK'S

THE MAHABHARATA

PART I: THE GAME OF DICE

PART II: THE EXILE IN THE FOREST

PART III: THE WAR

...ERN SOCIETY. A COMPILATION OF ...MYTHS, LEGENDS, WARS, FOLK-...LORE, ETHICS, HISTORY AND THE-...OLOGY OF ANCESTRAL INDIA, IT ...PORTRAYS THE UNIVERSALITY OF ...MAN'S HOPES, STRUGGLES AND ...VICTORIES THROUGH THE ...APOCALYPTIC CLASH OF TWO ...GREAT DYNASTIES.

...ONLY 25 CYCLES OF THE COM-...PLETE WORK WILL BE GIVEN AT ...THE BAM MAJESTIC THEATER, ...AFTER WHICH THE PRODUCTION ...WILL MOVE ON TO AUSTRALIA ...AND CONTINUE ITS WORLD TOUR ...TO INDIA. TRULY A ONCE-IN-A-...LIFETIME EVENT.

DEAR FRIEND:

HERE IT IS OUR 5TH ANNUAL **NEXT WAVE** FESTIVAL — MY GOD, WE ARE BECOMING AN INSTITUTION! THE TRICK IS TO KEEP CHANGING THE MODE, TO CONTINUE LOOK-ING FOR EXCITING NEW WORK, AND TO GUARD AGAINST HARDENING OF THE ARTERIES.

THE GREAT PETER BROOK RETURNS TO **BAM** TO OPEN THE FESTIVAL WITH WHAT IS JUST ABOUT A FESTIVAL IN ITSELF, **THE MAHABHARATA** — A NINE-HOUR EPIC WHICH I SAW FOUR TIMES IN FRANCE AND WHICH I CANNOT WAIT TO SEE AGAIN, THIS TIME IN ITS ENGLISH-LANGUAGE INCAR-NATION AT OUR **NEW BAM** MAJESTIC THEATER. THE REFURBISHED THEATER (DATING FROM 1903) IS A BLOCK AND A HALF FROM **BAM**, AND WILL BE A REAL STUNNER IN ITS UNIQUE CONFIGURATION AND BEAUTIFUL LIVED-IN DÉCOR. **THE MAHABHARATA** IS THE WORK OF A THEATRICAL WIZARD; YOU SHOULD NOT MISS IT.

production either. When the budget ran out, tickets to BAM performances were traded for photographs. Over the years BAM has developed good financial relationships with their printers, which came in handy. Although this job was done on a web-offset press, it required major strip-ping and other significant press work. What began as a four-color job ended as a six-color job, including an extra gold and a blue touch plate to make type more legible. Doublespace's ambitious de-sign project contributes to establishing BAM's celebrated image as a major internati-onal performing-arts institu-tion. And Kosstrin and Sterling's sacrifice not only made for an aesthetic tour de force, but was also a good business decision, since they are now recognized for their avant-garde work.

Art Directors: Doublespace
..................................
Designers: Jane Kosstrin,
David Sterling
..................................
Client: Brooklyn Academy
of Music

Museum Brochure

To solicit donations for a newly created Center for Advertising History, the American History Museum of the Smithsonian Institution required a snappy brochure as part of its overall funding package. The piece had to reflect the commercial exuberance inherent in America's advertising legacy. The museum had, however, budgeted low: only $1,000 for design, which even at Judy Kirpich's reduced design fee for nonprofit organizations caused the total (which was determined by time spent on the job) to be $600 over budget. This was ultimately absorbed by her firm, Grafik Communications Washington, as a donation of services. The client helped keep the costs to a minimum by doing all the fundamental research, providing the artifacts and images used in the brochure. Additionally, the client purchased the typesetting directly, avoiding mark-up and handling expenses usually billed to the client as additional costs.

Art Director: Judy F. Kirpich

Designer: Beth Bathe

Client: Smithsonian Institute American History Museum

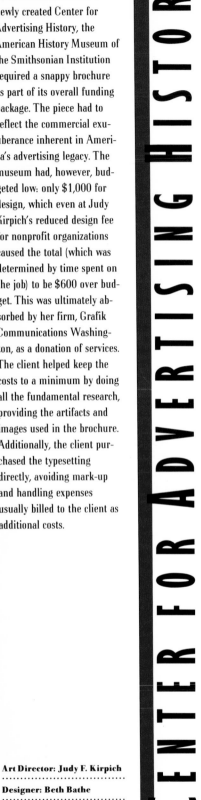

CENTER FOR ADVERTISING HISTORY

"You can tell the ideals of a nation by its advertisements."
—Norman Douglas (1917)

"We grew up founding our dreams on the infinite promise of American advertising. I *still* believe that one can learn to play the piano by mail and that mud will give you a perfect complexion."
—Zelda Fitzgerald (1932)

4. Ford Motor Co., 1940, Ayer Records
5. Rheingold Beer, 1914, Warshaw Collection
6. Pepsi-Cola Co., 1954, Pepsi Collection
7. AT&T 1952, Ayer Records
8. AT&T 1960, Ayer Records
9. Federal Express Corp., "Ambidextrous," 1983, Federal Express Collection
10. Campbell Soup Co., 1912, Warshaw Collection
11. Container Corporation, 1964, Ayer Records
12. Miles Inc, "Speedy," 1976, Alka-Seltzer Collection
13. Miles Inc, "Restaurant," 1971, Alka-Seltzer Collection

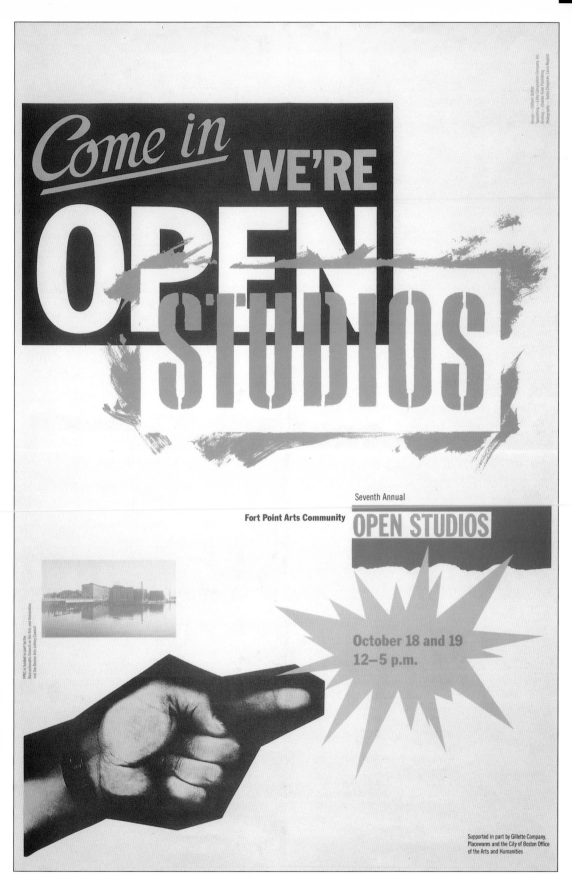

Open-House Announcement

The Fort Point Arts Community in Massachusetts sponsors an annual open house of artists' studios. Clifford Stoltze was given the assignment to design an announcement for the seventh annual event. The budget, however, was low — only $1,500 was allotted for printing. Stoltze waived his design fee and got the photography and typesetting donated from suppliers he had previously worked with. He designed the piece to be printed on a web-offset press on 50-pound newsprint (an inexpensive white paper that is not as lightweight as regular newsprint), making it possible to have two extra colors at minimal cost (adding color to a web-press job is rather easy). Stoltze reports that this open house was the best attended in their seven-year history.

Art Director: Clifford Stoltze

Designer: Clifford Stoltze

Photographers: Kathy Chapman, Larry Muglott

Client: Fort Point Arts Community

Museum Brochure

When the Noguchi Museum
realized that they needed a
new informational brochure
to update the public about
their unique holdings, they
called on Woody Pirtle at
Pentagram Design, New York.
The problem was simple: say
the most, in the most elegant
manner possible with as little
outlay as possible. Since the
museum is a nonprofit organ-
ization, Pirtle waives his
design fee on the condition
that the client pay for pro-
duction and printing. The
photography was supplied
by the museum and used to
cinematic effectiveness in the
long and narrow accordian-
folded, one-color brochure.
The accordian fold is rather
easy for a printer to produce
at minimal cost for scoring
the folds.

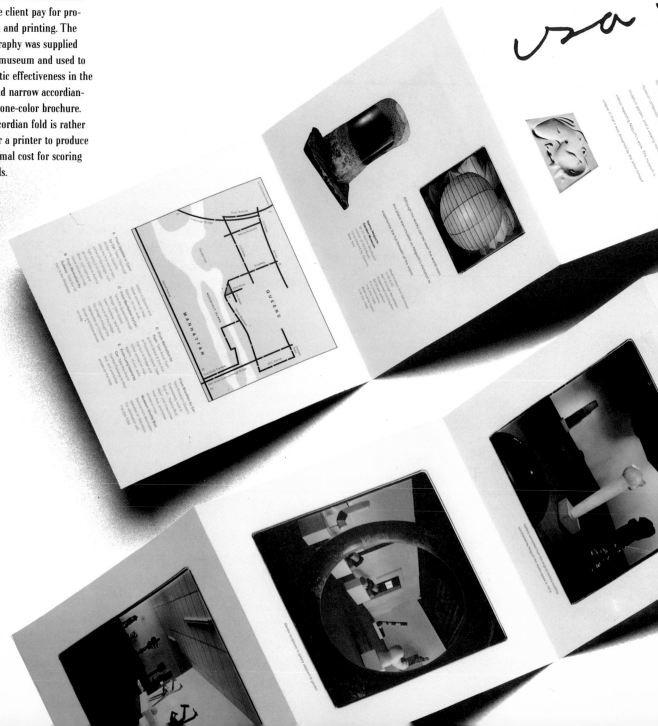

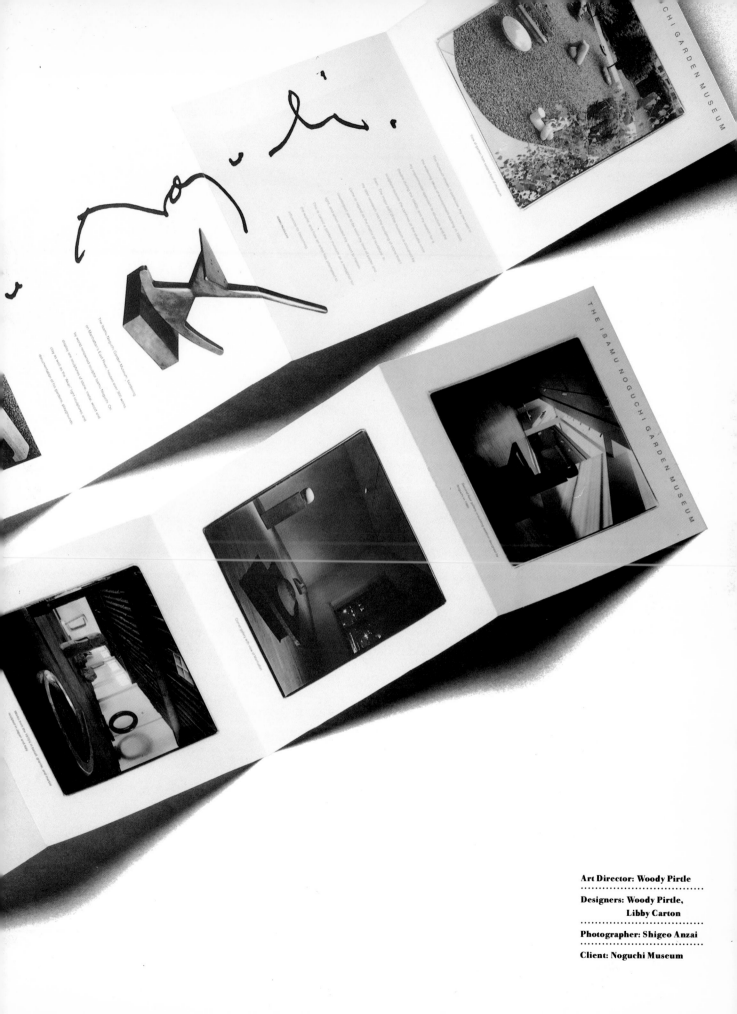

Art Director: Woody Pirtle
..
Designers: Woody Pirtle,
 Libby Carton
..
Photographer: Shigeo Anzai
..
Client: Noguchi Museum

Funding Guide

During the late 1970s government played an active role in funding the arts, and the American Council on the Arts wanted to make this known to arts groups nationwide. Data was researched, case histories were compiled, and a lucid report written, but a design format was required to make it all accessible. Enter John Morning of John Morning Design, who suggested that the material be designed as a workbook. "A loose-leaf format suggested itself," he recalls, "because it would save considerable money on conventional binding processes and be easily updated by printing individual sheets." Morning was given staid photographs to use as illustration, which he converted to line art by photostating with Kodalith film, saving on halftone costs and, as he puts it, "ironing out the discrepencies in value." Nothing, however, was donated by suppliers. Typewriter type was used for headlines, and inexpensive, traditional typesetting was used for text. Morning's fee, which is usually based on a reasonable estimate of how much time and energy a job will take, was slashed. The result was an important and useful document that gave arts groups invaluable insight into government programs. The client was pleased, and the design was hailed as "exemplary" in a *New York Times* article.

Art Director: John Morning

Designer: John Morning

Photographers: Various

Client: American Council on the Arts

12 Federal/State Programs

12. FEDERAL/STATE PROGRAMS

13. ALTERNATIVE FUNDING

13 Alternative Funding

Funding Booklet

The Massachusetts Council
on the Arts and Humanities
had high hopes that with a
limited budget they would
get a quality booklet giving
guidelines for their comtem-
porary arts program. The
purpose was to give acces-
sible how-to information to
those artists interested in
applying for grant assistance.
This genre is often replete
with incomprehensible rules
and regulations. The chal-
lenge went to Clifford Stoltze
and Alice Hecht, who were
given $1,500 to design the
basic format, which included
a standard type treatment for
the inside and a cover that
changed with each booklet.
The individual pieces were
designed and produced for an
additional $1,200 to $1,600,
based on the number of
pages. Typesetting was dis-
counted by a willing vendor,
coming in between $800 and
$1,000 per piece. The two-
color printing was reasona-
ble: between $1,800 and
$2,400. And the booklets
were much in demand.

PROGRAMS AND SERVICES

Massachusetts
Council on
the Arts and
Humanities

**Art Directors: Alice Hecht,
Clifford Stoltze**

**Designers: Alice Hecht,
Clifford Stoltze**

**Client: Massachusetts Council
on the Arts
and Humanities**

Contents

The Massachusetts Council on the Arts and Humanities is a state agency whose budget is recommended by the Governor and appropriated by the Legislature.

Publication of this document approved by State Purchasing Agent.
7500-10/86-812651
Estimated cost per copy $.40

The programs described herein are subject to change.

The Council

The Massachusetts Council on the Arts and Humanities is a state agency established in 1966 to "stimulate the practice, study, and appreciation" of the arts and humanities throughout the Commonwealth. Through its various funding programs, planning, and advocacy, the Council promotes active participation in the arts, humanities, and sciences for both children and adults.

The Council administers over 14 programs and supports many others administered by The Artists Foundation, New England Foundation for the Arts, and The Institute for the Arts. An introduction to Programs and Services, a 20th Anniversary Report, and guidelines for the programs of other departments—Organizational Support and Contemporary Arts—are available upon request. Funding lists which describe previously funded projects within each funding category are also available at the Council.

The Council is committed to Affirmative Action not only as a matter of law but also as a policy designed to encourage the participation of all segments of the Commonwealth's population in Council programs. The Council encourages requests for projects in the arts and humanities which address the needs of Asian, Black, Cape Verdean, Hispanic, and Native American peoples, females, the disabled, and self-identified Vietnam-era veterans.* The Council also welcomes proposals for programs which reach geographically underserved and economically disadvantaged populations.

The Council continuously refines its programs and services to more effectively serve the arts, humanities, and informal science communities and the public.

Introduction to the Community Arts and Education Department

Two years ago, the Council reassessed its education programs. The Council recognized that, in order to have a lasting impact on the life of a child, continuous exposure to the arts, humanities, and sciences is necessary. A one-time field trip to a museum or cultural event is not enough. The Council determined that it should support programs which:

• Stimulate that child's parents, principal, teachers, daycare and community agency workers to recognize the value of cultural learning; and,
• Promote ongoing, active participation in the arts, humanities, and sciences for children and adults.

As a result of these findings, the Council merged its education programs with those that focus on the development of the arts, humanities, and informal science education at a local level, creating the Community Arts and Education department.

The Community Arts and Education department provides support for programs in which cultural institutions (libraries, museums, visual arts centers, science centers, historical societies, dance, music, and theatre groups) and individuals in these disciplines work with schools and community organizations to provide participatory experiences for children and adults.

There are five programs in the Community Arts and Education department:

Community Arts Programs
• **Heritage** promotes the cultural traditions of Afro-American, Native American, Hispanic, Cape Verdean, Caribbean, and Asian Communities;
• **Folklife and Ethnic Arts** provides support for traditional artists in community settings. The program encourages the perpetuation of folk music, dance, storytelling, and functional crafts, especially when presented by members of local ethnic or occupational groups;
• **Local Arts** helps regions and municipalities plan and develop the role of the arts in their communities;

*This designation of minority populations is derived from the standards used by the State Office of Affirmative Action.

Program Guidelines
Fiscal Years 1988–89

Contemporary Arts

Massachusetts
Council on
the Arts and
Humanities

Literary Review

Roy R. Behrens initially had asked for a $3,000 fee to design three covers of the *Indiana Review*, a small literary periodical, but his request was denied. So he offered to do it for free. Each cover was a collage made with public-domain engravings that were distorted on a photocopying machine and then printed in two colors. The printer made two plates of the same artwork—a positive and a negative—that were sandwiched together and printed in different colors to give a psychedelicized or solarized effect. Behrens used the series as a way to learn about what he calls "high density compositions and color rhyme" (the effects the discordant colors have when placed against each other). Reaction was positive and subscriptions increased.

Art Director: **Roy R. Behrens**

Designer: **Roy R. Behrens**

Illustrator: **Roy R. Behrens**

Client: ***Indiana Review***
Indiana University

Design Expo Promotion

When the International Interior Design Exposition (IIDEX) wanted promotional material to attract related industries and others to their show they called in Taylor & Browning of Toronto. The budget for design, art direction, illustration, and mechanicals totaled $16,000 for studio time (of which $6,000 was donated by Taylor & Browning) and $3,000 for typesetting. Printing was arranged by the client. Additionally, Browning says. "It was desirable to project a lean economical and environmentally friendly message." Therefore, the entire promotion (including posters, invitations, flyers) was printed using only black and a second color. Recycled paper was also used, not so much for cost savings, but to help the cause of environmental clean-up. William Lam's illustration echos "man's concern in relationship with his space and man entering the new age." The result was high visibility and a large turnout for IIDEX.

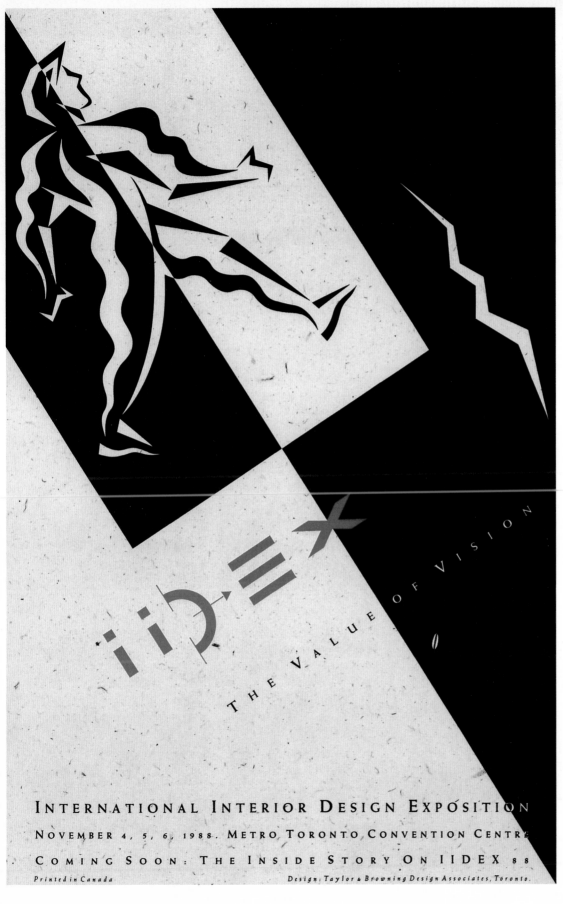

iiDEX

THE VALUE OF VISION

INTERNATIONAL INTERIOR DESIGN EXPOSITION

NOVEMBER 4, 5, 6, 1988. METRO TORONTO CONVENTION CENTRE

COMING SOON: THE INSIDE STORY ON IIDEX 88

Printed in Canada Design: Taylor & Browning Design Associates, Toronto.

Art Director: Paul Browning

Designer: William Lam

Illustrator: William Lam

Client: International Interior Design Exposition

Design Center Promotion

In the early 1980s, Lazard Realty Company approached Vignelli Associates in New York to design the print materials used to sell prospective tenants on the idea of investing in a new New York merchandise mart in a run-down, former industrial district of Long Island City (just across the East River from Manhattan). At the time they believed that the design budget was adequate to get a slick, four-color brochure. But Massimo Vignelli had decided against a four-color job in favor of a two-color strategy that ultimately allowed the developer to have more publicity for less money. Vignelli reasoned that the enormity of the challenge to influence manufacturers, wholesalers, and customers to become pioneers in an *outré* neighborhood actually made a reasonable budget seem quite low. Both he and the project's principal designer, Michael Bierut, realized that neither the neighborhood nor the four run-down factory buildings destined to be transformed into the International Design Center (IDC/NY) would benefit from exquisite photography printed with an array of varnishes. The area was tough and raw. The colors black and red symbolized this atmosphere and the renovations to come, and the use of inexpensive paper was consistent too. A regularly issued tabloid newspaper, printed on inexpensive 50-pound offset newsprint served as the main source of information and the archetype of Vignelli's design approach. The artwork was mostly engravings from

IDCNY 33

The International Design Center, New York

January/February 1988

The Right Stuff

The world's leading design publications, associations and practitioners show their stuff at IDCNY. The Center is the great location for their seminars, celebrations and exhibitions of award-winning, innovative projects. The adventure continues. See the Coming Up columns and make sure you're a part of it.

Color Day at IDCNY, March 8th

Professional Office Design's Awards, February 11th

Big "I" Awards Evening, January 20th

Thank Brahms It's Thursday Concert, February 25th

Italian Tile Environment, March 1st through 23rd

Progressive Architecture Awards, January 28th

Store Planners Dinner, January 20th

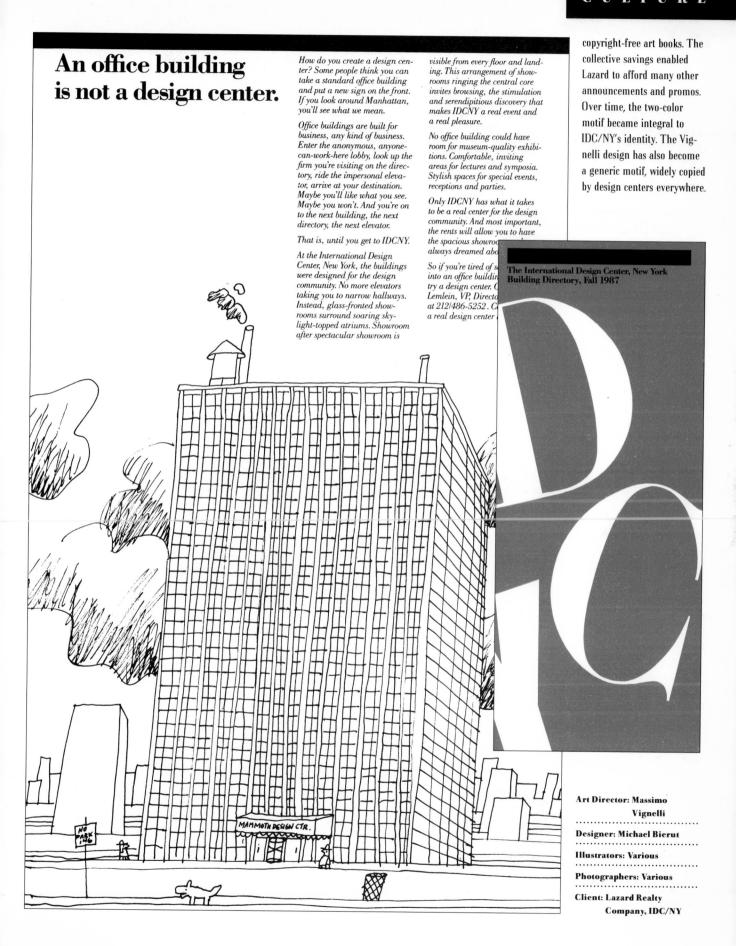

An office building
is not a design center.

How do you create a design center? Some people think you can take a standard office building and put a new sign on the front. If you look around Manhattan, you'll see what we mean.

Office buildings are built for business, any kind of business. Enter the anonymous, anyone-can-work-here lobby, look up the firm you're visiting on the directory, ride the impersonal elevator, arrive at your destination. Maybe you'll like what you see. Maybe you won't. And you're on to the next building, the next directory, the next elevator.

That is, until you get to IDCNY.

At the International Design Center, New York, the buildings were designed for the design community. No more elevators taking you to narrow hallways. Instead, glass-fronted show-rooms surround soaring skylight-topped atriums. Showroom after spectacular showroom is

visible from every floor and landing. This arrangement of show-rooms ringing the central core invites browsing, the stimulation and serendipitous discovery that makes IDCNY a real event and a real pleasure.

No office building could have room for museum-quality exhibitions. Comfortable, inviting areas for lectures and symposia. Stylish spaces for special events, receptions and parties.

Only IDCNY has what it takes to be a real center for the design community. And most important, the rents will allow you to have the spacious showroo̲m ̲ always dreamed ab̲o ̲

So if you're tired of s̲ into an office buildi̲n ̲ try a design center. C̲ Lemlein, VP, Directo̲ at 212/486-5252 . C̲ a real design center ̲

copyright-free art books. The collective savings enabled Lazard to afford many other announcements and promos. Over time, the two-color motif became integral to IDC/NY's identity. The Vignelli design has also become a generic motif, widely copied by design centers everywhere.

The International Design Center, New York
Building Directory, Fall 1987

Art Director: Massimo Vignelli
.....................................
Designer: Michael Bierut
.....................................
Illustrators: Various
.....................................
Photographers: Various
.....................................
Client: Lazard Realty Company, IDC/NY

Museum Drive Package

To announce its membership drive and new-building fund-raising campaign, and to keep a positive image fresh in people's minds, the Heckscher Museum commissioned DeHarak & Poulin Associates of New York to develop a format for its bimonthly newsletter and seasonal schedules. As with all such publicly funded institutions, the materials had to be handsome and functional but not extravagant. A basic grid was developed that made designing the individual newsletters easier because the designers did not have to reinvent the wheel with each new project. To differentiate each cover, a "ghost image" of a featured event or artwork was overprinted in a different color. The "ghost" did not cost any more than an extra color. The newsletter's typographic format was adapted for the schedules. Five thousand newsletters were printed at a unit cost of thirty cents each — a rather impressive savings on comparable material. The project was enthusiastically received by members and, more important, was demonstratively successful, since the Heckscher Museum is now proceeding with the new building.

Art Director: Richard Poulin

Designers: Richard Poulin, Kirsten Steinorth

Client: Heckscher Museum

Heckscher Museum

Newsletter May/June 1987

Old Master to Early Modern: Work from Long Island Collections

Old Master to Early Modern: Work from Long Island Collections opens with a special Members' Preview on Friday evening, May 15, from 7:00 to 9:00 p.m. and to the general public on Saturday, May 16.

This wide-ranging exhibition features selected paintings and drawings from over two dozen private Long Island collections and spans five centuries of European art from the Renaissance to the early 20th century. Few other regions in the country are capable of supplying an exhibition of such ambitious scope and quality. Works by as yet unidentified masters from the Italian and Northern Renaissance are included as well as by such artists as Titian, Rubens, Manet and Picasso. Subjects range from everyday life in 17th century Holland to dissolving French Impressionist landscapes, from Baroque to Cubist still life paintings and from austere portraits of Renaissance humanist scholars to poignant evocations of
continued on inside

The Madonna and Child, by Joos Van Cleve, undated, oil on wood

Concerts

Saturday, October 31
8:30 pm
Candlelight Concert: Magicial Music for a Halloween Evening with the Festival Chamber Players
My White Lady—David Maslanka, Blue Mountain Ballad—(Settings of Tennessee Williams), Paul Bowles, The Harp of Life—Henry Cowell, The Magic World—Judith Lang Zaimont

Featuring:
Thomas Buckner, Baritone
Joseph McIntyre, Percussion
Zita Zohar, Piano

Admission: $10.00, Members: $8.50
Come in costume and get a free surprise!

Programs

Monday, October 5
12:30 pm
Art A La Carte
William Merritt Chase: American Artist and Educator
With Maureen O'Brien, Curator, The Parrish Art Museum, Southampton. Bring your own lunch and we'll provide beverages and dessert.
Admission: $4.00, Members: $3.00

October 5th to October 12th will be Heckscher Museum Week.

Sunday, October 18
10:30 am to 12:30 pm
Brunch With The Director
Enjoy a feast for body and soul! Join us for a delicious Sunday brunch and an illustrated talk on selected artists from our special exhibition, *The Art Students League: Selections From The Permanent Collection*, with Museum Director Christopher Crosman.
Admission: $8.50, Members: $7.50

Pre-registration for all programs is necessary as seating is limited.

Heckscher Museum

Heckscher Museum
Prime Avenue
Huntington, New York 11743
516 351 3250

Non-Profit Org.
U.S. Postage
PAID
Huntington, N.Y.
Permit No. 428

Heckscher Museum
October 1987
Announcement!

The Festival Chamber Players

Ralph Albert Blakelock, *Landscape with Waterfall*, n.d.

Artist/Master Printer Dan Welden.
Photo by Roy Nicholson.

Roving Billboard

The Go Van Gogh outreach program sponsored by the Dallas Museum of Art brings cultural programs to schools, hospitals, and other groups and institutions. For its tenth anniversary Sibley/Peteet Design was asked to develop a "roving billboard" on the side of a van to promote the program, as well as the artworks in the museum's permanent collection. The total budget was $2,500 to design, paint, and fabricate. A new van had been donated by the Communities Foundation of Texas and the school bus-yellow paint job was negotiated with a local car dealership. Sibley/Peteet donated their services. The halftone was given to the museum at cost ($500). A fabricating firm did glass resin silkscreening (a process whereby the image is put on dry and fired; glass pigment is then fused with metal), creating a practically indestructible surface ensuring fade-resistance and vandal protection. Afterward, the metal graphics were grommeted to the panel-van walls to suggest window openings and passengers within. All this for a fee of $2,000. Type and stats were billed at $250, bringing the job in slightly over budget. "This is an ongoing program," says Rex Peteet, the principal designer, "and continues to turn heads on the highway."

Art Director: Rex Peteet
.................................
Designer: Rex Peteet
.................................
**Illustrator: Sibley/Peteet
Design**
.................................
Client: Dallas Museum of Art

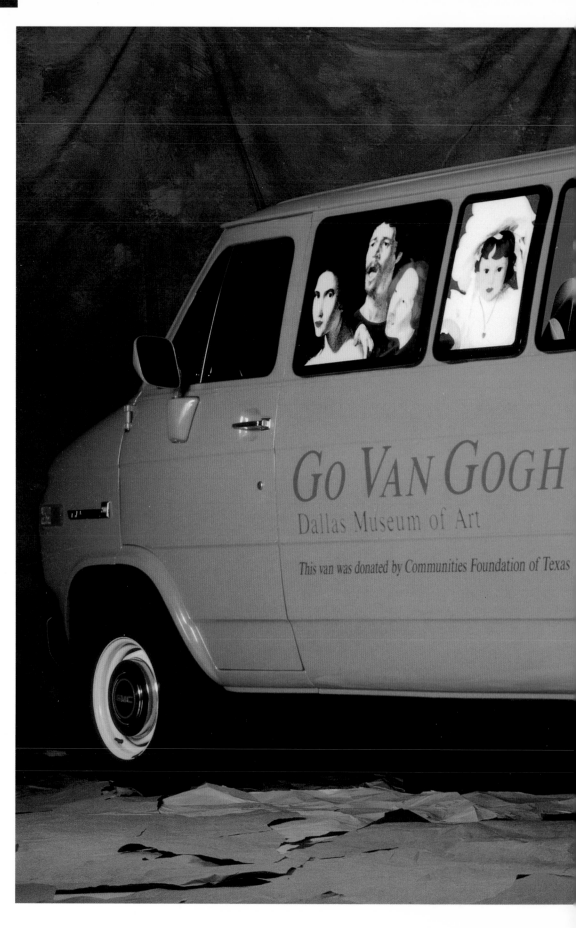

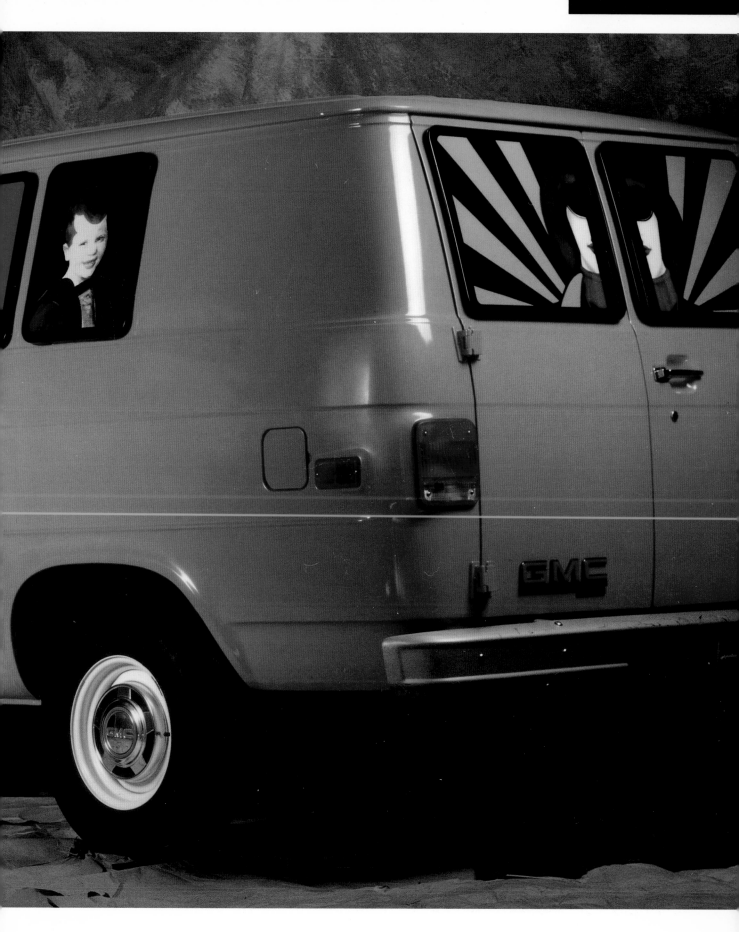

Museum Identity

Often the most satisfying job that a young designer can get is for a nonprofit institution, especially one that is grateful for anything that costs next to nothing. For Michael Bierut, only a year out of art school, being asked to design the printed material for the Hudson River Museum offered a wealth of excellent portfolio pieces. By using the simplest materials and tools —press type, typewriter, and photocopier—he could make printed pieces "that were beyond their wildest dreams." Making everything as cheaply as possible was indeed a labor of love. During the day, Bierut worked at Vignelli Associates, and every night after dinner he would return to the office to design invitations, schedules, brochures, catalogs, and even the museum's annual report. "It was the best value on the East Coast," he admits proudly. "I would slave away on the stupidest details." And all for about $140 per job. The logo, originally designed by Ivan Chermayeff, worked well with Bierut's own concepts. For the schedule he would use two colors, changing the second color every two months for variety. Photographs were donated and were usually poor quality, but Bierut recreated them by cropping in on them and enlarging interesting details. With the advent of computers, he was able to switch from typewriter type to Century Schoolbook generated from the PC. By transmitting the text over a modem to a typesetter who could set type off a computer disk, Bierut saved keyboard time and

costs. Nevertheless, "making the type sharper," he admits, "did not make it better." The overall design gave the museum a distinctive image and a sense of professionalism lacking in their prior non-unified approach.

Art Director: Michael Bierut

Designer: Michael Bierut

Client: Hudson River Museum

Gallery Guides

To earn credit for one third of their terminal degree, students in Cranbrook Academy of Art's graduate design program are required to do a variety of projects, including the museum catalogs and invitations shown here. Under the direction of co-chairperson Katherine McCoy, the student works directly with the client to solve the specific design problem. The work is then critiqued in class. "These projects make a bridge between theory, practice, and professional application," says McCoy. They also test the limits of design in the service of the message. Indeed, in exchange for the donated design and production, the client must "show a willingness to consider new design ideas." The graphics sampled here include an exhibition catalog for a show of work by the chairman of the metalsmithing department, an invitation/mini-poster for an exhibition of sculpture by Duane Hanson, and an announcement for a student degree show.

Cranbrook ACADEMY OF ART Museum

Gary S. Griffin

Recent Works In Steel

(this page)

Art Director: Katherine McCoy

Designer: Jan Marcus Jancourt

Client: Cranbrook Academy of Art Museum

(opposite left)

Art Director: Katherine McCoy

Designer: Scott Santoro

Client: Cranbrook Academy of Art Museum

Art Director: **Katherine McCoy**

Designer: **Edward McDonald**

Client: **Cranbrook Academy of Art Museum**

Fiber-Arts Catalog
..............................

Face to Face is a catalog for
an exhibition of fine artworks
in fiber held at the Cranbrook
Academy of Art Museum. Par-
ticipating artists were gradu-
ate students from the fiber-
arts department who, after a
field trip to study Mexico's
visual culture, wove the
works to document their
experiences. Various sponsors
supported the student trip in
exchange for works from the
show. The intricate design of
this catalog echos the com-
plexity of the art and offers
the viewer a complimentary
visual experience. The design
and production was donated
by the Cranbrook students as
part of their degree require-
ment. The client purchased
the paper and printing. The
only real payment required
from the client was that the
student be given license to
try new design approaches.

Art Director: Katherine McCoy
..............................
Designer: Darice Koziel
..............................
**Client: Cranbrook Academy
of Art Museum,
Department of Fiber**

CRANBROOK FACE

Occassionally, there exist moments in time when circumstances and opportunities are aligned in a way leading to inevitable action. Such was the case on an afternoon in June, 1987.

I had been invited to Mexico City to represent **Cranbrook Academy of Art** at the opening in the *Franz Meyer Museum* of an exhibition of work by Cranbrook faculty, which was completing a one year tour of South and Central America. Having a few hours before the opening reception, I wandered across to the old *Alameda Park*, and past the *Bellas Artes Museum* along *Avenida Madero* to the heart of old *Ciudad Mexico*, a grand square called the *Zocalo*. In front of me, across the vast stone covered plaza, stood the monumental Baroque facade of the *Cathedral* which looks down on seven lanes of auto traffic, forming an endless procession around the *Zocalo*, complete with noise and exhaust. Next to the *Cathedral* on the right, were the ruins of *Templo Mayor*, an enormous Aztec pyramid which was mostly removed under the authority of the Spaniards who were quite convinced that their god was the one and only. Crowds of people filled the sidewalk and plaza between the two monuments, accompanied by a troupe of mariachis singing *Celita Linda*.

All around the square were rhythmically patterned facades and arcades connecting shops of gold and silver merchants with department stores and old hotels. On one side of the square, I recognized the *Palacio National*, where I knew I would find on the walls of its inner courtyard, the powerful murals of *Diego Rivera*, expressing his pride for a unique heritage and history of the Mexican people. Next to it were the first stalls of a street market. Underground, I could feel the rumbling of subway trains arriving and departing the Zocalo Subway Station. Great crowds of people surged in and out of the entrances, in time with the movement of the trains.

Glancing back at the Cathedral again, I noticed vendors with booths set inside elaborate wrought iron gates, symbolically protecting the entrance. In a moment, after quickly maneuvering between rows of auto traffic, I arrived at the entrance gate where I found myself on the edge of another world at another time. Before me was a wonderful gathering of people who had come together to celebrate a traditional children's day. Everything that was there for me to see and hear was uncommon: the costumes, the food and music, the songs coming from inside the *Cathedral*, the smell of the air, the color, the dark eyes, the smiles, the language. Yet for the Mexicans, this was familiar, a part of tradition, a continuation of something that is because it must be.

I had arrived in Mexico only a few hours earlier from Michigan where I had slept the night before. Earlier in this day, I had followed a predictable path to the Detroit airport, enjoyed breakfast served at 32,000 feet, and survived a hair-raising ride through crowded streets to central *Mexico City* where I met with officials of the United States Information Agency, talked with the Director of the *Franz Meyer Museum*, reviewed the Cranbrook exhibition, and eventually meandered to a place where I saw things I'd never previously seen! Experiences of early hours of this day, dominated by rituals and symbols of my own world, now were giving way to unfamiliar sites and experiences surrounding me.

I was suddenly aware of standing at the confluence of time past, present and future, a place where diverse experience and conditions meet for the first time. Everything within and around me became consciously layered into a bizarre sandwich of experience. Standing within that vast conceptual sandwich I discovered extraordinary energy generated at the place where opposites meet for the first time. I had to react!

It didn't take long to devise a plan. During Cranbrook's Fall semester I had planned to offer to members of the Fiber Department a course in the History of Fabrics in order to increase understanding about the rich heritage of concepts and images comprising the foundation of our field. Now it seemed the field work in *Mexico City* could provide first hand experience to help the lessons of history come alive. In the lecture hall one can talk about objects and ideas, and one can examine the works themselves, but the ultimate understanding of any remnants of material culture from the past is dependent on establishing a feel for context. A costume is part of celebration; its iconography may only make sense, or be read accurately, in the field of activity in which it is intended to be involved. A religious banner makes little sense when seen in a storeroom, but in its place at the head of a parade, it shares in the power of the moment and it contributes to the meaning of the moment as well. Mexican fiestas, markets, and churches still provide a focus for the making of objects for celebration, objects with meaning that affects life, objects with meaning which is widely understood.

Born
Newark, New Jersey
1949

Educational experience
Cranbrook Academy of Art.
M.F.A. 1988
Purdue University,
M.A. 1980
Rhode Island School of Design,
B.F.A. 1971
Workshops at Penland School.
Miami University.
New School for Social Research.
School of Visual Arts

Altar for Day of the Dead
With Nick Cave
7'h x 7'w x 4'd approx.

••••

I was familiar with the Mexican artist Frida Kahlo through an exhibit of her work and her biography by Hayden Herrera.
The visit to her house in Mexico was like a pilgrimage for me.
I was curious to see what objects she surrounded herself with: Mexican folk art and costumes, pre-Columbian ceramics and goddess figures, and a garden wall embedded with conch shells. Her paintings, primarily self-portraits, are intensely personal and often contain elements of surrealism.
In Shrine For Frida, I gathered images which were significant in her life and combined them with surrealistic plant forms to evoke the mood and persona of Frida.

Another facet of Mexico which influenced me was the love of decoration one sees everywhere. The tradition of building altars for Day of the Dead is a spiritual
manifestation
of this tendency. These exuberant, baroque accumulations of offerings and decorations serve to welcome the spirits of dead relatives. I respond to this
synthesis
of spiritual and decorative
expression.

Shrine For Frida
13'h x 47'w
Cotton, dye, pigment
Screen print
Collection of Mr. and Mrs. George Zonars

JO ANN GIORDANO

Born
Daejeon, Korea
1959

Educational experience
Cranbrook Academy of Art
M.F.A. 1988
Haystack Mountain School
of Craft, 1986
Long Island University, 1985
Ewha Women's University, Korea,
M.F.A. 1985, B.F.A. 1983
Academy of National Museum of
Korea, 1984
University of Bridgeport,
Connecticut, 1982

ADJONG PARK

Window of Life and Death
47'h x 50'w

My trip to Mexico enabled me to see two things: tradition and morality. There were so many churches, and children praying with a strength from within – a strength passed from generation to generation. In Mexico, I came to value my own foreign traditions and morality, as well as other people's.

One simple paper cutout that I bought in Mexico shows an image of a male skeleton drumming and a female skeleton weaving at her loom.
It casts a fragile, temporary shadow, animating my room with Mexican folk history.
Every night this paper cutout comes alive with the light of a Pontiac street lamp, like the moon illuminating a story of death. During the day, the sun shines through, as life continues. This duality of life and death, sun and moon, inspired me to weave a transparent piece for a window, a window of life and death.

Untitled
7'4'h x 2'4'w
Mixed media
Collection of Mr. and Mrs. Leslie Rose

The streets of Mexico also provide opportunity to experience the overlap of cultures in material objects and to realize the objects which are often regarded as pure manifestations of nationality or ethnic identity are, in fact, shaped by the most unexpected influences from foreign places. The Spaniards brought European culture to Mexican Indians. They also brought silk and wool and metallic thread, and new ideas about clothing oneself or one's environment. A brilliant tradition of ceramics was dramatically altered when Mexican craftsmen saw Chinese porcelains which were being shipped overland from the Pacific to the Atlantic on their way to European markets. The richly decorated tiles of *Puebla*, regarded by many people as being quintessentially Mexican, would not exist without that Chinese influence. Even *Diego Rivera*, with his own great respect for the traditions of image-making in Mexico, superimposed Italian Renaissance and French Cubist principles of space and composition into his visions representing the Mexican people.

The influences continue to arrive, one after another, on every jet, automobile, airwave, or newspaper that brings in the exotic or foreign. Today, one must recognize intercultural exchange as the chief characteristic currently redefining the products, including the art, of people everywhere, and nothing is immune to that change (a frustrating fact for the purist who only finds value in objects of the past and expects that everything new should comply). The life of any art exists on the edge of change. Is it possible that the pluralism of our own time may result in important new expressive forms? As many people lament the loss of tradition, are new traditions being formed? What is the role of art in the expression of those new traditions?

Most Americans have grown up with the condition of change and with anticipation for that which is new. One of the greatest pleasures of our ability to travel outside the United States is the discovery of traditions and customs which often satisfy needs that are unfulfilled in our own cultural environment. *Mexico City* was an easily accessible place where the members of our department could experience a degree of cultural homogeneity linked with a past that is different from our own, a place where we might discover something more about the link between art, craft, and living experience, a place where need determines the form and function of art.

Nancy Yaw, owner of the Yaw Gallery in Birmingham, MI and a dedicated supporter of past endeavors, suggested it might be possible to find patrons to sponsor transportation and hotel expenses for each student. As a benefit of sponsorship, each patron would receive a work produced by one of the students, following our return. The involvement of the patrons who generously supported the project was particularly significant. It opened some channels of communication demonstrating that meaningful interaction between artist and patron can occur and that each has something to learn from the other.

A highlight of our experience occurred at the Franz Meyer Museum where Director Eugenio Sisto Velasco and Assistant Director Hector Rivero Borrell made gallery space available for an exhibition of works by Cranbrook students along with works produced by students of textiles at the *Universidad Ibero-Americano* under the direction of Marcella Gutierrez and Lydia Soto. A symposium held the evening of the opening provided opportunity for all of the artists involved to meet and exchange ideas in the presence of their works. For this exhibition we are pleased to welcome Marcela Gutierrez to Cranbrook as visiting artist and lecturer.

In Mexico, we had opportunity to see many wonderful traditional textiles that served as one source of inspiration for our own responses. Some examples of traditional Mexican textiles are included in this exhibition, generously loaned from the collection of James Bassler, artist, Professor of Fibers, and acting head of the Department of Art, U.C.L.A. We anticipate his visit to the Academy during the course of the exhibition as guest artist and lecturer.

Face to Face: Cranbrook/Mexico is evidence of a brief moment with people, environment and experiences in a foreign place. The exhibition also shows the result of a face to face encounter with the self, as each artist consciously enquires about his or her own identity and values in the presence of that which is foreign. We welcome the opportunity to share those moments which have contributed to the development of our art and our future.

Gerhardt Knodel
Artist in Residence and Head of Fiber Department

Arrive Mexico City 1
("House of Tiles"), Iglesia de San Francisco, dow

Depart by bus to Oaxaca, town know
where ikat robozos are woven. Drive through

Bus to Aztec City called Teotihuacan. Climb

Installation of work at Franz Meyer Museum als
of Education and

Bus to Cacaxtla with Mexican studen
Out to Puebla, famous for ceramic tiles. Lu

Early morning trip to La Merced, large city
Diego Rivera's museum housing his pre-Columb
filled with Rivera paintings and pre

To National Anthropological Museum in

Take down exhibition at Franz Meyer Mu

The planning of our itinerary was facilitated
and in Mexico. Our thanks is extended to all

Animal Adoption Folder

"Contribute to the Dallas Zoo and adopt an animal too." That was the idea behind the 1983 fundraising brochure titled *The Dallas Adopt-an-Animal Catalog*. The amount pledged determined the animal species that the donor was entitled to adopt. Rather than simply adopt one small creature, Richards, Brock, Miller, Mitchell & Associates of Dallas adopted the entire zoo. "It was one of several organizations we elected to help with their communications," says Richard Mitchell. The firm designed the Dallas Zoo's logo and several smaller projects including this brochure. While the zoo paid for the printing and typesetting, the firm absorbed the cost for the time, production, and implimentation of design, illustration, and copywriting—a sizable donation of funds and resources given its firm's overhead and production expenses. The fundraising effort succeeded in raising 80 percent of the zoo's goal.

Art Directors: Robert Forsbach, Nancy Hoefig

Illustrator: Robert Forsbach

Client: Dallas Zoo

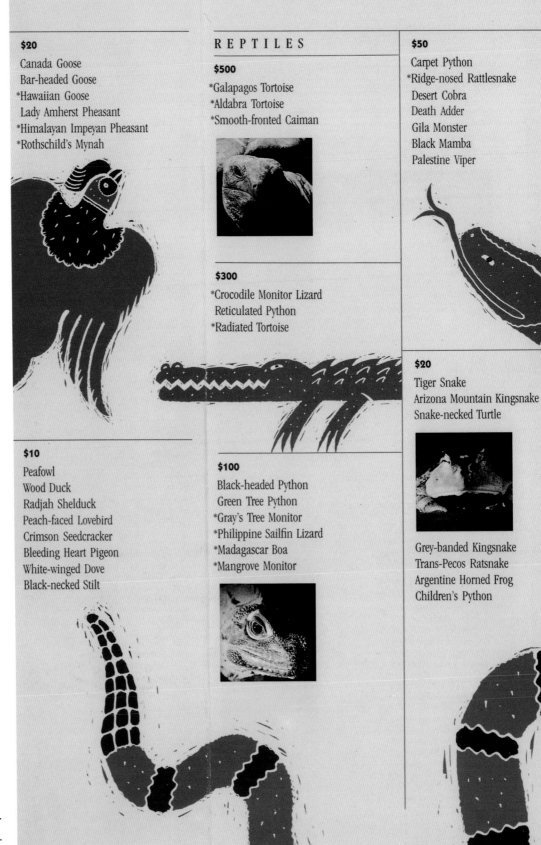

$20

Canada Goose
Bar-headed Goose
*Hawaiian Goose
Lady Amherst Pheasant
*Himalayan Impeyan Pheasant
*Rothschild's Mynah

$10

Peafowl
Wood Duck
Radjah Shelduck
Peach-faced Lovebird
Crimson Seedcracker
Bleeding Heart Pigeon
White-winged Dove
Black-necked Stilt

R E P T I L E S

$500

*Galapagos Tortoise
*Aldabra Tortoise
*Smooth-fronted Caiman

$300

*Crocodile Monitor Lizard
Reticulated Python
*Radiated Tortoise

$100

Black-headed Python
Green Tree Python
*Gray's Tree Monitor
*Philippine Sailfin Lizard
*Madagascar Boa
*Mangrove Monitor

$50

Carpet Python
*Ridge-nosed Rattlesnake
Desert Cobra
Death Adder
Gila Monster
Black Mamba
Palestine Viper

$20

Tiger Snake
Arizona Mountain Kingsnake
Snake-necked Turtle

Grey-banded Kingsnake
Trans-Pecos Ratsnake
Argentine Horned Frog
Children's Python

on Dart Frog
r Salamander
r Siren
rded Dragon
defoot Toad
ailed Gecko
e-headed Lizard
e-tongued Skink

EDUCATIONAL ANIMALS

While not on public display, these animals are used in the Zoo's school outreach programs. They need Zoo Parents too!

$50

"Christian", the Burmese Python
"Junior", the Burmese Python
"Tommy", the Yellow-headed
 Amazon Parrot

$20

"Terry", the Screech Owl
"Noah", the Rainbow Boa
"Ringo", the European Ferret
"Laverne", the Opossum
"Shirley", the Opossum
"Taco", the Bolivian 3-banded Armadillo
"Chaco", the Bolivian 3-banded Armadillo

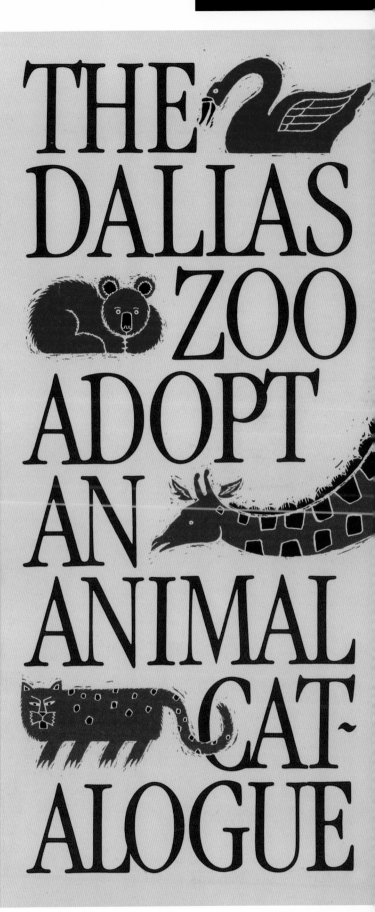

THE DALLAS ZOO ADOPT AN ANIMAL CATALOGUE

**Zoo Newspaper
and Stationery**

For many years the printed matter used to promote The Zoological Society of Houston was at best amateurish. Lowell Williams Design of Dallas convinced the society that an updated image could be conceived for an initially small investment. They donated the design and mechanicals for a flagship project called *Zoo Quarterly*, a sixteen-page, three-color tabloid, printed on 50-pound newsprint on a web-offset newspaper press. Exciting typography was one way to overcome the inexpensive look of the printing, and custom photography (usually shot for half the usual day rate) enhanced the content of the publication. Today, the entire journal is produced on the MacIntosh using Quark Express, representing enormous production savings. Though Williams designed the initial format, all the studio members offered versions of the masthead (a children's book aesthetic that later carried over to the zoo's general signage). The design and mechanical services involved in producing the stationery were also donated, and printing costs for an adequate number of letterheads, envelopes, business cards, memo and note pads came to only $4,500. The donations proved profitable for Williams, since his firm was also commissioned, for a reasonable fee, to design most of the zoo's graphics and sign systems.

ZOO BABY

Baby Brisbane Takes a Bow

For the first time at the Houston Zoo, a Bennett's wallaby has successfully reproduced. Discovery Zoo Keeper Carol E. Nickson photographed the male joey, which was probably born in September 1985. A joey emerges from its mother's womb still in the embryo stage and crawls up into her pouch. There it stays for seven or eight months before it takes a look at the world for the first time.

"When we first looked at the [] he had a pink head with no ha[] Nickson recalls. "He started d[]oping after that."

Brisbane is housed in a g[] pen on the east side of the [] ery Zoo, along with a coupl[] and Roody the kangaroo. []garoos, wallabies are very [] like to hide, and they see[] the heat of the day," Nic[]

Visitors must be pati[] a good look at Brisban[] definitely worth the v[]

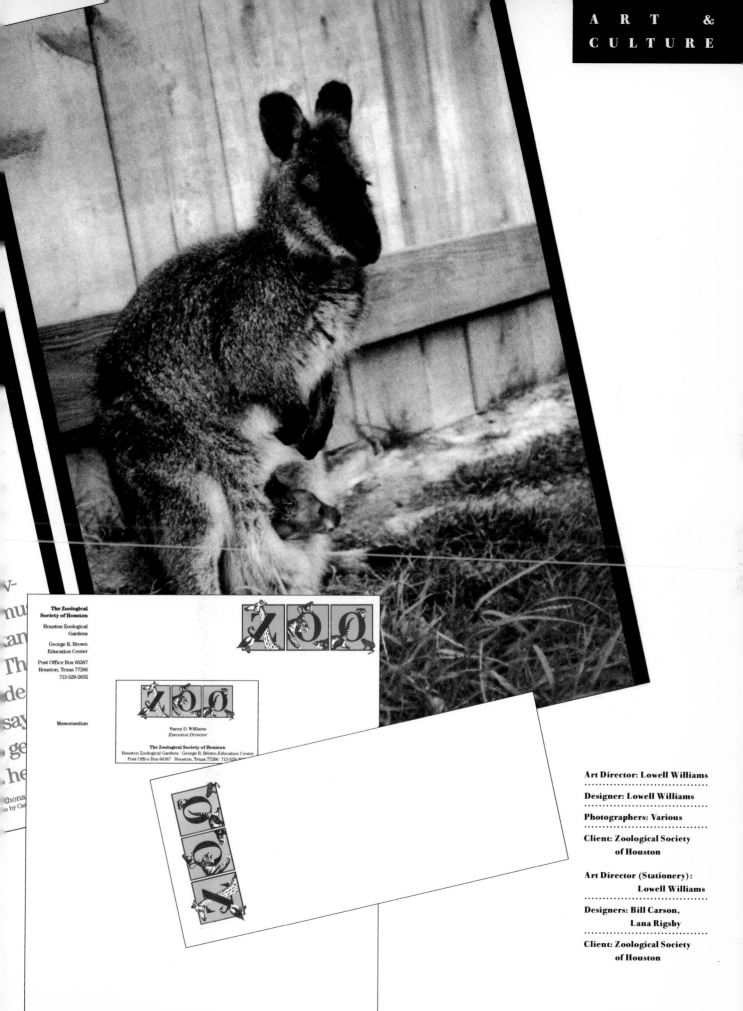

The Zoological
Society of Houston

Houston Zoological
Gardens

George R. Brown
Education Center

Post Office Box 66387
Houston, Texas 77266
713-529-2632

Memorandum

Nancy D. Williams
Executive Director

The Zoological Society of Houston
Houston Zoological Gardens George R. Brown Education Center
Post Office Box 66387 Houston, Texas 77266 713-529-2632

Art Director: Lowell Williams
......................................
Designer: Lowell Williams
......................................
Photographers: Various
......................................
Client: Zoological Society
of Houston

Art Director (Stationery):
Lowell Williams
......................................
Designers: Bill Carson,
Lana Rigsby
......................................
Client: Zoological Society
of Houston

Experimental Magazine

In 1984 Rudy Vanderlans and Zuzana Licko began publishing *Emigre* magazine, a revue of contemporary culture and phenomena. In recent years it has become a paean to experimental design and the archtype of computer-inspired typography. Unline commerical publications that start with a targeted base of advertisers and readers, *Emigre's* founders were initially unconcerned with the vicissitudes of the marketplace. Not having an existing publication through which they could test the limits of graphic communication, Vanderlans, a designer for the *San Francisco Chronicle*, and Licko, a designer and typographer, wanted a discrete outlet to try their own experiments.

Emigre was produced without any budget. Funds were limited to the bare essentials—type and printing. For content, they depended on artwork and writing donated by friends. For production, since the first few issues were produced before computer-aided design (specifically, the Macintosh) was perfected, they used traditional paste-up methods and a photocopier for enlargements and reductions. They nurtured a relationship with a local printer, whom they convinced could benefit from their burgeoning periodical. Most important, Vanderlans studied and practiced pre-press production shortcuts (including darkrooms skills and stripping techniques) that would save money and increase his options. "We wanted design to be afford-able," he says. "It was a chal-

Jeffery Keedy.
Announcement for Los Angeles
Contemporary Exhibitions (LACE).

same medium. Therefore, they are conceptually closer together than they once were. As we move on, I think that that idea will evolve and be represented in different ways. For myself, I don't use the bitmap look very much. I am interested in other things. But I understand the idea and I incorporate it conceptually, not just formally, into what I do. I am very suspicious of notions of purity and appropriateness.
Emigre: Do you think that the Macintosh contributes to a homogenization of design?
Jeffery: I think it will on some level, in a way that any other tool has. Typewriters certainly created a homogenous look to letters and at one time, press type created a certain homogenous look among headlines. Of course the computer will do this, too, in some respects, but I don't know what an alternative to that would be. It would be the case regardless, for any tool that we all use. But as the tool and its user become more sophisticated, the similarities become less apparent.
Emigre: What do you tell a fellow designer who comes to you for advice about the Macintosh?
Jeffery: Most people want advice about purely technical things. They are mainly concerned about what computer to get and such, and are not worried about what this is going to mean to them and their work. Most designers will want to find that out by themselves. They realize that the Macintosh is a great tool that allows them to cross over into other disciplines. That's one of the attractions of the machine.
Emigre: Is there still a fear of computers with the designers around you?
Jeffery: Yes, there is still a fear or resistance with designers in regard to the computer, although when I speak directly,

one-on-one, with designers, I don't find much of it. But in a broader sense, in terms of the design profession, I find a lot of paranoia about it.
Emigre: What does the paranoia stem from?
Jeffery: Design is a busines. And just as with any other business, there is a fear about how the computer is going to affect people's jobs. People ask, "When I'm a production person, will this machine put me out of work?" Or, "If I am an illustrator, am I going to lose work from this?" That is the underlying fear that a lot of people have. The other fear that designers have is of the computer's autonomous nature, the way that it defines itself--it has so much control. And I think that designers, out of ignorance and arrogance, feel that they have to relinquish control or transform themselves or their vision, which I think is actually not the case at all. And I 'm finding it again and again with students and younger designers who are getting into this with no preconceptions or fears. It is unfortunate that a de-

signer like Paul Rand would say he "resents computer graphics--they are an affront to his sensibilities" ("ID" Magazine, Nov./Dec. 88), but understandable from someone who just can't see beyond the most superficial aspects of new work and new possibilities. His retirement is obviously past due. Computers are for the designers of the present, not designers of the "timeless" past.
Emigre: I think the industry is waiting for the Macintosh to grow up and become the perfect tool, which can mimic exactly what they have done for years.
Jeffery: That's true. And then more people will use it. And after a certain point, they will start doing new things with it, things it alone can do. It was the same with cars. The first cars looked like horseless carriages. They had to have that familiarity, even though cars had absolutely nothing to do with horses. They were an entirely new mode of transportation. I think that many designers are looking for the computer to do things in a traditional way, even though that doesn't make any sense; it's a new mode of communication.

tosh will contribute to a homogenization of design. They fear that the Macintosh has too strong a character and will therefore overshadow and restrict personal expression. You mentioned yourself that you enjoyed some of the Macintosh characteristics, such as funky spacing and low resolution.
Rick: That's just a coding attached to the most basic function of the system. That's like typewriter type. It tells you where it came from. Letterpress type has this too; you know it by how it feels. It's the difference between engraving and offset. I don't think you should dismiss it because of that. I think the Mac aesthetic should be employed when it's necessary because when it's employed it brings a meaning, like a "power" tie brings to a meeting a certain meaning and a definition. Just as manipulated photography brings meaning to a design. You don't dismiss a photographic image because you can see that it was manipulated. I think that the aesthetic of the Macintosh will become as vernacular or as accepted as the typewriter has.
But to answer your question about homogenization, it will perhaps be no more dramatic than the International Style was and its use of Helvetica and three-or four-column grids.
Emigre: The reason why you see similar results now is probably due to the newness of the computer. Designers are in an experimental phase.
Rick: That's right, we have not used the computer as a natural extension of the individual. But when that happens...and it is happening in Wolfgang Weingart's work for instance, it has his mark all over it. And in April Greiman's work; it's very rich. The computer is just another hand on her body...(Sorry April, I couldn't resist that rather provocative image.)
Time is the issue now. Currently, the most significant contributors to the Mac catalog of design are young designers. These designers, while exploring the Mac, were in the early stages of their careers. The traditions of design that they bring to their work are less experienced.
As soon as the more experienced graphic designers find time to work and experiment with the Mac, the results will appear very different from what we see now, because they will bring much more past experience to this new process. We have seen this happen before, in situations where the letter press typographer set type photomechanically. Their expectations of the process were different. Their typographic concerns surfaced. It's all a matter of time. I look forward to seeing what designers such as Ivan Chermayeff, Woody Pirtle, or Michael Manwaring will bring to the ever-growing Mac catalog.
Emigre: A lot of the early work that was produced on the Macintosh was low resolution, and with this we saw the emergence of quite a few low resolution typefaces that were mostly designed for screen display. Now we see these typefaces in print as well. How do you feel about this?
Rick: Actually, I already see some of this low resolution, Mac-inspired, digitized type on public access stations. And nobody seems to want to turn it off because it wasn't set in Garamond. However, the applause for it remains silent.
Emigre: Why do you think most people have no problems reading low resolution type on a screen but are bothered by its appearance in print?
Rick: It may be that it becomes this little "design" device, like typewriter type is a "design" device, and people will only use it as a novelty, which will be sad. It's with the high resolution capabilities of the Mac, such as with the Adobe Postscript fonts, or even the Emigre type that you are reading right now, where it has its own character. There, it's not about bad resolution type on a TV screen. It's about new letterforms. And with Adobe, it's about the reproduction of existing letterforms in an economical way.
Emigre: How do you feel about Adobe and their effort to reproduce existing type for use in Postscript? Most of those typefaces were originally designed for lead, and were later redesigned for photographic reproduction and now, again, they have been redesigned for digital reproduction.
Rick: It doesn't matter where it came from. We will always have an appreciation and a need for the letterforms that were rendered in the sixteenth century. And just as those letterforms represent a certain attitude, whether those attitudes are about stability or refinement, we'll use them for those messages. Today, when we see such fonts as Zuzana Licko has designed, where the character of the letterforms speaks about a spirit of technology as well as about the machine that they were generated on, we will use those for *their* inherent meanings.
Emigre: Where will we use it? When is it appropriate to use low resolution type or imagery, or high resolution computer-generated type, such as Zuzana's? Only in print work that is computer-related?
Rick: That's a great question. It requires a crystal ball to answer. The creative vision of our design community will provide visual answers. Let me give you an example. If we assume that any typography that reflects Mac technology carries with it the assumption of lower costs, then a non-profit corporation or a healthcare facility will employ it for their annual

GO TO

scanned], while at the same time you can beef up some of the more textural things that you might import from other tools. **Emigre:** Are there still things that you find are impossible to do on a computer, but that you would like to do? **April:** I have one problem with the graphic paintbox, and it's not the fault of the equipment. The problem is that **I can't afford,** either for a client or even for myself, **to experiment enough** in order to get loose on it. A lot of the work on the paintbox is done with an operator. Now, I have one operater who just sets up the machine for me and lets me play on it, but mostly I have to give instructions like, "Oh, please a little more red," "Eh...could you just move that slightly..." So the graphic paintbox lets me do things that are wonderful and that I need, and the Macintosh does some things

Jeffery Keedy
Announcement for Los Angeles Contemporary
Exhibitions (LACE).

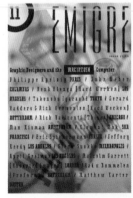

lenge to make a limited amount of money go a long way."

When the Macintosh was introduced in 1984, Vanderlans and Licko immediately bought one. Like true pioneers, they began to push the limits of the primitive type and design programs and developed a decidedly unconventional appearance and unique identity. They soon subscribed to *Font Editor*, a public domain bitmap editor, now replaced by Altsys' Fontastic, which allowed them to design new typefaces for the computer. Vanderlans had dubbed this foray into uncharted waters as a "new primitivism." Critics have equated his approach with the early twentieth-century typographic avant-garde. With

continued on next page

the availability of Adobe's Postscript, Licko is now able to design high-resolution typefaces. Today *Emigre* is hardly dependent on advertising reveneue because it is supported, in part, by Licko's typeface designs, which are advertised by example in *Emigre* and through distinctive catalogs and specimen sheets. Freedom from advertising constraints allows Vanderlans and Licko increasingly more experimental leeway. As an example, issue no. 11 is completely devoted to the design possibilities of the Macintosh as practiced by a group of international designers.

Emigre has increased its print-run from five hundred to four thousand copies, yet owing to the unfaltering relationship with their printer,

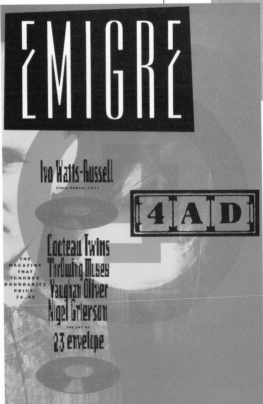

Clement Mok, San Francisco, 1/29/88

Emigre: Tell me about how you got your job at Apple.

Clement: It was by accident that I ended up at Apple. During the summer of 1982, I was on vacation in San Francisco when a friend of mine suggested that I check out an Art Director position at Apple. Apple what? And where was this godforsaken place? I was working in New York at the time and the thought of relocating to the "outer outer suburbs" of San Francisco was like moving to Timbuktu or to Siberia. No way in hell would I consider it. Yet I was intrigued by what I had heard about Silicon Valley. Steven Jobs had just appeared on the cover of "Time" magazine, and I thought, wouldn't it be great to work there and maybe even work side by side with this great entrepreneur? Anyway, to make a long story short, I paid Apple a visit and I was hired right on the spot. It took me another two months before I took up the offer. I had never worked on a computer. Closest I'd ever been to a computer was PacMan. Tom Suiter was Creative Director at that time and he told me I would have an option to work on one of two projects; either the Lisa or the Macintosh. I had no idea what either computer was about and at that point in time I couldn't have cared less. No matter what, it would be a great opportunity to be exposed to this new technology of which I was absolutely terrified. I was very intrigued though, by some of the early animation graphics such as those in TRON, and the Scitex had just come out. The first design work I did at Apple was all promotional material for the introduction of the Macintosh. Nothing was actually done on the Macintosh at this time. The first thing that was demonstrated to me on the Macintosh was MacPaint. At this point, there was no printer for it, and all you could do was bitmaps. I still have some of the early development material and much of that early vocabulary was all bitmap. Susan Kare was also hired by Steven Jobs to come in and help design the screen displays and screen typefaces.

Emigre: This is when you designed the first manuals for MacPaint, with the robot drawing, etc.?

Clement: Yes, we designed all the early manuals but also all the screen displays, such as the menu bar for MacPaint and MacWrite. Steve Jobs had certain suggestions about the graphics and we did, too. As on hindsight, I'd say we made some bad decisions, because we were constantly defaulting to what we knew worked in print. Some of the stuff is really funky, but it did project a personality and reflected the people who created the computer.

Emigre: Those first screen layouts became a standard for many software programs that followed. Did you realize you were creating a solution that would be copied for years to come?

Clement: No, we had no idea, although we realized there was an opportunity here to define some standards. We were trying to come up with solutions for some radically new notions. How do you show "dragging," or "double-clicking"? In print, this does not exist. You understand how the machine works but how do you visually explain these things to people? So there was an incredible opportunity to create something new.

Emigre: Was there proper time to test these things?

Clement: Hell, no! The MacPaint manual was designed and printed in one month. The first draft was very long and Bill Atkinson said it shouldn't be that long because it was such a simple program. So it ended up being only thirty pages.

Emigre: I think it is still the best manual I've seen for any Macintosh software. I only had to read the first six pages and I was able to work with it.

Clement: Yes, I still think it's the best piece I've produced there. It's simply because I fully understood the product. In order to deal with these projects, you have to live and breathe them for a while.

Emigre: Correct me if I'm wrong, but it's my observation that Apple was always the last to utilize their own technology in the design and production of their print work. Why was this?

Clement: It's true. Part of it has to do with growth and, also, they were too close to it. It's like the cobbler's kids. They are the last to look at the shoes. Having all these computers around you and trying to design all this stuff for it, there was just no time to sit down and explore and use the computer.

Emigre: How do you feel about the early explorations that were done on the Macintosh, the low resolution bitmap graphics? Do you expect any of this to survive?

Clement: I've been thinking about this. There have been instances when new visual vocabularies were introduced and some have been accepted by the general public and some have not. The Dada and Futurist movements were not accepted or even regarded in the past by the general public. But over time, they were accepted. Right now, people look at this low resolution stuff and they think of it as another one of those crazy movements, or as a new style or trend, and they don't like it. A lot of the work that was produced between 1984 and now on the Macintosh, such as April Greiman's, with the exaggerated jaggies etc., is in a new visual language, but it is one of those things that people just don't feel comfortable with yet. They will have to slowly familiarize themselves with this. Designers will have to adapt it and change it a bit or do different things with it. But I do think that low resolution has created its own language and it's definitely a very viable quality that hasn't been properly explored yet.

Emigre: In an earlier conversation, you mentioned that low resolution will disappear because of the demand for high resolution computer screens and output devices, and you said that the industry is working towards these rapidly. Will this contribute to the eventual disappearance of low resolution graphics?

Clement: Low resolution is just a result of what was possible at a given time. The fact that it happened was determined by all sorts of social and economic factors. If you look at the psychedelic sixties for instance, they had all these great dayglow colors which were new and people loved them. Out of this came a look which was represented by the psychedelic and paisley patterns. Or look at "Memphis," for instance. It was tremendously popular. The time was right for it and then it sort of disappeared. But that doesn't invalidate what it represented. And those styles are not going to go away. I see low resolution as an art form in the same context as I see other art forms that existed in a certain time period, and which still exist and are still legitimate in the context in which they were created. Graphic design is about mixing. Designers will take a bit from Mondriaan, a bit from Dada, and will eventually mix in some of

GO

No, just give me a basic system hard-

core supporters and zealots could such

information be supplied Have you ever

wondered what it would original television te

chnology something I've already done like this

almost as much

as I like I want

to hook up my

I'm also w on de

ring if I can do

Soon you will b

e to c rea te Lea ding -edge I was shocked when I

open en my eyes even if you've never been When I saw a

Full-page photo after I'd carefully read it needs

a lot of care and the same concern

I have I drew from the experience

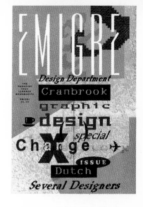

printing costs remain low.
After six years *Emigre* is
nearing a degree of profita-
bility. *Emigre's* focus has also
become clearer. Now aimed
exclusively at graphic design-
ers, the business is able to
stay relatively small and deci-
dedly manageable, allowing
the pair the luxury to refuse
unwanted outside work.
Vanderlans and Licko admit
that doing a "no-budget"
magazine "takes heart and
hard work seven days a
week," but it is worth the
effort if the result is original.
Emigre shows that a mixture
of passion and devotion are
active ingredients in the de-
velopment of a significant
body of work.

Art Directors: Rudy
Vanderlans,
Zuzana Licko
...........................
Designers: Rudy Vanderlans,
Zuzana Licko
...........................
Illustrators: Various
...........................
Photographers: Various
...........................
Contributing Designers:
Various
...........................
Client: *Emigre*

Scholarly Journal
...

The *Visible Language* was
founded by Merald Wrolstad
in 1967 (and published by
him until his death in 1988)
to investigate the effects of
typography and design on the
broader visual culture. Its
contributors include anthro-
pologists, linguists, perceptual
psychologists, calligraphers,
and, of course, graphic
designers — all of whom sub-
mit papers for review.
Scholarly journals are tradi-
tionally low-budget opera-
tions, and despite grants
from funding institutions,
The Visible Language is no
exception. Its new editor,
Sharon Poggenphol, asked
Thomas Ockerse and his stu-
dents at the Rhode Island
School of Design to work on
issues for which a $500 con-
tribution was alloted for
"design materials" (which was
applied to a variety of things,
including photocopies, stats,
and so forth). In addition to
the overall design, the gradu-
ate students are responsible
for the production. Currently
it is being done as a desktop
publication, with $1,500
given to cover secretarial and
word-processing chores, com-
puter and darkroom use, and
all materials for mechanicals,
layout, and design. Each issue
is designed differently to
compliment an issue's special
theme, as well as to explore
the boundaries of the new
technologies. The issue
shown here was half an exhi-
bition catalog for "The
Avant-Garde and the Text,"
and half a commentary and
analysis of this historical
show.

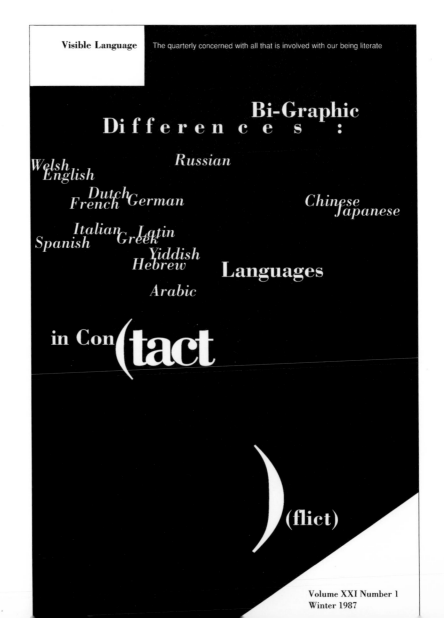

64. Wieland Herzfelde, editor of Malik-Verlag publishing house, would regularly assist George Grosz in the organization and preparation of his prints for folio editions, often providing timely political captions for the satirical works. Composed of a series of lithographs completed by Grosz over a period of five to six years prior to its release, Ecce Homo was produced in both regular and deluxe editions, the latter prepared for publication in order to accrue funds for other Malik-Verlag publication ventures.

62. Richard Huelsenbeck, *Phantastische Gebete*
Berlin, Der Malik-Verlag/Abteilung Dada, 1920
Book, 26 x 18 cm., 31 pp.
Covers, front, and back by George Grosz.

*63. Wieland Herzfelde, *Tragigrotesken der Nacht: Träume*
Berlin, Der Malik-Verlag, 1920
Book, 23.5 x 16 cm., 89 pp.
Cover, twenty drawings and
one photomontage by George Grosz.

*64. George Grosz, *Ecce Homo*
Berlin, Der Malik-Verlag, 1923
Folio of lithographs, deluxe edition,
in cloth-covered slipcase, 35.5 x 27 cm.
Vol. I, 176 pp.
with 84 black and white lithographs;
Vol II, 16 color lithographs.

BENSON

possible audience. While the Berlin Dadaists were as deeply ambivalent of a future utopia as they were skeptical of the means of its attainment recommended in either political or aesthetic radicalism, they were able to envision what the "Dadasoph" Raoul Hausmann called an *Übergangsform* [form of transition] in the immediate present.[5] While ultimately no less "fictional" than the historicist myth it sought to replace, this concept accepted the material conditions in which meaning occurs and thus conferred an unprecedented degree of objecthood on the text. This attitude briefly opened aesthetic activity, and in particular treatment of the text, to a host of hitherto excluded influences from the broader culture. The Dada text assumed guises ranging from the vernacular to the fashionable, from the found object to the commercial product, illustrated journal, and American film. This paper is concerned primarily with the formal transformation of the text as artists took advantage of this opportunity.

. . .

In the early modernist era prior to the twentieth century, it had generally been the content rather than the appearance of a given text which conveyed the revolutionary objectives of radical artists and writers. There existed, however, a long tradition of declarative devices alluding to the text. The red masthead of Hans Leybold's journal *Revolution* (figure 25, cat # 18) continues this legacy while sharing with Richard Seewald's cover woodcut the straightforward purpose of referring to the image of revolution as "active, singular, sudden," and "chaotic," as Erich Muhsam defined it when setting forth the journal's ideological framework in its opening essay.[6] Developing a circulation of 5,000 during just two months of publication, *Revolution* was quickly banned by the censors.[7] Within the context of other such journals, the visual format for *Revolution* assumes additional impor-

Figure 25

Art Director: Thomas Ockerse

Designers: Peter K. C. Chan,
Doug Banquer

Client: Visible Language

Art Director: Thomas Ockerse

Designers: Thomas Ockerse,
Laura Chessin

Client: Visible Language

Independent Magazines

When two teenage brothers with the *noms de plume* Knickerbocker and Domino Knox decided to coedit and publish an arts, politics, and satire journal, they had to scrape to come up with the $500 necessary for printing 1,000 copies (a figure that was bargained down from $750). But the "graphic itch," as Knickerbocker calls his compulsion, and the "political urgency" that his brother felt, caused them to produce a rather handsome-looking and surprisingly literate journal titled *Surge*. Most of the typesetting was done on a Selectric typewriter and handlettering is pervasive, yet the typographic texture is consistent with the cheap newsprint on which it is printed. The graphics have a homemade quality, but the cover (which was originally drawn in miniature by Knickerbocker during an English class and then radically enlarged on a photocopier) has a remarkably fresh poster-like appeal, despite the fact that Knickerbocker says the color is "all wrong." By using photocopies for repro and correcting fluid to mask out unwanted material production costs were minimal. *Surge* has sporadic distribution to comic-book stores, groceries, and was sold at street events and demonstrations. An unresolved "graphic itch" is a good reason for continuing to publish, but Knickerbocker also felt that he had more to say about politics and the environment than *Surge* allowed him to express. *No Zone* was the next step in his publishing adventure. It has comics and

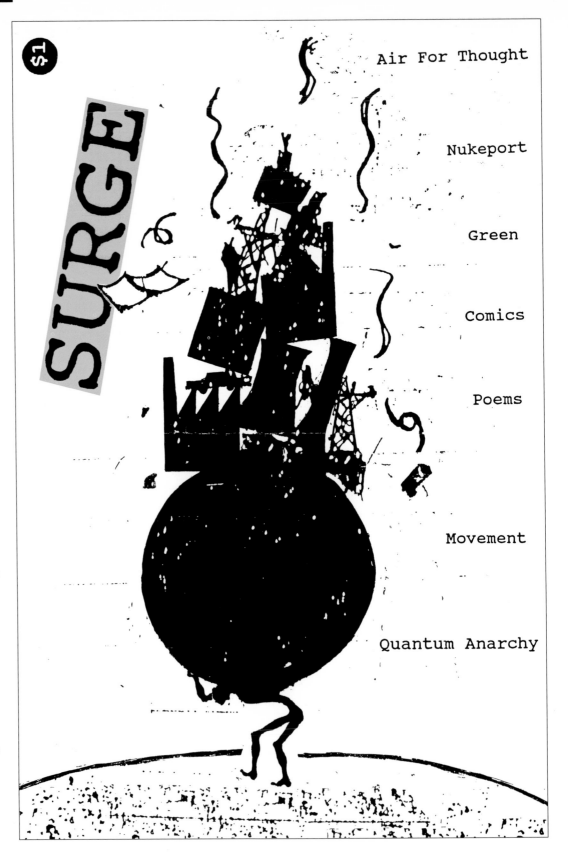

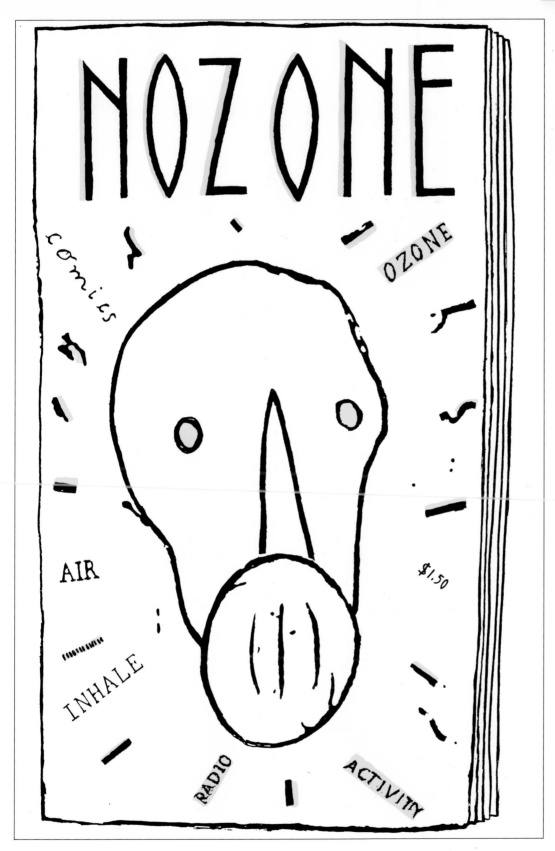

graphics (by such veterans as Mark Allan Stamaty, Edward Sorel, and others) and includes a *No Zone* gas mask as a premium. The separate cover and bindery expenses are $300 and the thirty-six newsprint pages cost $350 for a thousand copies. *No Zone* will be professionally distributed to comic-book stores and newsstands.

Art Director: Knickerbocker
.
Illustrator: Knickerbocker
.
Client: *Surge*
.
Art Director: Knickerbocker
.
Ilustrators: Various
.
Client: *No Zone*

Texas Guidebook

Simply designing a book for
a client is time consuming
and labor intensive. Packag-
ing a book for oneself,
however, is even more so,
owing to the fact that the
"packager" must conceive,
write, design, and sell the
property. *How to Be a Texan*,
a guide to explaining Texas
to the masses, grew out of a
brochure that Mike Hicks
produced for *Texas Monthly*
magazine. Though a $15,000
advance (plus royalties) was
paid by Texas Monthly Press,
the initial investment in
time, services, and artwork
was considerably higher than
the budget allowed. Illustra-
tors were asked to work for
below their market value,
and the studio labor was
marked down considerably.
The result was more than
satisfactory: The book is in
its sixth printing. Royalties
are sent out regularly, and
though Hicks still hasn't
earned "enough to start his
early retirement," he is proud
to report, "I am Texas
Monthly Press' bestselling
author, even though I have
never written anything with
plot or chapters."

**Art Directors: Mike Hicks,
Tom Poth**

**Designers: Mike Hicks,
Tom Poth**

**Illustrators: All Hixoids,
Tom Ballenger,
Tom Curry,
Patty Heid**

Client: Texas Monthly Press

HOW TO BE TEXAN

Here it is, Bubba. All you'll ever need to know about walking,
eating, talking, dressing, drinking, driving, and thinking Texas-style.

By Michael Hicks

*Produced in Texas
by Texans*

BOOTS

**1. The proper way to wear boots
in Texas.** Buy your boots. Select
something that is not absolutely
covered with delicate leathers and
western scenes. A straight brown
leather, saddleheel pair will
do nicely.

2. Take them home (or to your
hotel) and find a rough-textured
surface like a driveway. Now, beat
and scrape your new boots until
they're dented, bruised, and scarred
deep enough to expose the lighter
colored leather under the skin.

3. Fill your bathtub or sin
soak the boots in water up
the ankles for an hour. Po
water out and put them o
stretch and fit your feet ex
your boots on, dry them
hot oven or with a hair d

CUISINES

CHICKEN-FRIED STEAK

If anybody did a survey on the subject, it would probably show that most of the steak consumed by Texans is chicken-fried.

For those new to Texas, that's steak prepared in the style of fried chicken (as opposed to being fried by large chickens). Alas, finding a good chicken-fried steak in a major city can be a problem. It may be easy to find a bad one, but it will be tasteless and unchewable. A truly great one, on the other hand, is fork-tender, lightly breaded, crisply fried, and covered with Mom's good cream gravy. Although living in an urban environment seems to render most cooks powerless to produce an acceptable chicken-fried steak, this is one dish that you *will* be able to find in Waco. Remember, there is just one way to cook a chicken-fried steak; ordering it medium rare will only get you a round of hearty guffaws from everyone within hearing distance.

CHILI

This has got to be the official dish of the state. As you might imagine, there are several factions among Texas chili fanciers, the most notable being the "bean" and "no bean" proponents. Regardless of your affiliations, there seems to be a consensus that the hotter the mixture the better for the soul. There are chili parlors spread all over the state, and there are few restaurants that don't have some form of this local favorite on their menu. One note to travelers: some years ago, a retired anvil salesman is rumored to have requested kidney beans to be added to Wick Fowler's chili recipe; he has not been seen since. There is no such thing as a kidney bean in Texas. This is an inferior bean at best and the color alone should preclude its use in any dish served to humans. Pinto beans are the only suitable accompaniment for as noble a dish as Texas Red.

BOOTS

4. Find some mud or fresh manure (available at most better nurseries) and pack it all around your boots. Get the mud real wet so that it will get caked around the soles and in the stitching. Now, take your boots off and put them back in the oven at low heat until they are thoroughly dry (being sure to leave as much on them as possible).

5. Take a butter knife and scrape off as much of the mud as you can. Put your boots on and stomp around, shaking off most of the remaining dirt.

6. Your boots are now ready to wear. Be careful not to prop your feet up on any expensive upholstered furniture for a few days, until your boots have fully cured. There's nothing worse than some green horn walking into an official get-down country affair with new boots on. He'll be ridiculed without mercy.

City Magazine

Although it was a "wild-hare scheme" to publish a magazine, Dugald Stermer and seventeen others each decided to invest $2,000 in buying and restructuring a failing San Francisco rock and roll magazine into a "radical, cultural, political statement" replete with humor, essays, fiction, and nonfiction. *Frisco* published four issues before bankruptcy and "fist fights" forced its demise. From the outset the staff was not paid, yet publishing was still very costly. "The realities of this business were clear from the outset: There was no way of making money on our investments! Moreover, making writers and artists cooperate with deadlines was impossible," laments Stermer. One of ten editors, Stermer designed an easy-to-maintain, inexpensive-to-produce format that, while allowing for visual surprise, was clean and logical. The logo was actually a photo of a neon sign for a transvestite-country western bar. Each issue of *Frisco* cost $8,500 for ten thousand copies (discounting the free labor, but including overhead, each issue cost almost a dollar to produce). The first issues were black and white and eventually went to four color. There were no subscriptions, so what few copies purchased were sold at newsstands.

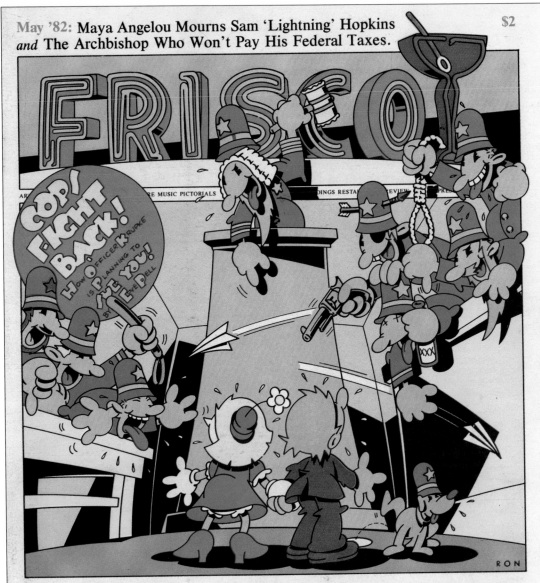

May '82: Maya Angelou Mourns Sam 'Lightning' Hopkins *and* The Archbishop Who Won't Pay His Federal Taxes.

$2

FRISCO

COPS FIGHT BACK! How Officer Krupke Is Planning To BITE YOU! by Steve Dell

EDITORIAL: **Yassir Arafat is a candyass; Ronald Reagan is the biggest terrorist in the Free World. The spies he loves have bombed airliners in flight, and he has made a charnel house of El Salvador. He's a peace faker who pretends to help the nutmeg trade in Granada, but (continued on page 3)**

SPORTS: **Why Vida Blue Had To Go by Harry Jupiter. Nobody can remember another big league team getting rid of its entire starting rotation between seasons, but that's what the Giants did, and they're catching a lot of ridicule for it. There's a suspicion in this (continued on page 12)**

INSIDE: **Novels I Never Finished by Don Asher, Don Carpenter, Herb Gold, James Houston, Cyra McFadden, Valerie Miner & Marilyn Sachs (page 14)** FICTION by **Alice Adams (page 15)** PHOTOGRAPHY: **The People of Earthquake Era Frisco (page 18)**

(COVER ILLUSTRATION BY RON CHAN)

Art Director: Dugald Stermer

Designer: Dugald Stermer

Client: *Frisco* Magazine

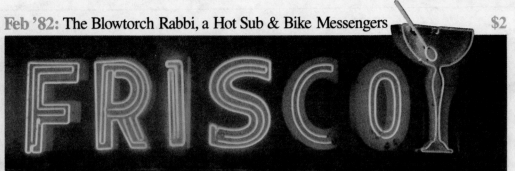

Feb '82: The Blowtorch Rabbi, a Hot Sub & Bike Messengers $2

FRISCO

ART DRINKING FASHIONS FILM LITERATURE MUSIC PICTORIALS POETRY POLITICS PUNK RECORDINGS RESTAURANTS REVIEW OF THE PRESS ROCK THEATRE ETC.

IN PRAISE OF LARGE WOMEN

An excerpt from the brilliant new book, "The Obsession, Reflections on the Tyranny of Slenderness," by Kim Chernin

EDITORIAL: THE CRIME AGAINST CUBA

Ronald Reagan is a likeable light bulb salesman with an empty shoebox for a brain. The only thing we have against him is that he is in the White House. Otherwise he'd be relatively harmless. Right now he's the most dangerous man in the world. He's

(continued on page 3)

Portrait of Adrianne Lee (after Renoir) by Nicole Bengiveno. See Fashions, page 17.

Quarterly Journal

BALLAST, an acronym for "Books Art Language Logic Anbiguity Science and Teaching," was founded by Roy R. Behrens, who edited and designed the first issues. Originally its mission was to counter illiteracy and other anti-intellectual tendencies among visual artists. Since its editor admits that he has "reached middle age, it is now chiefly a harmless pastiche of odd and indelible extracts from books and articles." BALLAST has always operated at a loss. Twelve hundred dollars is the average printing bill for eight hundred copies per quarterly issue—equalling about thirty-seven cents per issue. There are six hundred subscribers who are asked to contribute two fifty-cent postage stamps per issue — one to mail, the other for the kitty. "If everyone sent in the requested stamps (which they don't)," says Behrens,"we would still lose thirteen cents on the printing of each copy. And this, of course, doesn't account for typesetting, production, research and secretarial chores, all of which are donated." Currently BALLAST is edited by Behrens and designed and produced by his students at the Art Academy of Cincinnati. "As compensation for our loses," he adds, "we get amusing mail."

BOOKS
ART
LANGUAGE
LOGIC
AMBIGUITY
SCIENCE
TEACHING

Diane Ackerman: I don't want to get to the end of my life and find that I lived just the length of it. I want to have lived the width of it as well.

Art Director: Roy R. Behrens

Designers: Julie Robben, Steven Andres

Illustrators: Various students

Client: *BALLAST Quarterly Review*

In 1954, Professor Frank retired from Harvard, and I helped him clean out his office. It was unbelievable chaos. He had, as I remember, a rolltop desk, and from it he extracted letters, some of which he had never opened, and which dated from the 1930's. He opened a few and observed, "You see, they were not so important anyway." ∎

Jeremy Bernstein (remembering Philipp Frank, his teacher), "The Education of a Scientist" in Joseph Epstein, editor, *Masters: Portraits of Great Teachers* (New York: Basic Books, 1981), p. 224.

Two women stopped in front of a drugstore and one intended to say to her companion, "If you will wait a few moments I'll soon be back." However, because she was on her way to buy some caster oil for one of her children, she said, "If you will wait a few movements I'll soon be back." ∎

Sigmund Freud (adapted), in A.A. Brill, editor, *The Basic Writings of Sigmund Freud* (New York: Modern Library, 1938), p. 77.

FGHIJKLMNOP

Albrecht Durer, broadside, 1515.

...I suddenly thought I had got it: I "saw" a book with the odd but promising title *Deceptive Beetles* -- obviously some treatise on camouflage. Alas, as I looked more closely the title turned out to read *Decisive Battles*. ∎

E.H. Gombrich, "Visual Discovery through Art" in J. Hogg, editor, *Psychology and the Visual Arts* (Middlesex, England: Penguin Books, 1969).

Tobacco drieth the brain, dimmeth the sight, vitiateth the smell, hurteth the stomach, destroyeth the concoction, disturbeth the humors and spirits, corrupteth the breath, induceth a trembling of the limbs, exsiccateth the windpipe, lungs, and liver, annoyeth the milt, scorcheth the heart, and causeth the blood to be adjusted. ∎

Tobias Venner, *Via Recta* (1620).

6

Chic Restaurant Package

In 1986 a young chef named Florent Morlet opened an inexpensive French restaurant in New York City's tawdry meat-packing district. Since he had no investors and little capital, Florent rented a funky little luncheonette that had recently gone out of business, but for thirty years prior had been the greasiest of greasy spoons. Despite his intention to remain overtly unpretentious (yet appeal to an exclusive clientele) Restaurant Florent did require the basic amenities, such as menus, business cards, and a sign. For these graphics Florent hired M&Co. Tibor Kalman, M&Co.'s creative director and a vernacular maven, suggested that Florent use all the fixtures, furniture, utensils, and even the sign that the previous tenant had left behind — "let the restaurant design itself," was Kalman's credo.

Fittingly, the menu (not shown here) seemed to have designed itself too. Kalman decided that to be consistent with the restaurant's ambience and to adhere to budget limitations, he would create a menu that looked like a printer had "thrown it together." He would have gone to a place where they print Greek-coffeeshop menus, he says, "but we [the team working on the assignment] felt that the result wouldn't be quite as charming as what a job printer might do, because those other printers are now imitating designed things." Instead, the menu looks as though it had been pieced together in a few hours using random type from a letter-press printer's shop. How

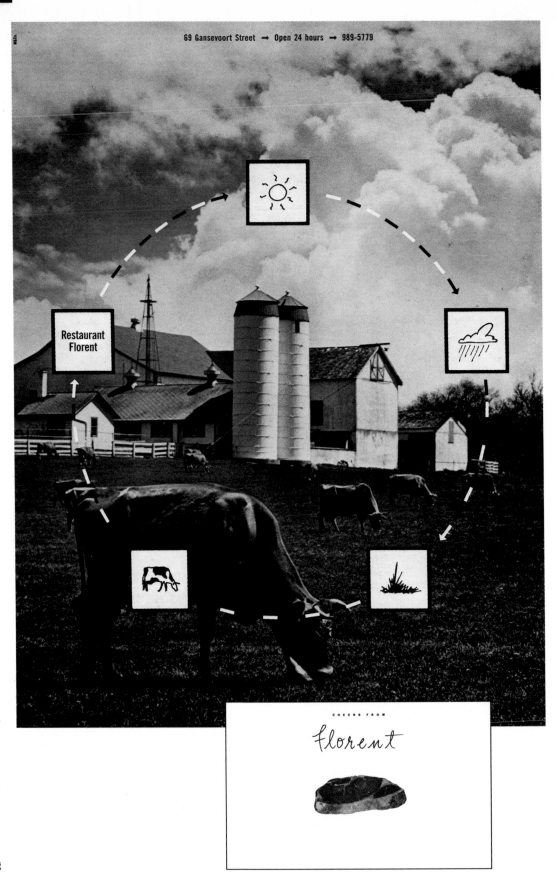

69 Gansevoort Street ➡ Open 24 hours ➡ 989-5779

Restaurant Florent

CHEERS FROM

florent

NOVEMBER

SOUP BOUDIN & WARM TARTS

GUSTY WINDS

HIGH S UPPER 40S TO MID 50S

LOWS UPPER 30S TO MID 40S

FLOR€NT

OPEN 24 HOURS 989 5779

WATCH FOR HEAVY R A I N S

WEAR YOUR GALOSHES

MNCO

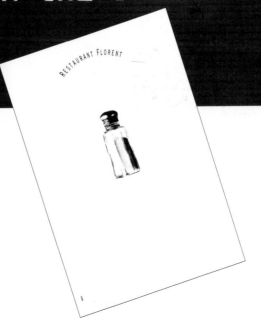

RESTAURANT FLORENT

much time did the job actually take? "Two months," admits Kalman. "If we weren't trained designers it would have taken less time. Remember, the difference between something really wonderful and really horrible is very close."

Using a mundane exterior photograph (the kind used for most diner postcards) M&Co. concocted Florent's first announcement, which was printed by a commercial postcard printer in Long Island. For the second, M&Co. decided to make a custom design and print it on a really bad chipboard stock. Since no central image was readily available, Kalman decided to deconstruct the *idea* of a restaurant into little icons lifted

continued on next page

(left top)

Art Director: Tibor Kalman

Designer: Timothy Horn

Photographer: Frederic Lewis

(left bottom)

Art Director: Tibor Kalman

Designer: Alex Isley

Photographer: Frederic Lewis

Client: Restaurant Florent

(right bottom)

Art Director: Tibor Kalman

Designer: Alex Isley

Photographer: Frederic Lewis

Client: Restaurant Florent

(right)

Art Director: Tibor Kalman

Designer: Timothy Horn

Photographer: Frederic Lewis

Client: Restaurant Florent

from the yellow pages (a chair representing the restaurant, a truck representing the address, a gun representing New York, and an old Bell Telephone Company logo representing a telephone). They formed a kind of rebus. "Our vocabulary was based on those really dumb, obvious, generic images used for most commercial advertising." But the intent was not to be nostalgic. In fact, Kalman insists that the difference between nostalgia (which he says is kitsch) and appropriation (which is more honest) is in how the finished product is filtered through the designer. When Florent eventually decided to advertise, he traded food for space in a local black-and-white culture tabloid called *Paper*. The early promos were successful. Extra funds were then available for larger ads on a more consistent basis. M&Co.'s solution was to create a different ad each week. Part of the appeal of the ads are the inexpensive stock photos and found objects (photographed in-house) used to convey a variety of messages. A three-dimensional menu-board leftover from the greasy spoon days, which — complete with misspellings — provided Florent's customers with daily weather reports, was photographed and printed as a full page; on another, arrows point to the shirt of a customer indicating which daily specials had been spilled; another, showing a cow and barn, was a parody of an ecological chart; and yet another ad echoed the inexpensive dadaist typography of the 1920s.

How much time is consumed by this weekly dead-

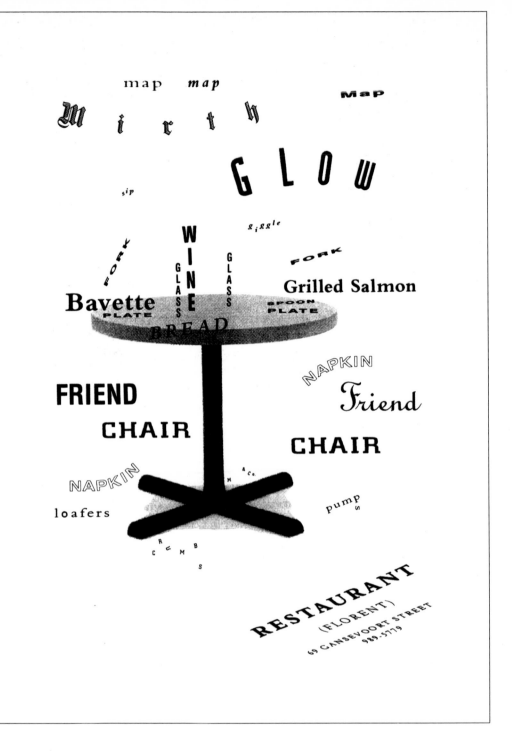

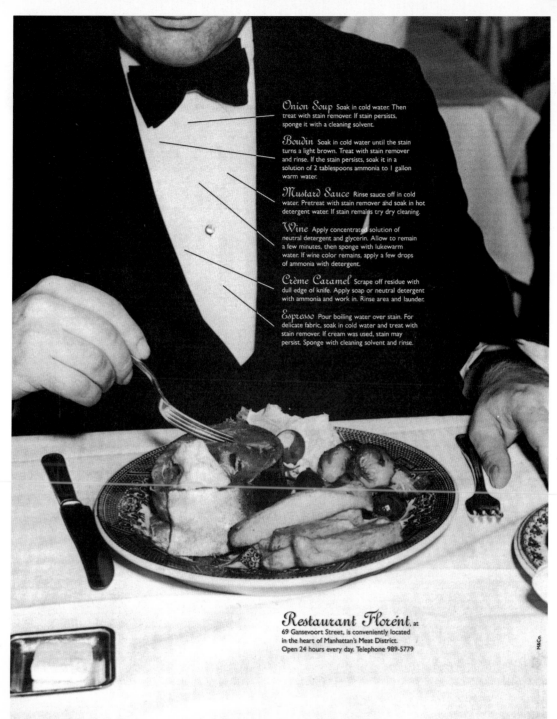

Onion Soup Soak in cold water. Then treat with stain remover. If stain persists, sponge it with a cleaning solvent.

Boudin Soak in cold water until the stain turns a light brown. Treat with stain remover and rinse. If the stain persists, soak it in a solution of 2 tablespoons ammonia to 1 gallon warm water.

Mustard Sauce Rinse sauce off in cold water. Pretreat with stain remover and soak in hot detergent water. If stain remains try dry cleaning.

Wine Apply concentrated solution of neutral detergent and glycerin. Allow to remain a few minutes, then sponge with lukewarm water. If wine color remains, apply a few drops of ammonia with detergent.

Crème Caramel Scrape off residue with dull edge of knife. Apply soap or neutral detergent with ammonia and work in. Rinse area and launder.

Espresso Pour boiling water over stain. For delicate fabric, soak in cold water and treat with stain remover. If cream was used, stain may persist. Sponge with cleaning solvent and rinse.

Restaurant Florent, at 69 Gansevoort Street, is conveniently located in the heart of Manhattan's Meat District. Open 24 hours every day. Telephone 989-5779

M&Co.

line? "Very little," says Kalman, "since becoming more familiar with the subject matter makes it easier to do." And what are the prerequisites? Instead of a retainer or fee, Restaurant Florent provides a sumptuous lunch for the staff of M&Co. on a regular basis.

(left)

Art Director: Tibor Kalman

Designer: Marlene McCarty

Photographer: Frederic Lewis

Client: Restaurant Florent

(right

Art Director: Tibor Kalman

Designer: Bethany Johns

Photographer: Frederic Lewis

Client: Restaurant Florent

Novelty Gem

Always looking to expand his business into new areas of design, Mike Hicks of Hixo Design accepted a commission to design a package that would launch a new novelty, "The Texas Diamond." His clients were two business-school fraternity brothers, one who inherited a coal mine from his parents. Realizing that coal is rally diamonds-in-the-rough, they dediced to sell it as a gag. Hixo was promised $6,000 for the design, which seems like a reasonable sum, but it was not enough given the studio's usual fees. "Therefore, we had to do it quickly, so as not to waste billable studio time, and used manipulated clip-art as illustration. Everyone was happy with the printed result, but since the entrepreneurs had not found financial backing, they could not pay their bills for design or printing. Hicks paid the printer, and unless he receives payment from the clients soon, he will own a Texas diamond company."

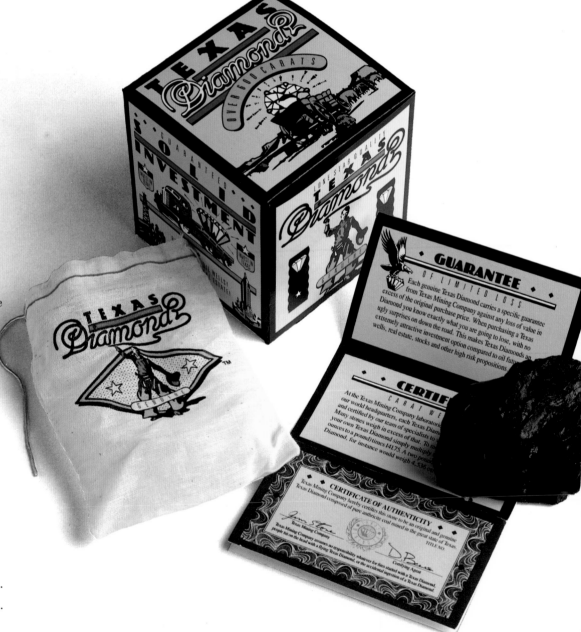

Art Director: Mike Hicks

Designer: Mike Hicks

Illustrators: Mike Hicks, Harrison Saunders

Client: Texas Diamond

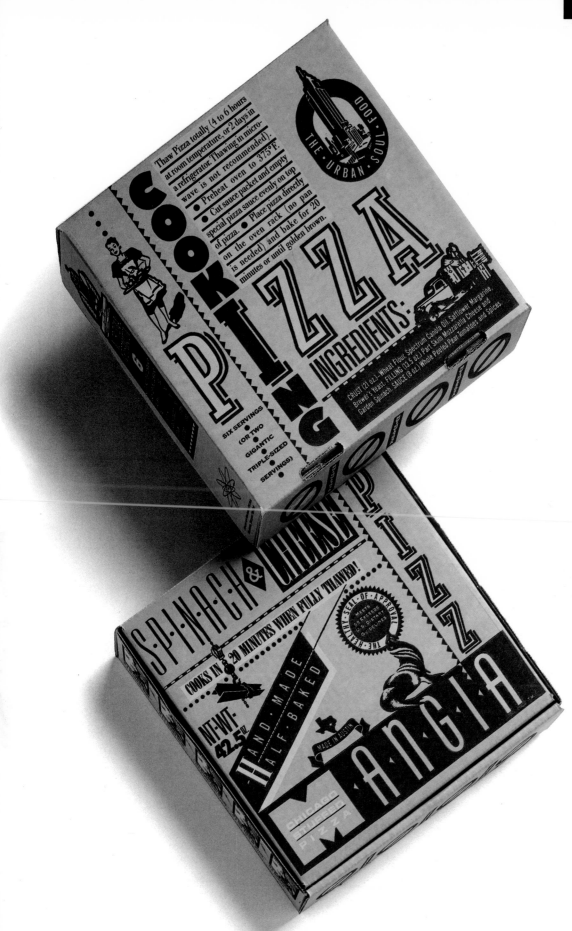

Pizza Box

Small entrepreneurs can benefit from good graphic design as proved by the owners of Mangia Pizza, a tiny mom-and-pop establishment in Austin, Texas, which approached Mike Hicks of Hixo Design to conceive a box for its new frozen pizza. The restaurant wanted something that would create awareness of the brand and give a unique look without using a photograph. The budget was $1,000 for design plus a little extra for type and printing of a thousand boxes. Says Hicks: "We did this because we like the client, the product is good, and because doing jobs like this is the only way to break into the very tight packaging design market." The type and illustrations were done in-house by the staffers, and it was reproduced on sturdy but inexpensive packing-box material. As proof that the product is selling well the client has purchased a new delivery truck and plans to introduce two new flavors. "They might even fork over $2,000 for the next design," says Hicks optimistically.

Art Director: Mike Hicks

Designers: Mike Hicks, Duana Gill

Illustrators: All the Hixoids

Client: Mangia Pizza

Business Identity

Lisa Ramezzano is a casting agent in San Francisco. Michael Mabry is her friend. Fortunately, he thought it would be fun to help advertise her business for free. "Since she casts character actors," he says, "I designed four different characters on four different cards." For $800, five hundred of each card were printed in two colors on an inexpensive chipboard, a kind of sturdy cardboard that is heavy enough to be used for mailing purposes. They were mailed to advertising designers and art directors. As payback, after finishing the job Mabry was cast in a local GAP advertisement.

 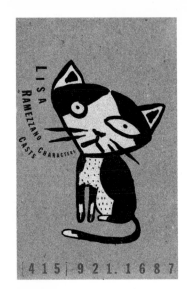

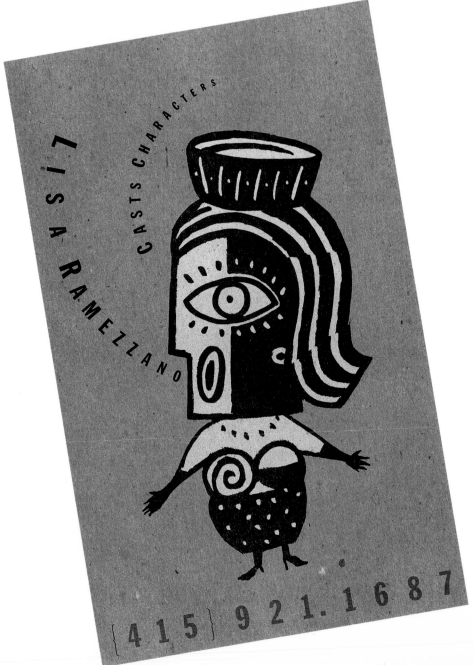

Art Director: Michael Mabry

Designer: Michael Mabry

Illustrator: Michael Mabry

**Client: Lisa Ramezzano,
Casting Agent**

Letterheads

Some design schools involve their students in pro bono activities for worthy causes, fledgling businesses, and needy organizations as a way to get hands-on experience, a portfolio sample, or just to do some good for society. Virtually every design school assigns its students to design their own letterheads and business cards. The idea is to be as creative as possible with absolutely no budget. In both cases the results can be quite satisfying. Indeed, students are often given carte blanche—the conceptual sky's the limit. Some might raid the public-domain art books and library collections for scrap and source material. Others might concoct an interesting graphic device using photography or illustration. With the advent of image-making computer programs that make accessible once-complicated or costly production techniques, letterheads have become more experimental than ever before.

(top)

Art Director: Katherine McCoy

Designer: Darice Koziel

Client: Darice Koziel

Budget: Nothing. Printed at school as part of a job search package.

(bottom)

Art Director: Katherine McCoy

Designer: Glenn Suokke

Client: Glenn Suokke

Budget: Nothing. Printed at school as part of a job search package

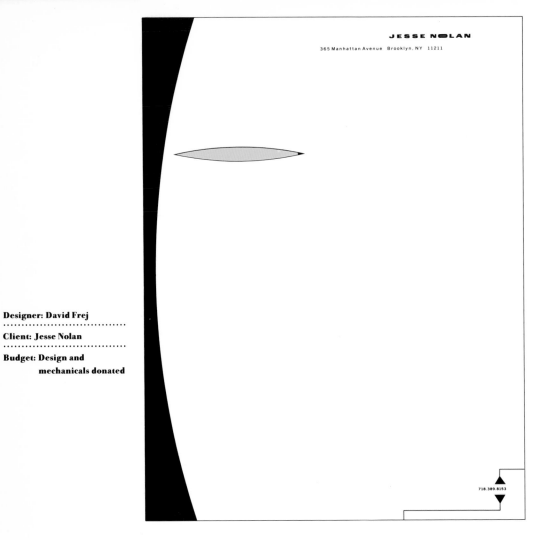

Designer: David Frej

Client: Jesse Nolan

Budget: Design and
 mechanicals donated

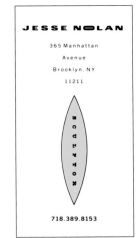

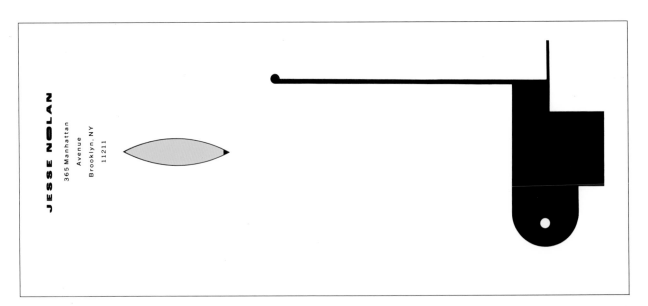

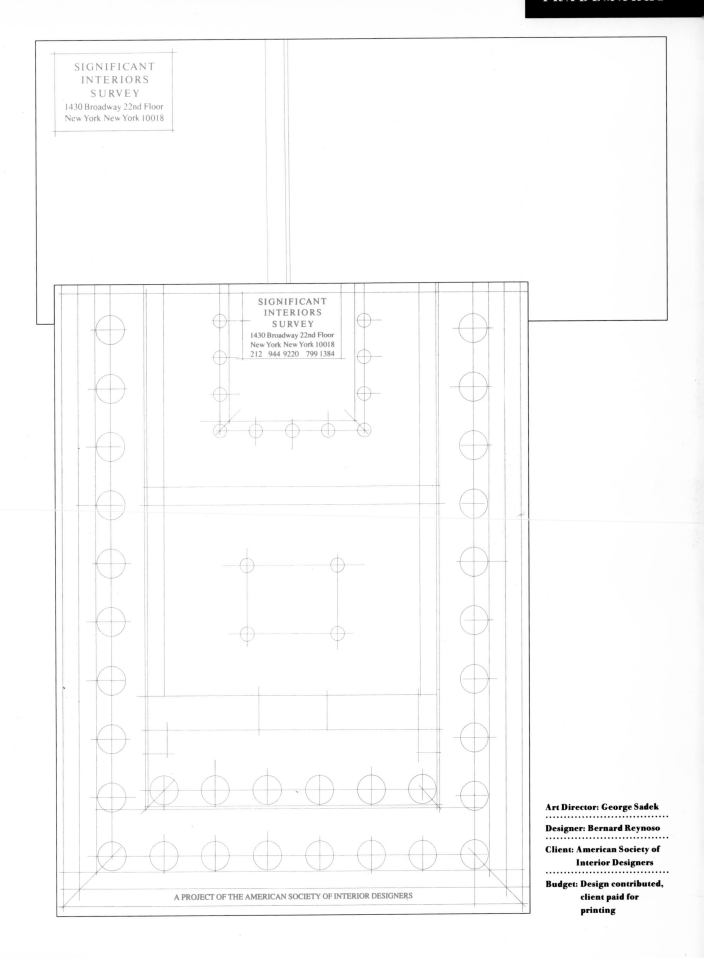

SIGNIFICANT
INTERIORS
SURVEY
1430 Broadway 22nd Floor
New York New York 10018

SIGNIFICANT
INTERIORS
SURVEY
1430 Broadway 22nd Floor
New York New York 10018
212 944 9220 799 1384

A PROJECT OF THE AMERICAN SOCIETY OF INTERIOR DESIGNERS

Art Director: George Sadek
.............................
Designer: Bernard Reynoso
.............................
**Client: American Society of
Interior Designers**
.............................
**Budget: Design contributed,
client paid for
printing**

Trademarks

Logos and trademarks are imbued with mythic power by their owners and are often charged for accordingly by designers. Logos also command high prices because they are continually used and therefore designers tend to bill for implied value. Sometimes the design of a logo is part of a larger identity system, and so the design is included in an overall design fee. Often for corporations and smaller businesses, many designs are proposed before one is selected, which also considerably boosts up a fee based on labor and concept. But a logo need not be expensive to be effective. Some of the most memorable marks have been made for small design fees. Those represented here were done for free, but for their owners they are as valuable as the higher-priced versions.

(top right)

Art Director: Ron Sullivan

Designer: Jon Flaming

Illustrator: Jon Flaming

Client: The Vagabonds Soccer
Club, Dallas

(bottom left)

Designer: Scott Ray, Peterson
and Company

Client: Phillip Cooke
Photography

(top right)

Designer: Ken Parkhurst,
Denis Parkhurst

Art Directors: ADLA Pro
Bono Group

Client: California Museum of
Science and Industry

(bottom right)

Designer: Michael Manwaring

Client: Youth Guidance
Center

EARSHOT

JAZZ

GIVE

PEACE

A

DANCE

(top left)

Designer: Art Chantry

Client: Friends of the
Conservatory

(top right)

Designer: Art Chantry

Client: Earshot Jazz

(bottom)

Designer: Art Chantry

Client: Give Peace A Dance
Fundraising Benefit

The Drama Board of
the Bathhouse Theatre
7312 Greenlake Drive North
Seattle, Washington 98103
(206) 524-9110

The Drama Board of the Bathhouse Theatre
7312 Greenlake Drive North
Seattle, Washington 98103
(206) 524-9110

(top)

Designer: Art Chantry

**Client: The Bathhouse
Theatre**

(bottom)

**Art Director: Katherine
McCoy**

Designer: Lisa Anderson

Client: Lisa Anderson

**Budget: Nothing. Printed as
school project**

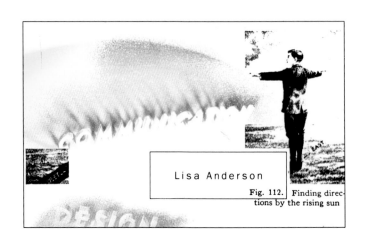

Lisa Anderson

Fig. 112. Finding direc-
tions by the rising sun

SCOTT ZUKOWSKI

...SOLVING BY REASONING, CALCULATION AND DELIBERATION.

()

500 LONe PINE Road
BOX 801
BLOOMFIELD HILLS MICHIGaN
48013

SCOTT ZUKOWSKI

TO ADAPT TO LIFE IN INTIMATE ASSOCIATION WITH
AND TO

[]

M U S I C BY APPOINTMENT

512 Briar Hill Ave.,

Toronto, Ontario

M5N 1M9

(416) 485-5903

Anne-Marie Applin

M U S I C BY APPOINTMENT

512 Briar Hill Ave.,
Toronto, Ontario
M5N 1M9
(416) 485-5903

(top)
...................................
Art Director: Scott Tayler
...................................
Designer: Lisa Miller
...................................
Client: Music By
 Appointment
...................................
Budget: Design, illustration,
 and mechanicals
 donated; $1,450 for
 printing and
 typesetting

(bottom)
...................................
Art Director: Katherine McCoy
...................................
Designer: Scott Zukowski
...................................
Client: Scott Zukowski
...................................
Budget: Nothing. Printed as
 school project.

↑ **THIS END UP** ↑

397 FIFTH STREET, BROOKLYN, NY 11215.

9½" X 4¹³/₁₆"

8½" X 11"

397 FIFTH STREET, BROOKLYN, NY 11215.

Designer: Woody Pirtle

Client: Libby Carton

Budget: $30 for rubber stamps
used on craft paper